Peter Paul RUBENS

Publishing Director: Paul ANDRÉ
Collaborator: Tatyana MORDKOVA
Translators: John CROWFOOT, Ruslan SMIRNOV, Paul WILLIAMS
Design and Layout: DES SOURIS ET DES PAGES

Printed by SAGER in La Loupe (France)
for Parkstone Publishers
Copyright 3rd term 1995
ISBN 1 85995 166 X

Peter Paul RUBENS

The Pride of Life

Texts
Maria Varshavskaya
Xenia Yegorova

PARKSTONE PUBLISHERS, BOURNEMOUTH
AURORA ART PUBLISHERS, ST. PETERSBURG

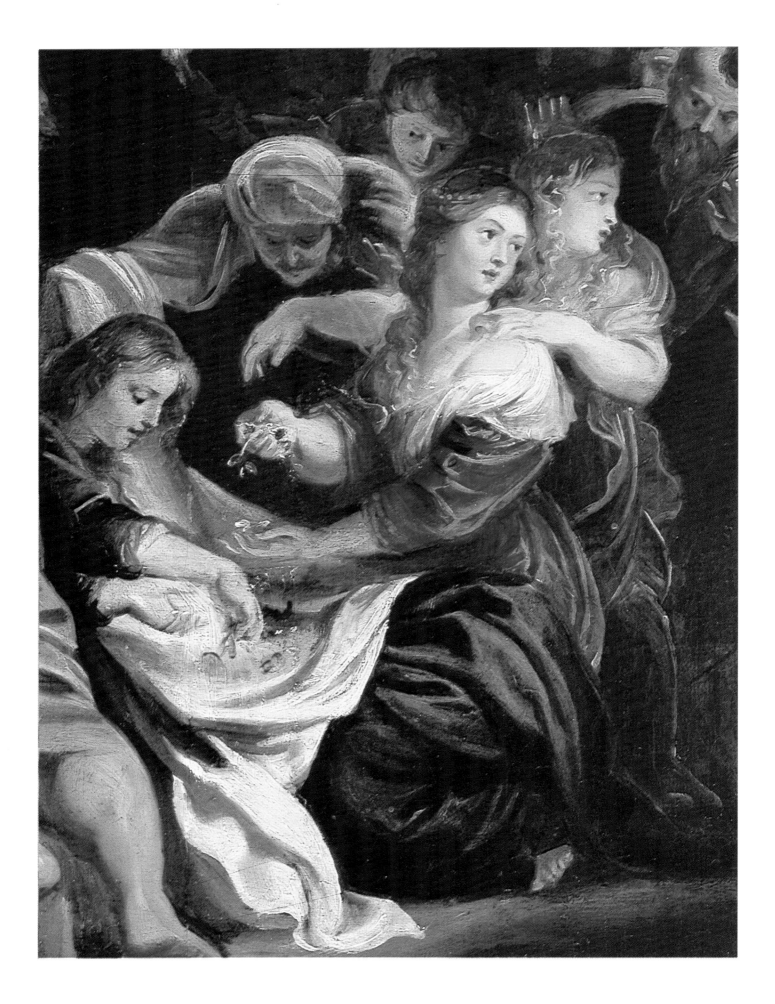

CONTENTS

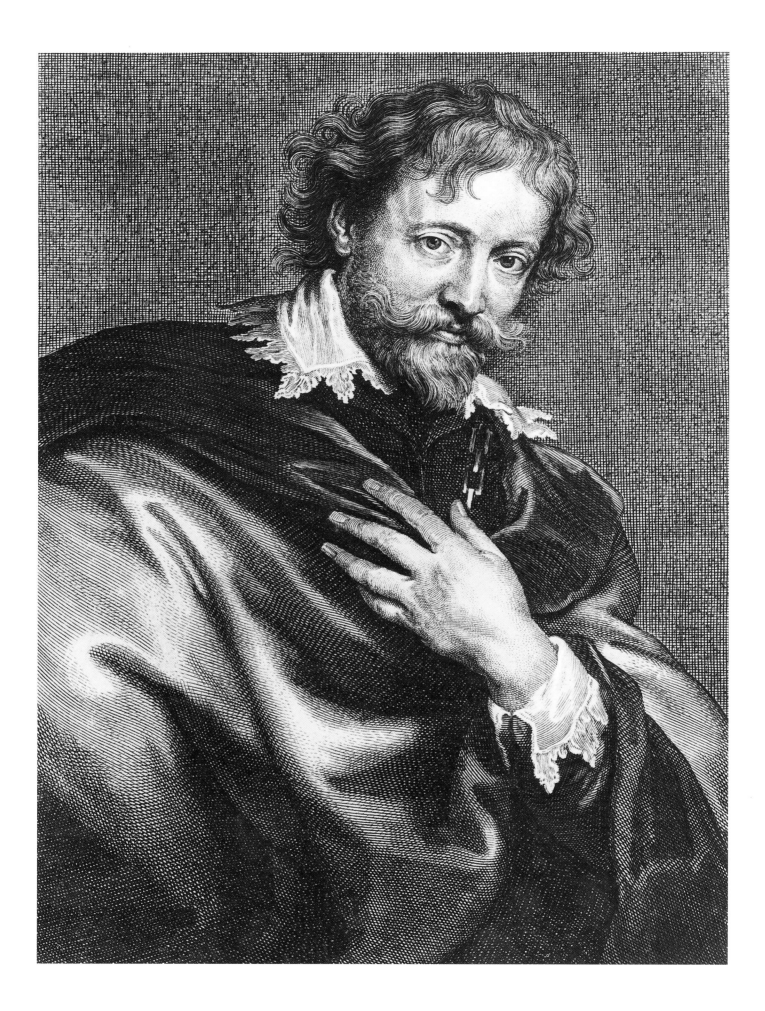

T HE name of the great seventeenth-century Flemish painter Peter Paul Rubens is known throughout the world. The importance of his contribution to the development of European culture is generally recognized. The perception of life that he revealed in his pictures is so vivid, and fundamental human values are affirmed in them with such force, that we look on Rubens' paintings as a living aesthetic reality of our own time as well.

The museums of Russia have a superb collection of the great Flemish painter's works. These are concentrated, for the most part, in the Hermitage Museum in St. Petersburg, which possesses one of the finest Rubens' collections in the world. Three works, previously also part of the Hermitage collection, now belong to the Pushkin Museum of Fine Arts in Moscow. The *Bacchanalia* (No. 9) and *The Apotheosis of the Infanta Isabella* (No. 33) were bought for the Hermitage in 1779 together with the Walpole collection (from Houghton Hall in England); *The Last Supper* (No. 27) came to the Hermitage in 1768 from the Cobenzl collection (Brussels). These three paintings were transferred to Moscow in 1924 and 1930.

The collection of the Russian museums is outstanding not just because it contains many original works by Rubens, or because many of these are genuine masterpieces, but also because its range is so extensive. The varied aspects of the painter's activities, the different genres of artistic expression and all periods of his creative career are represented here. There are paintings on religious, mythological, allegorical and historical themes; landscapes; portraits; monumental altarpieces completed through the efforts of his whole workshop; and sketches that represent the first conceptions or initial individual stages in the development of the artist's creative thoughts. There are life studies and plans for complex decorative ensembles; official court commissions and intimate portraits of close friends; his first works, following in the footsteps of his predecessors, and the epitome of his life work. The creative world of the great artist reveals itself both in its achievements and its development.

Previous page: *The Coronation of the Virgin*, detail. The Hermitage, St. Petersburg.

◀ *Portrait of Peter Paul Rubens.* Engraved by Paul Pontius (after Anthonis van Dyck).

Rubens' works occupied a notable place in leading European collections, the purchase of which in 1764 provided the starting point for the Hermitage. Four of the paintings reproduced in the present book were obtained in 1768 as part of the Brussels collection of Count Carl de Cobenzl, the Austrian viceroy of Belgium; three others came in 1769 with the collection of Count Heinrich Brühl, who was a minister of the King of Saxony in Dresden. Eight paintings formed part of the collection of the French financier Pierre Crozat in Paris and were acquired in 1772, while a further nine works entered the Hermitage in 1779 with the collection of the former British Prime Minister Robert Walpole. One Rubens' painting arrived with the Paris collection of the Comte de Baudouin in 1781, and another was bought in Amsterdam in 1770 at the auction of the Dufferin collection. The provenance of certain other paintings has not been precisely established but they entered the Hermitage collection before 1783.

The Hermitage is also indebted to eighteenth-century collectors for two further additions to its collection: one painting bought no later than 1800, and another that joined the other Rubens' works as part of Empress Josephine's collection in 1814 but that had evidently already been in her possession at the end of the previous century. Likewise, the painting from the Shuvalov and Kushelev-Bezborodko collections (which were added to the Hermitage after 1917) had already belonged to those collections, in all probability, in the eighteenth century. Only two paintings added from private St. Petersburg collections cannot be traced back that far (for details of the provenance of each, see the relevant entry in the catalogue).

The collections from which all these paintings entered the Hermitage were formed in the eighteenth century. In most cases it is almost impossible to determine the pictures' earlier history; we know only the original intended settings and initial owners of some of these works. Rubens' paintings had various objectives. As a rule, his large-scale compositions were conceived for architectural settings and painted so as to match the interiors of specific buildings, whether ecclesiastical or secular. His small and medium-sized works were generally easel paintings intended for the private collections (or "cabinets" as they were then called) of connoisseurs and art lovers, which in the seventeenth century came to include paintings. Thus *The Descent from the Cross* (No. 13) hung in the

Capuchin Church in the town of Lierre; *The Carters* (No. 16) evidently belonged to Cardinal Mazarini, a minister of Louis XIV, while a sketch for *The Apotheosis of James I* (No. 29) was in the collection of the English artist Godfrey Kneller. Five sketches of decorative ornamentation for the city of Antwerp on the occasion of the new Governor's arrival (Nos 31-37) were part of the collection of Prosper Henry Lankrink, another English artist. From time to time the owner's name appears in the titles of the engravings copied by contemporary artists from Rubens' paintings. On the engravings by Cornelis van Caukercken taken from the *Roman Charity (Cimon and Pero),* a work in the Hermitage (No. 4), for instance, there is a dedication to Carl van den Bosch, the ninth bishop of Bruges; the painting must have been in the latter's collection, evidently before 1680 (when the engraver died). Of three other paintings — *Landscape with a Rainbow* (No. 30), *Feast in the House of Simon the Pharisee* (No. 15) and *Bacchus* (No. 38) — we know that they formed part of the collection of the Duc de Richelieu, the Cardinal's nephew.

One gains the impression that in the seventeenth century Rubens did not attract as much attention as later. This may appear strange: indeed his contemporaries praised him as the "Apelles of our day". However, in the immediate years after the artist's death in 1640 the reputation which he had gained throughout Europe was overshadowed. The reasons for this can be found in the changing historical situation in Europe during the latter half of the seventeenth century.

In the first decades of that century nations and absolutist states were rapidly forming. Rubens' new approach to art could not fail to serve as a mirror for the most diverse social strata in many European countries who were keen to assert their national identity, and who had followed the same path of development. This aim was inspired by Rubens' idea that the sensually perceived material world had value in itself; Rubens' lofty conception of man and his place in the Universe, and his emphasis on the sublime tension of man's physical and imaginative powers (born in conditions of the most bitter social conflicts), became a kind of banner of this struggle, and provided an ideal worth fighting for.

In the second half of the seventeeth century the political situation in Europe was different. In Germany after the end of the Thirty Years' War, in France following the Frondes, and in England as the result of the Restoration, the absolutist regime triumphed. There was an increasing disparity in society between conservative and progressive forces; and this led to a "re-assessment of values" among the privileged, who were reactionary by inclination, and to the emergence of an ambiguous and contradictory attitude towards Rubens. This attitude became as internationally prevalent as his high reputation during his lifetime, and this is why we lose trace of many of the artist's works in the second half of the seventeenth century after they left the hands of their original owners (and why there is only rare mention of his paintings in descriptions of the collections of this period). Only in the eighteenth century did Rubens' works again attract attention.

In the course of the three centuries which have elapsed since the death of Rubens his artistic legacy, while not losing its immediate aesthetic value, has been variously interpreted. Prevailing aesthetic opinion has never been able to ignore his influence, but at each specific historical juncture it has sought to channel this influence in a particular direction. At times the perception and interpretation of the artist's legacy has been determined by those features which people desired to see in his works, or those that they hesitated to find there. Rubens' creative activities were so closely interwoven with the world he lived in that the detachment necessary for an overall assessment of his role and importance was not possible to achieve during his lifetime. His contemporaries did not furnish literature on his art.

Only a few brief reviews or verses dedicated to his works by his contemporaries confirm his wide recognition.[1] The opinion stated in a letter by Vincenzo Giustiniani, the well-known Italian maecenas and patron of Caravaggio, may be considered one of the first attempts to define the nature of the artist's work.

Writing during Rubens' lifetime, Giustiniani discussed the development of contemporary art: he considered it possible to place Caravaggio and Guido Reni in one group, with Rubens in another. He included Rubens, together with Ribera, Terbrugghen and Honthorst, in the group of "naturalists".[2] Critical writings about Rubens began to appear when enthusiasm for him was moderated, and when the aesthetics of the "Grand Manner" began to take hold. One of the chief proponents of this trend was Giovanni Pietro Bellori, the director of

the Academy of St. Luke in Rome. His classical theories have a decisive influence on the formation of artistic taste throughout Europe in the second half of the eighteenth century. According to his aesthetic principles, the main requirement of art was that it should embody "the ideal of beauty"; moreover, all that was individual, partial, accidental or transitory had to be raised to the level of the universal, eternal and immutable. Rubens, with his concrete observation of life and sensualistic approach, was seen as an underminer of such canons, and as an offender against social decorum (although, even so, he impressed Bellori in many ways).[3]

At the end of the seventeenth century Roger de Piles, a recognized art specialist and leader of the "Rubensistes" (a new tendency in French painting and the theory of art) praised Rubens as a brilliant master of colour. Like adherents of the hedonist aesthetics in the eighteenth century, Roger de Piles considered colour as the "spirit of painting" and "the satisfaction of the eyes" as the basic purpose of art.[4]

With the approach of the French Revolution of 1789, however, new movements of artistic theories grew, and Neo-Classicism was being formed. Its theoretician, Johann-Joachim Winckelmann,[5] promoted it to counteract the "defiled" culture of the aristocratic drawing room. The rationalist aesthetics of his ideal, "the noble simplicity and calm majesty of free Greece", naturally rejected Rubens as he was then understood. It was to be expected, furthermore, that the artist's supposed hedonism was quite unacceptable to the severe civic-mindedness of the revolutionary Jacobin Classicism of David.

In eighteenth-century Germany the protagonists of the "Sturm und Drang" period had already advanced concepts directed against the *ancien régime* which were also contrary to Classicism. They had declared the free development of the personality to be the sole source of artistic creativity and had regarded Rubens with joy.[6] Goethe, to the end of his days, considered Rubens to possess great virtues.[7] These ideas were opposed by the narrow nationalist tendency in German Romanticism. The latter regarded the spiritual world of the Middle Ages, and the Gothic style as an expression of abstracted religious feeling, to be their ideal. For Friedrich Schlegel, Rubens was merely "an extremely misguided talent, and a false artistic innovator".[8]

The French Romantics of the early nineteenth century took a characteristically different attitude towards Rubens. Delacroix produced a veritable apotheosis of Rubens in his *Journal*.[9] The artist Eugene Fromentin who was a follower of Delacroix and passionate admirer of Flemish painting, compared Rubens' works to heroic poetry and wrote enthusiastically about the "radiant light of his ideas".[10]

In nineteenth-century Belgium, which had just won its independence, there was an ambiguous attitude to Rubens. The progressive democratic movement bore his name on its banner. Andre van Hasselt, a poet and publicist, saw Rubens as the founder of the national school of painting; he revealed Rubens' importance in establishing a national self-awareness which had in turn shown the Flemish people the real possibility of their further advance.[11] The view of official circles, however, was expressed by Van den Branden, the keeper of the Antwerp city archives. He complained that the artist had "endowed his figures with a heroic mobility and liveliness that was unsuitable for their setting in the peaceful temples of God". Van den Branden reproved Rubens with having betrayed the national character: for him, only the masters of the fifteenth century and Quentin Massys were the true exponents.[12]

The artist's Belgian biographer, Max Rooses, devoted his entire life to the collection of material relating to Rubens. He completed the major work of publishing Rubens' correspondence which he had begun with Charles Ruellens; it amounted to six volumes and included letters to and from Rubens and those which discussed him.[13] To this day the publication has remained unique of its kind; only a very few letters by Rubens have been discovered since Rooses completed his work. The only exhaustive publication of Rubens' works is even now the fundamental catalogue compiled by Rooses, which includes all the then known paintings and drawings of the master.[14] In gathering together Rubens' legacy, Rooses was continuing the work begun in 1830 by the English antiquarian, John Smith, who had produced a multi-volume catalogue devoted to the best known Dutch, Flemish and French artists.[15] The second volume of Smith's catalogue deals with Rubens and notes everything that the author was saw or heard concerning Rubens throughout his lifetime. Another book published in 1873 which is on a par with Smith's catalogue as the earliest record of its kind is

C. G. Voorhelm-Schneevoogt's list of the engravings made from Rubens' paintings.[16]

By the end of the nineteenth century art history as an independent field of research had begun to stand distinct from the broader study of culture as a whole. It was the publication in 1898 of Jakob Burckhardt's book *Recollection of Rubens* [17] that initiated the historico-cultural approach to the study of art. In his book the German scholar (who had worked in Switzerland) recognized and defined Rubens' aspiration towards the "extolling of man in all his capabilities and aspirations". Burckhardt insisted that, in contrast to the theatricality and rhetoric of the Italians, Rubens' figures were true to life, and he laid emphasis not only on their formal qualities (of colour and chiaroscuro) but also on the importance of their moral and spiritual values. Burckhardt presented extremely significant evidence of the close ties between Rubens and his native Antwerp, and showed that the substance of his portrayals had much in common with the outlook of those who were his most important and frequent patrons — the influential city guilds and ecclesiastical fraternities. The scholar noted, with some pleasure, that "there was no royal throne in Rubens' immediate vicinity" and that "Antwerp was not a papal residence". For Burckhardt, Rubens was the standard-bearer of the great new, universal flourishing of art which had been born in the Low Countries, the "Italy of the North", and continued the work begun during the Renaissance.

At the turn of the century there developed a more biased opinion that Rubens was a prophet of passive sensuality and nothing more. However, both "art for art's sake" aesthetics and formal art criticism again acknowledged Rubens since they saw in his art a degree of the primacy of form which they had proclaimed. In this respect the interpretation of Rubens' artistic approach by the German scholar Rudolf Oldenbourg was typical.[18] Although the formalist school was incapable of understanding the complex variety of artistic phenomena, it nevertheless played a great role in the history of art criticism. The actual study of Rubens' works, in particular, and of their specific "forms of expression" laid the foundations of contemporary Rubens studies. By singling out the distinctive features of Rubens' artistic style it became possible to distinguish the master's own works from the enormous

The Descent from the Cross, detail.
The Hermitage, St. Petersburg.

number of those produced under his direction, to establish who had influenced him, and to define the stages through which he had evolved. In short, it was possible to clarify the features of Rubens' individual creativity.

In the years between the two world wars the work of Rubens was increasingly regarded as a direct expression of the anti-materialist and anti-realist trends that were identified with the feudal and absolutist Counter-Reformation in seventeenth-century Europe. The French historian Gabriel Hanotaux[19] emphasized the hedonistic sensuality and outward splendour of Rubens' art, considering that, by his very nature, this artist of elaborate spectacle was only suited to praise the monarchy and the church. Leo van Puyvelde, a Belgian art critic, imputed to Rubens a striving to transform the artistic image into a subjective world divorced from reality. "These creations are raised to such a high level", Puyvelde wrote in 1943, "that all the sounds of the real world have been muted."[20]

After the Second World War there was a notable return to an appreciation of the primary materials and actual circumstances of Rubens' art. Much has been achieved in this direction. First and foremost, the number of works known to be genuine Rubens has grown due to the inclusion of those that had been attributed to other painters or to none — quite unknown compositions, variants of already familiar pictures and preparatory works, drawings and sketches. This has involved a reexamination of some previous conceptions of Rubens' development as an artist and adjustments to the datings. Entire periods and aspects of his artistic activities are now seen in a new light, and the gaps in the history of his artistic career are constantly decreasing. To give examples: we have a quite different impression of Rubens as a draughtsman; his early pre-Italian works are more precisely placed; we understand better his relations with his predecessors and successors, and how his workshop was organized; and light has been shed on many iconographic problems, on the actual way in which he worked, and on the process whereby his conceptions were brought to life.

The following scholars have made major contributions to this development: G. Glück, W. R. Valentiner, L. Burchard, O. Benes, F. Lucht, J. S. Held, H. Gerson, M. Jaffé, R. A. d'Hulst, J. Millar, E. Haverkamp-Begemann, F. Baudouin, and O. Millar. Rubens the man and his art are far more complex than was appreciated before. We now have an incomparably wider view of the artist's capabilities, and see a more varied range of sources from which he drew his inspiration and his different artistic tastes.

While Rubens inherited the realist Flemish traditions of the art of Van Eyck and Brueghel, he was, at the same time, a loyal student of the Romanist master painters — the Antwerp Italianizers who had taken the achievements of the Italian Renaissance as their ideal. Following the example of his teachers, he travelled to Italy in 1600 when he was a young man of twenty-three to be in direct communion with the treasures of ancient and Italian cultures. However, he approached what he had seen in Italy with a critical eye, and we may judge his true aspirations from what actually attracted him there.

It was not so much as models of a formally strict and ideal beauty that Antiquity drew Rubens: he preferred the relics of the late classical period and the sculpture of Hellenistic Rome, where "noble simplicity and calm majesty" were softened by the evocation of the living flesh — Praxiteles' *Resting Satyr,* the *Laocoön, Heracles of Farnese,* and small decorative fountain work. Rubens would return to the great art works and monuments he had seen in Italy more than once in his later artistic career. Among the Italian masters of the previous era he singled out the Venetians for their attachment to colour as the basic means of expression in painting, and Correggio with his sensuality and magical chiaroscuro. Rubens was enthralled by the dynamism of Leonardo da Vinci's *Battle near Anghiari,* and the titanic power of Michaelangelo's heroes. Rubens also took an interest in the expressiveness of the images in the work of Pordenone, an original but in no sense "great" master, attracted by his attempts to reconcile the ideal world of art with real life.

During Rubens' years in Italy Annibale Carracci, the head of the Academic school, was at the height of his reputation. Carracci's efforts to revive the objectivity of the Renaissance, its harmony of artistic vision, and to pay closer attention to the live model after the "excesses" of the mannerist approach, impressed Rubens. He was enraptured by Carracci's brilliant murals in Palazzo Farnese but in his own subsequent decorative works hardly followed this example. The small landscapes of Elsheimer (a German who had settled in Italy), on the other hand, which were pervaded by lyrical emotion, remained in Rubens' memory for a long

time. The innovative approach of the rebellious Caravaggio proved especially close to Rubens' heart. Caravaggio had demolished the abstracted character of religious painting by treating the conventional images and scenes from the ecclesiastical doctrine as earthly events, taking place among living people with real human concerns.

Consideration of his Italian contemporaries and the experience of the entire past of Italian art helped Rubens to find his own artistic idiom in which he addressed his Flemish compatriots on his return in 1609. All the works that he produced here in the very first years (e.g. *The Adoration of the Magi*, Prado, Madrid; *The Elevation of the Cross* and *The Descent from the Cross*, Antwerp Cathedral), were executed with such a burning and passionate affirmation of life, permeated with such unsuppressed energy, and were addressing the viewer with such authority, that these canvases immediately outshone all the achievements of his Flemish predecessors.

Young artists began to flood towards Rubens' workshop from every corner of the country: he evidently had given expression to a feeling that had been maturing for a long time. His art flowed into the current of his compatriots' common interests and passions. It had organically become part of the affirmation and preservation of a common and distinct identity which Flanders had to make, finding itself once again part of the Spanish Empire of the Hapsburgs after a stormy period of revolutionary struggle. Moreover, the political division of the Low Countries which resulted from the sixteenth-century revolution spurred a further need to give the separation from neighbouring Holland a spiritual and aesthetic expression.

In these circumstances the propaganda of the Catholic Counter-Reformation in Flanders took a distinctive form: while emphasizing their Catholicism as a countercharge to the Protestantism of the Dutch, the Flemish at the same time tried to secure their own place in the modern world and, in some degree, oppose the official outlook of the Vatican. It should not be forgotten that the church commissions created in Rubens' workshop were not directed towards the Europe of the Counter-Reformation but intended for Flemish churches. Even individual commissions from outside Flanders still fell within the limits of that region's cultural influence: paintings for the Duke of Neuburg, who was entirely dependent on the Vice-regal court in Brussels, as well as for Genoa and Cologne, which formed part of Antwerp's economic and cultural sphere of influence.

One cannot speak of Rubens' "atheism" for he was a man of his time. Yet there was no contradiction in his religious paintings between the eternal divine values and those that were transitory and earthly. Rubens translated the abstracted dogmas of the church into the language of concrete living images; he likened the mystical meaning of Christ's sacrificial feat to entirely human virtues — such as unyielding endurance and fearless selflessness *(The Descent from the Cross*, No. 13; *The Crown of Thorns*, No. 5)*. The artist sought examples of elevated personal courage in ancient history, classical literature and mythology: it might be the public-spirited valour of the Romans Mucius Scaevola and Decius Mus; the self-sacrificing love of daughters *(Roman Charity*, No. 4)*; or the bold challenge to the monster which threatened to violate youth and beauty *(Perseus and Andromeda*, No. 19)*. Even traditional abstract allegories became brilliant embodiments of the vital and active forces of nature and the human spirit *(The Union of Earth and Water*, No. 14; *Statue of Ceres*, No. 8)*.

Having accepted the legacy of Italian art, Rubens remained a Flemish artist in the most specific qualities of his work. A worldly attention to detail and the palpably material quality of his images were the great legacy of his ancestors. The inspired emotion of his works was the voice of contemporary Flemish or Netherlandish reality. Rubens demonstrated his predilection for native traditions in that he even departed from the techniques he had acquired in Italy after he returned to Flanders. He ceased to paint on canvas using dark underpainting and began to cultivate the old "Flemish style": he painted on wood, against light backgrounds, and in perfecting these methods achieved that resonant radiance of colour for which he is renowned. Rubens' achievements as a master colourist and creator of images of a sensual beauty are acknowledged. Yet we must not forget that it is precisely to Rubens that we are beholden for a new, integral interpretation of the image of man.

Rubens refused to adopt the conventional and abstract mannerist conceptions of the human form and its movement; when he used such devices as *contrapposto* (the contrasting play of rest and motion) or depicted the *figura serpentinata* (snake-like figure), he tried not only to capture external movement — facial expression and bodily pose and gesture — but also to make it accord with internal

movement. Such a consistent psychological conditioning of the figure's movements was a direct elaboration of Renaissance accomplishments. And it was Rubens' achievements that made possible the subsequent triumphs of Van Dyck's portrait painting and even the innovations of Rembrandt and Velázquez.

After the creative flights of the first years following his return from Italy Rubens had to tackle the task of organizing his workshop, arranging the principles of his artistic vision into a coherent system and reducing them to basic forms and types. He undertook the writing of the alphabet of a new language, as it were; he began to bring together those elements from which he would build his universe. His resolution of this problem underlay his works executed during his so-called period of "Classicism", 1611-1615.

Step by step he studied the animated dynamism of the human body, paying attention both to the movements of individual figures and to their interrelations. Persistently, stage by stage, he perfected his ability to convey the hidden dramatism and inner tension that guided any interplay between human figures. He wanted to communicate the unstable, volatile and mobile balancing of forces, or, to be more precise, the transient equilibrium of volitions independent human, which were then simply juxtaposed rather than opposed in conflict (*Roman Charity*, No. 4). It was only when he had resolved this task at the beginning of the 1620s that Rubens turned to the dynamic interaction of human crowds; he created powerful images executed with the sense of man's self-affirmation in his frenzied struggle against hostile forces.

It was then that his famous paintings of battles, of fights with wild animals or of bacchanalia appeared, spectacles of joyful celebration in the life forces inherent in human nature. Yet the human figure does not become lost or merged in these dynamic and turbulent compositions. In Rubens' works the human figure always retains an independent significance: it is always the mainspring of the action, the centre which attracts energy to itself, and the rallying-point in a general unity which is torn by contradictions.

The real content of the artist's paintings, whether religious or secular, was the purposeful human will that made its own way by solitary combat with the Universe. It enlivens all around it, and subordinates all parts of the work to the expression of this basic idea. It is as if the force of the hero's

passion, as he strives towards his goal, is embodied in the folds of his cloak which streams behind his shoulders (*Perseus and Andromeda*, No. 19). The strained efforts of the carters who, as they push their heavy cart with difficulty over the potholes of a mountain road, seem to encounter the resistance of the threatening cliffs that surround them and of the fantastically contorted trees, which like living beings, repel the invasion (*The Carters*, No. 16).

Battles and hunts, scenes from classical mythology, Old Testament legends or stories from the life of Christ and the deeds of the saints, or representations of nature — all becomes the field of action in which man's creative will reveals itself. The artist's portrait painting in which he captured the characteristic features of a particular personality was also seen by him as the depiction of a protagonist in the same drama; he wanted to set down the individuality as expressed in an inimitable personal gesture which seemed to be an active and dynamic reaction to the impressions and influences from without (*Portrait of a Young Man*, No. 12).

However, the external plastic dynamism was but one of the stages in the development of Rubens' art. In the last ten years of his life Rubens moved from compositions which had been organized as a tangled mass of force and motion bursting into the pictorial expanse or striving to break its bounds (*Feast at the House of Simon the Pharisee*, No. 15; *The Lion Hunt*, No. 17; *Perseus and Andromeda*, No. 19) to those conceived as a different and new type of unity. It was the unity of the energy of living beings that permeates the world, and the unity of the Universe itself — of that extended material world in which this energy was in play. It is the very "corporeality" of the world in all its facets that now revealed itself before the artist, and took on a new expressiveness.

The themes of Rubens' works became calmer and more soothing. It was not the sense of the struggle for life which now resounded through the landscapes and mythological scenes but the fullness and beauty of life itself, which was worth struggling for and which was revealed to the viewer in all its brilliance. The image of man was only a part of the integral picture of the world created by the artist. Flowing movement was linked to the motion of colour and air which filled the universal expanse.

Feast in the House of Simon the Pharisee, detail.
The Hermitage, St. Petersburg.

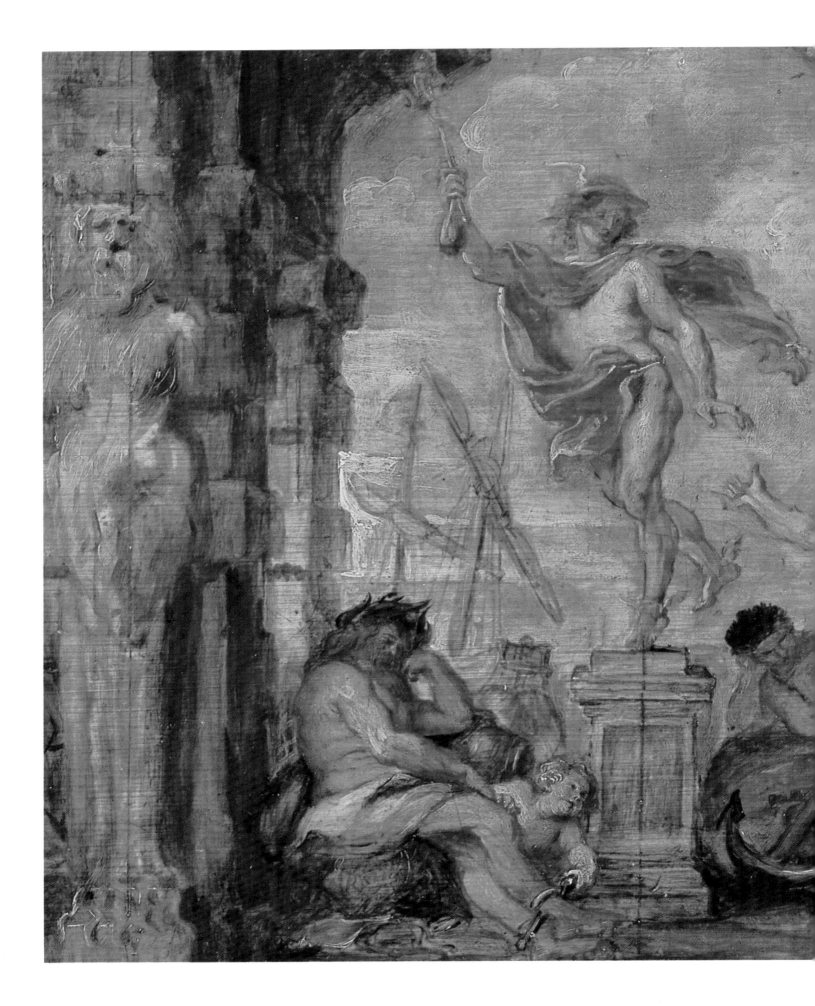

The precision of outline is blurred and the colours lose their local definition and isolation (*The Vision of St. Ildefonso,* No. 26). Compared to the cold brilliance and bright tonality of his early works, the colouring now became warmer and richer: the silvery-golden range is perceived almost as a single, blended coloured medium rich in nuance.

Yet human figures, as before, remained at the centre of the compositional and colouristic entity. The infinite space, air and light medium which surround them gave them a still greater significance (*Landscape with a Rainbow,* No. 30; *Bacchus,* No. 38). In this period of true artistic maturity Rubens fully appreciated his great predecessors Breughel and Titian, more than once drawing on their experience.

Rubens' artistic world, even in his easel works, seems either to burst beyond the frame or to entice the viewer into the depths of his vision. This to a great extent determines the expressiveness and power of his decorative works.

The illusory expanse of his decorative paintings is perceived as a continuation of the real world in which the viewer finds himself. That is how they achieve that enthralling emotional impact which makes the viewer sense that he is in direct contact with them. Furthermore, as a decorative artist Rubens never attempted a purely decorative approach. In his series of paintings for official palatial residences in Paris and London, or in his decorative structures for the streets and squares of Antwerp to greet the Infante Ferdinand, the new Governor, Rubens wanted to say many things to the onlookers. Rubens knew how even the eulogistic conventions of a court order could be refreshed with a lively reference to contemporary events. In his monumental paintings Rubens worked more on subjects of wide public concern. These were close to his own interests as an active public figure and as one who undertook important diplomatic assignments. At times, he also resorted to the language of artistic imagery to bolster the language of diplomacy. When he was conducting negotiations in London in 1630 over the signing of a peace treaty between Spain and England, Rubens presented the English King with a painting on a topical theme, *Peace and War* (National Gallery, London). In 1638, powerless to halt the misfortunes which had befallen Europe, he painted *The Horrors of War*

Mercury Leaving Antwerp, detail.
The Hermitage, St. Petersburg.

17

for the Duke of Tuscany (Uffizi, Florence) — that large-scale frontispiece to the Thirty Years' War, as Burckhardt called it.[21] In trying to express the current interests of his homeland when it was subordinated in difficult conditions to a despotic foreign regime, Rubens was also inspired by the same tasks in his political activities as directed his hands as an artist: the patriotic tasks of national consolidation and self-affirmation.

The same purpose pervaded his activities as a connoisseur of ancient history, literature and classical remains. Rubens used the entire accumulation of eclectic pedantry that the late epigones of Renaissance humanism had accumulated to enrich his system of representation; in his hands it became a means whereby the discoveries of contemporary reality could find expression and urgent or even distressing ideas might be given artistic form.

In Rubens we do not see the follower of a tradition: he was a master who was able to apply the achievements of classical art to new tasks and in new conditions. Enriched by the understanding of the world in its sensual tangibility, infinity and mutability which had developed in the seventeenth century, Rubens used the experience of various contemporary artists to blaze his own trail to his personal goal.

Since he shared the life of his contemporaries and that of Europe as a whole, he was well aware of the leading idea of the period: not only the self-affirmation of the individual, but that of the nation as well. He also felt the drama of the inevitable struggle with those forces which opposed such self-affirmation. Nevertheless, his belief that the chosen goal was attainable allowed Rubens to perceive the final unity and harmony through an apparent chaos of discordant strivings. In Rubens' art we find all the aspects of seventeenth-century art — the frenzy of the Baroque, the harmony of Classicism, and the authenticity of Realism — subordinated to one idea: man's victorious triumph over the world.

Maria VARSHAVSKAYA

Following page:
Landscape with a Rainbow, detail.
The Hermitage, St. Petersburg.

NOTES

1. G. Mancini, *Considerazioni sulla pittura*, vols. I-II, Rome, 1956-1957; see the Latin odes of the Leyden Professors, Daniel Heinsius and Dominicus Baudius (1609 and 1612), and the Dutch verse of Anna Rumers Fischer (1621) in *CDR* 1887-1909, II, pp. 12, 55-57, 330,331.

2. Bottari (1768) considered that the letter was written around 1630; Haskell (1963), citing B. Nicholson, suggests an approximate dating to 1620. (See G. Bottari, *Raccolta di lettera sulla pittura, scultura ed architettura*, vol. VI, Rome, 1768, p. 751; and F. Haskell, *Patrons and Painters*. London, 1963, p. 94).

3. G. P. Bellori, *Le Vite de pittori, scultori ed architetti moderni*. Rome, 1728, p. 150.

4. Roger de Piles 1677, pp. 77-107, 227-290.

5. J.-J. Winckelmann, *Gedanken uber die Nachahmungen der griechischen Werke...*. Dresden and Leipzig, 1756, pp. 123-124.

6. W, Heinse, "Über einige Gemälde der Düsseldorfer Galerie. An Herrn Canonicus Gleim", *Der Teutsche Merkur*. 1777, No. 5, May, pp. 131-135; No. 7, July, pp. 60-90.

7. W. Goethe, "'Nach Falconet und über Falconet'. Aus Goethes Brieftasche (1775)", *Sämtliche Werke*. Jubiläumsausgabe, vol. XXXIII, p. 40.

8. Fr. Schlegel, "Gemäldebeschreibungen aus Paris und den Niederländen", 1802-1804, *Sämtliche Werke*, vol. VI, Vienna, 1823, p. 192.

9. E. Delacroix, *Journal*. Paris, 1865.

10. E. Fromentin, *Les Maîtres d'autrefois*. Paris, 1965.

11. A. van Hasselt, *Histoire de P. P. Rubens...*. Brussels, 1840, pp. 2, 26-27, 39, 40, 180.

12. F. Jos van den Branden, *Geschiedenis der Antwerpsche Schilderschool...*, Antwerp, 1883, pp. V-VI, 497, 499, 501.

13. *CDR* 1887-1909, vols. I-VI.

14. Rooses 1886-1892, vols. I-V; see also the *Corpus Diplomaticus Rubenianum Ludwig Burchard* (Brussels), which is being published. To date the following volumes of the *Corpus* have been issued: I, 1968; II, 1978; VII, 1984; VIII, 1972; IX, 1971; X, 1975; XV, 1987; XVI, 1972; XVIII, I, 1982; XIX, 1977; XXI, 1977; XXIII, 1986; XXIV, 1980. When complete the *Corpus will* consist of 26 volumes and provide an exhaustive record of Rubens' works and of documents associated with his art.

15. Smith 1830-1842, vols. II, IX.

16. V.-S. 1873.

17. J. Burckhardt, *Erinnerungen aus Rubens*. Basle, 1898, passim.

18. R. Oldenbourg, "Die Nachwirkung Italiens auf Rubens und die Gründung seiner Werkstatt", in R. Oldenbourg, *Peter Paul Rubens*. Munich and Berlin, 1922, p. 12.

19. G. Hanotaux, "Richelieu et Rubens", in G. Hanotaux, *Sur les chemins de l'histoire*, vol. 1, Paris, 1924, p. 272.

20. L. van Puyvelde, *Le Génie de Rubens*. Brussels, 1943, pp. 20, 27.

21. Quoted from: J. Burckhardt, *Erinnerungen aus Rubens*. Leipzig, 1928, p. 130.

THIS volume allows the reader to form a judgement as to the extent and significance of the Rubens collection held by museums in Russia. Every type of artistic activity in which the Flemish master engaged is represented here, although not in equal proportions.

The intended purpose of a painting determined the subject, size and manner of its execution. As a rule, Rubens worked on commission and knew beforehand the future setting of his works and the role they were to play. A large altarpiece was not just a colourful element within the internal space of a church; it served as the spiritual focus and the minds and hearts of onlookers were subordinated to it. An example of this genre is the tragic *Descent from the Cross* (No. 13).

The Crown of Thorns ("Ecce Homo") (No. 5) is of a different character: here Christ is presented as a hero stoically accepting his cruel fate. Evidently, this picture of much smaller dimensions, painted after Rubens' return to Flanders, was intended for the collection of some enlightened patron of the arts rather than for a church altar. Perhaps it was meant for the Duke of Mantua whom the young artist had served in Italy as Court Painter. Nevertheless, in its subject and iconography the work borders on the tradition of ecclesiastical painting and could have been appropriately placed at the altar of a small chapel. In contrast to this, *Hagar Leaves the House of Abraham* (No. 10), although based on a subject from the Old Testament, was practically devoid of religious associations. The first variant is in the Hermitage. In 1618 when Rubens offered a replica of the painting to Sir Dudley Carleton (it is now in the Duke of Westminster collection, London) he referred to it in his letter as *una galanteria,* a small pleasant object. This brilliantly executed panel with its didactic but entertaining theme was indeed a pleasing offering for the collector with a subtle understanding of art. The secular interests of the collectors are clearly evident in the selection of paintings by Rubens in the Hermitage and other Russian museums. Altarpieces are rare, although apart from *The Descent from the Cross,* there are several pictures of that genre by the artist's assistants and followers. Works with a secular mood and content, on the other hand, astonish by their abundance, variety of themes, and beauty of execution, which is now detailed and now sweeping and generalized. The

Roman Charity (No. 4) represents an example of virtue and daughterly devotion; while in the story of *Venus and Adonis* (No. 7) the artist, like his contemporaries, was attracted by a dramatic contradiction — Venus' love is not returned: the youth she loves prefers the hunt, in which he is destined to die. Among the masterpieces in the Hermitage is *Perseus and Andromeda* (No. 19) with its combination of two themes: heroic endeavour and love as the joyful triumph which crowns that endeavour. In Rubens' work, the ancient myth is enriched with all the colours of life, and with the plenitude and subtlety of human emotions; and yet the hero retains a particular inner integrity in his joy and sorrow that links him to the images of Antiquity. Rubens was almost the only great artist, after the Renaissance masters, to succeed in retaining this link, and to have escaped the self-analysis and spiritual duality of the modern times. In Rubens' understanding there was no contradiction between lofty moral values and the healthy plenitude of the life of the flesh: on the contrary, high spirituality was rooted in physical health.

Man's physical existence, blending with the powerful life of nature, was to become the theme for an entire series of *Bacchanalia* by Rubens. One of the most original of these is a picture in Moscow (No. 9), while a superb later treatment of the theme is *Bacchus* (No. 38) in St. Petersburg, remarkable for its radiant colour scheme.

Rubens' numerous allegories stemmed from his profound humanist cultural background and inventive fantasy. Centuries later, the meaning of several of them is today still clear: this is the case with the *Statue of Ceres* (No. 8), the Goddess of Fertility who is being adorned with garlands of vegetables and fruit by small *putti.* Not so obvious to us is the content of the picture *The Union of Earth and Water* (No. 14) linked to the social and political realities of Rubens' day, highly important for his contemporaries — the country's flourishing depended on sea trade, but in those years that was simply a dream.

In the Hermitage collection large compositions destined for courtly halls alternate with works of a smaller "cabinet" format, the latter being intended for the "cabinets" (collections) of artistic and natural curios which became widespread in Rubens' time. "History" subjects, i.e. pictures which dealt with religious, mythological, allegorical or other "elevated" themes, play a dominant role in Rubens' work, and this is true of Russian collec-

tions too. Portraits and landscapes occupy a much smaller part, although Rubens produced masterpieces in both genres, among them the portrait of a girl traditionally referred to as *Portrait of a Lady-in-Waiting to the Infanta Isabella* (No. 25). In all probability this was a picture of Clara Serena, the artist's young daughter who died at the age of 12, and he charged her portrait with the most subtle charm and spirituality. The *Portrait of a Young Man (George Gage?)* (No. 12) and the *Portrait of a Franciscan Friar* (No. 11) are expressive in another way. The Hermitage owns two equally contrasting landscapes. *The Carters* (No. 16) presents a tense dramatic picture of eternally changing nature, which can also be viewed as an allegory of man's difficult path through life. The *Landscape with a Rainbow* (No. 30) on the other hand, is a pastoral idyll, a vision of a happy life surrounded by the beauties of nature. There is yet another type of painting to be found among the works of Rubens: the sketch for reproduction by engraving. An outstanding work of this kind is the *Portrait of Charles de Longueval* (No. 18) which was the model for Lucas Vorsterman's superb engraving.

The Russian Rubens' collections are distinguished by the exceptional abundance of sketches. These belong to various stages in Rubens' artistic development and are related to his work on many pictures, sometimes in a large decorative series. Examples are the series of sketches for the cycle of canvases illustrating the *Life of Marie de' Medici* (Nos 20-24) or for the ceiling paintings for the Banqueting House of Whitehall in London (Nos 28-29). Of particular interest are the series of sketches for the temporary decorations of Antwerp on the occasion of the triumphal entry of the country's new Governor, the *Cardinal Infante Ferdinand* (Nos 31-37). This string of short-lived works was Rubens' greatest creation as a decorative artist and for a brief while transformed an entire city. We can form an idea of it by examining engravings, contemporary descriptions and, most important of all, the artist's painted sketches.

However, the importance of these sketches is not limited to the recollection of large-scale works which no longer exist. They have their own inimitable beauty and pictorial originality. They bear the stamp of Rubens' artistic genius with exceptional clarity, revealing his vision and taste, the development of his conceptions, and his hand as a painter. We are enraptured by their free invention, and the subtlety of their colouring; and yet also by the sure

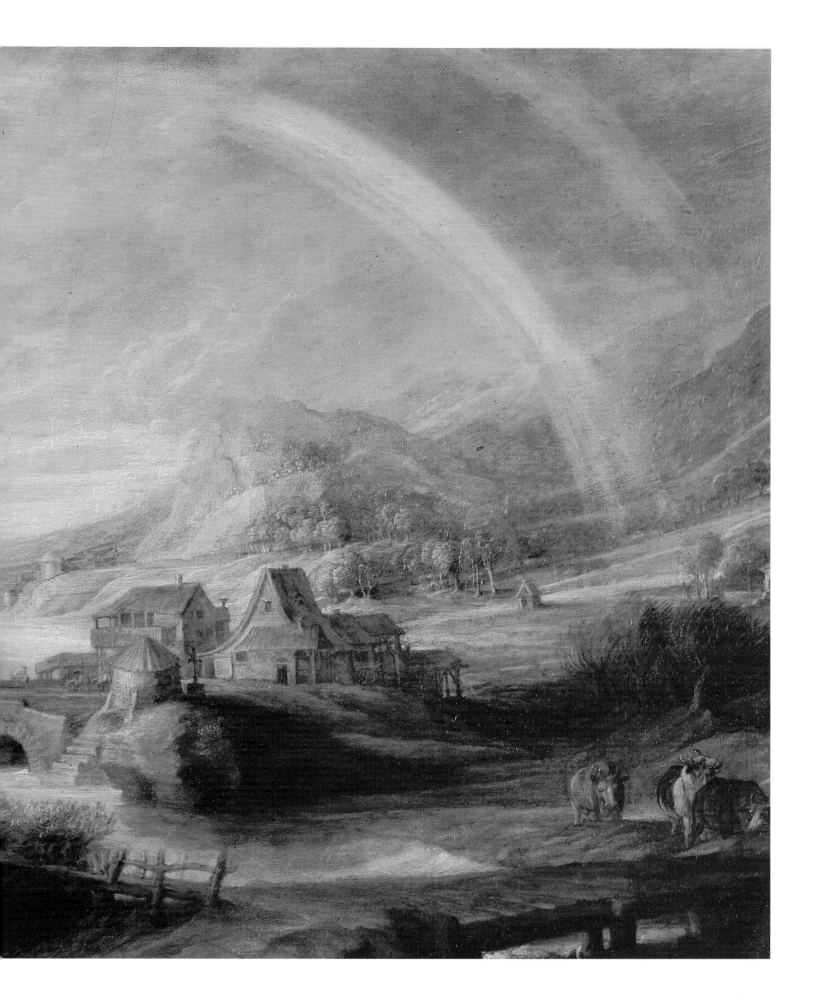

touch of the virtuoso who developed his conceptions just as far as was necessary, and no further. The sketches served as auxiliary material during work on a large composition; they also were made to show a patron what a picture would look like and to secure his approval. To this end Rubens, at the early stage of his career, used to execute a developed sketch resembling a reduced version of the future picture *(The Adoration of the Shepherds,* No. 1*). The Coronation of the Virgin* (No. 3) was a particular case in Rubens' work of this kind; it was apparently produced in connection with the Antwerp City Council's intention of ordering an altarpiece on this theme. The artist strove to show the city fathers what a fine picture he was capable of producing, and in this way a work came into being that was a *modello* (working sketch) in purpose, but significantly larger in scale and more complete. Gradually the type of sketch that we are accustomed to associate with the name of Rubens came into being: a small panel on which a transparent and flowing paint is applied with a swift, light, almost flying stroke. This was a revelation to his contemporaries used to the traditional thorough finish: they learned to appreciate the specific beauty of the painted sketch. Rubens began to use the same techniques in his larger works as well; carefully finished and sketchily worked areas were skilfully combined in one and the same painting — e.g. *Perseus and Andromeda* (No. 19) or the *Bacchanalia* (No. 9).

The evolution of Rubens' form of sketch may be traced in such works as *The Descent from the Cross* (No. 13) and *The Lion Hunt* (No. 17). The group of preparatory works for the *Life of Marie de' Medici* cycle mark the final constitution and brilliant flowering of the sketch as a part of Rubens' art. Three of the sketches *(Marie de' Medici in the Guise of Pallas,* No. 20; *The Meeting at Lyons,* No. 21; and *The Birth of Louis XIII,* No. 22) are almost colourless grisailles. They sum up the results of the first stage in the work: the main figures are clear — as are their poses (although the seated figure in the first sketch would be later replaced by a standing one) — and an expressive harmonious composition has been devised. The next stage in the work, which preceded the creation of the pictures, is reflected in the exquisite multi-coloured sketches for *The Coronation of Marie de' Medici* (No. 23) and *The Apotheosis of Henry IV* (No. 24). Yet more elaborate sketches for both these themes have been preserved (Alte

Pinakothek, Munich); these were the *modelli* from which, with little deviation, the enormous vivid canvases for the French Queen's Palace were created (now in the Louvre, Paris).

In other cases, when the commission was not so important, Rubens could introduce changes in an already existing sketch so as to produce yet another variant: hence the numerous corrections to be seen in *The Last Supper* (No. 27). The sketches of the works for the decoration of Antwerp in 1635, mentioned earlier, are particularly distinctive. Each one was an architectural plan as well as a pictorial sketch: the city engineer used them in compiling his detailed working drawings for the carpenters who erected the temporary wooden constructions; from them painters produced enormous pictures, or painted cut-out wooden shapes to resemble statues. Then all their work was brought together, forming colonnades and triumphal arches embellished with painting and sculptures. It was Rubens' sketches that determined the activities of all those who participated in this massive undertaking.

Among the great masters of the past Rubens was distinguished by his exceptional erudition, in literature as well as in the arts. His contemporaries regarded him as an authority on classical art and literature. He had a superb knowledge, not only of the painting of the Renaissance and his own time, but of the sculpture and architecture of those periods as well; he was also versed in philosophy, theology and emblematics (the study of the symbolic significance of different works of art). He made use of this learning in his art, when interpreting a subject, organizing a composition, or drawing his characters. One or another of his figures might be based on a drawing from a classical statue or the recollection of a picture he had seen in Italy in his youth.

The other extensive group of auxiliary works are studies from nature. Several painted studies, such as the *Head of an Old Man* (No. 2) used for Pilate in the painting *The Crown of Thorns* (No. 5) belong here. However, much more frequently, these nature studies are found in drawings. Many such drawings are famed for their delicacy and expressiveness.

A compositional theme, pose, or type of face might be transformed and repeated in several pictures. The decisive stage in Rubens' work on a painting was the creation of the sketch. The initial concept took shape in drawings on paper, often as rapid and involved numerous corrections and variants.

They were followed by a brush sketch on a small panel that was similar to a grisaille; and then, finally, a more detailed multicoloured sketch or *modello* was produced from which the artist would paint a picture of the desired dimensions. The material of the sketches, studies and drawings was transformed into magnificent paintings which radiated with colour, and were full of life, movement and tempestuous human emotions.

To define the place a particular work of art occupies in Rubens' œuvre, or to specify the connections between his works, it is necessary to refer to numerous paintings and drawings which are spread among many museums throughout the world. Our publication takes the form of a catalogue in which the text is accompanied by drawings, sketches, variants, related compositions and so on. Such an approach was deliberately adopted to give an impression of the complex development of Rubens' artistic conceptions.

Only works by Rubens himself are included in our volume. In Russian museums, as in other world collections, there are several pictures which are stylistically close to his art but not executed by his hand. Many of them were painted from Rubens' sketches and under his direction in his workshop. For the realization of his largest artistic conceptions the participation of assistants was inevitable. They could have also produced large paintings, relying on his sketches, and he supervised their work and often finished it off himself. His assistants made reproductions and variants of his most popular compositions and copied his studies and drawings. The brilliant Van Dyck worked with Rubens for some time during his youth, and he achieved such a mastery of the latter's manner of painting that for some time an entire group of the younger painter's works were attributed to Rubens. Rubens often collaborated with outstanding painters who worked in different genres: Jan Wildens might paint the landscape in a Rubens picture and Jan Bruegel the Elder and Frans Snyders, the still lifes or animals; in turn, Rubens might paint in the figures in a picture by Bruegel, or produce a sketch for Snyders. On such a gigantic enterprise as the decoration of Antwerp in 1635 a vast number of the city's artists worked from his sketches.

Rubens had a very strong influence on the seventeenth-century Flemish school of painting. His contemporaries and successors imitated his works, copied them and borrowed his motifs, altering them in some way. All this makes the attribution of pictures to Rubens and his circle a very complex problem. He himself emphasized the decisive role of "invention" as embodied in a sketch, and considered himself the chief author of all the works that relied on his artistic ideas and embodied his conceptions. Contemporaries were of the same opinion, but they particularly valued the works done exclusively by his hand. Many generations of collectors and museum experts have tried to separate these works from those of Rubens' assistants and imitators.

The legacy of Rubens held in Russian museums is in no way limited to his pictures. There are also superb collections of his drawings and of engravings based on his works. Rubens himself attached great importance to them and persistently strove to ensure that they conveyed as fully as possible the originality and beauty of his paintings, and spread his fame throughout the world. He is regarded as the founder of a new school of engraving. Books with engravings from Rubens' drawings, and copies of his album *I Palazzi di Genova* are held in Russian libraries. In publishing views and plans of Italian buildings, the artist wanted to develop in Flanders a more comfortable and attractive domestic architecture and with it, a more reasonable and civilized way of life.

Rubens was also a major influence on the decorative and applied art of his time. The cartoons for the famous series of tapestries *The History of Constantine* were executed after his sketches. This series of tapestries is represented almost in full in the Hermitage collection.

Rubens' painting was associated in many ways with his other artistic activities, with the art of his contemporaries, and with the spiritual and material world of his time. The holdings of Russian museums have much to contribute to an understanding of his art and their collections have been thoroughly studied by several generations of specialists. Together with Maria Varshavskaya, an expert on Rubens' paintings (and main author of the text of this volume), mention should here be made of Mikhail Dobroklonsky and Yuri Kuznetsov. They have devoted long years to the study of Rubens' drawings and the graphic production of his circle.

Rubens' paintings published here allow us to enter a world of intense creativity, and afford us great aesthetic and intellectual pleasure.

Xenia YEGOROVA

THE COLLECTIONS
of the Russian Museums

1. *THE ADORATION OF THE SHEPHERDS*

1608.
Oil on canvas. 63.5 x 47 cm.
Transferred from wood by A. Sidorov in 1868. Later additions made during the transfer (5.8 cm at the top and 3.5 cm at the bottom) were removed in 1965.
The Hermitage, St. Petersburg. Inv. No. 492.

The subject, closely connected with the Nativity, is derived from the Gospel according to St. Luke 2: 15-21, whose short account was elaborated in the apocryphal Gospel of James, 19, and the Pseudo-Gospel of Matthew, 13 (for more details see Künstle 1928, pp. 344-353; Réau 1955-1959, II, 2, pp. 224-226). At the time of its acquisition and in subsequent inventories and catalogues the painting was listed as a work by Cornelis Schut. It was B. von Bode who, in his letter to A. Somov of 16 July 1893, attributed the picture to Rubens and dated it to *ca.* 1604-1605. In 1902 Somov reported this as Bode's hypothesis, appending a mark by Schut's name. In the Hermitage catalogues of 1911 and 1916 it was ascribed (with a question mark) to Jacob Jordaens. L. Burchard (1927) placed this painting among Rubens' works. The attribution was decisively confirmed when, in 1927, R. Longhi published as a Rubens of the Italian period the altarpiece (*The Adoration of the Shepherds*, or *The Nativity*) of the San Spirito Church in Fermo (R. Longhi, "*La Notte* del Rubens a Fermo", *Vita artistica,* September 1927, pp. 191-197).

The present Hermitage painting is evidently a sketch for the altarpiece in Fermo, or, to be more precise, its *modello,* a preliminary drawing for which is in the Museum Fodor, Amsterdam.

The Fermo altarpiece must have been modelled on the famous *Night* by Correggio (Gemäldegalerie, Dresden) which he may have seen in San Prospero in Reggio. Apparently derived from this prototype are both the

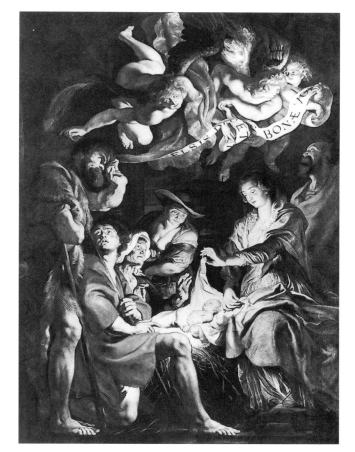

Workshop of Rubens. *The Adoration of the Shepherds.*
Church of St. Paul, Antwerp.

general design of the painting and a number of its elements, such as the angels at the top, one of whom is shown in a characteristic movement described as a "frog leap", and at the bottom the Virgin bent over the manger with the Child, who radiates light; in the left part of the painting one can see the full-length figure of a shepherd, cut short by the edge of the picture, a youth turning to him, and a shepherdess throwing up her hands.

The Correggian dynamism and emotional intensity are more pronounced in the sketch than in the painting itself: the emphasis is laid on the general diagonal motion from the left into the centre. The figures are grouped more tightly round the manger and are floodlit by the stream of light emanating from the Child, whereas in the altarpiece each figure is picked out of the darkness and seen as a separate image. The artist's interest in the contrast of light and shade in the final version evidences an increasing influence of Caravaggio. It was this fact that made it possible for Burchard (1928) to draw a parallel between Rubens' development from this sketch to the altarpiece and his general artistic evolution from Correggio to Caravaggio.

The influence of the Venetian school, which is particularly characteristic of Rubens' work painted in Italy, is especially evident in this Hermitage sketch, with its free handling, impasted brushwork and highly saturated deep reddish tonality (unlike works in the "Flemish manner", this sketch was painted over a dark lay-in, in imitation of Venetian pictures, which were generally painted over grounds tinted in red).

The only trace of Caravaggio's influence in the Hermitage sketch is the appearance of a new type of character — a common old woman. It is hard to tell whether she was painted after a study from life (see No. 2) or, as believed by Longhi (*op. cit.*), derived from Caravag-

gio (the old woman in the *Madonna of the Pilgrims*, or *Madonna di Loreto*).

The young shepherd's face in the sketch and in the final version were modelled on the same face as that of St. Maurus in both versions of the altarpiece painted in 1607-1608 for the Church of S. Maria in Vallicella, Rome (the first version is in the Musée de Peinture et de Sculpture, Grenoble). Longhi (*op. cit.*) believed that the character had been suggested by some antique marble such as a work by Scopas or one of the Pergamum statues.

Longhi points to one more analogy with Rubens' Italian works: Joseph in the Hermitage sketch and the Fermo altarpiece was painted from the same model as Joseph of Arimathea in Rubens' *Pietà* and an old man on the left in *Susanna and the Elders* (both in the Galleria Borghese, Rome).

It is known from records in the archbishop's archives in Fermo, which were published by Jaffé in 1963, that on 23 February 1608 Father Flamminio Ricci of the Oratorian Fathers in Rome, wrote to Father Francesco Francelucci of Fermo that he had ordered a painting of the Nativity from Rubens for their church in Fermo. On 12 March Ricci sent to Fermo a receipt signed on 9 March 1608 by Rubens and his assistant Deodat van der Mont for 25 scudi in payment for "a painting representing the Nativity..., which I promise herewith to execute for the afore-mentioned Father Ricci, with at least five large figures, namely of the Madonna, St. Joseph, three shepherds and the Christ Child in a manger, with a requisite host of angels over the manger..." At that time Rubens had evidently not begun working on the sketch, for it contains four shepherds.

Thus the commission for Fermo was received after the rejection (on 30 January 1608) of the original version of the altarpiece for the Church of S. Maria in Vallicella (see Jaffé 1963; M. Warnke, "Italienische Bildtabernakel bis zum Frühbarock", *Münchner Jahrbuch der bildenden Kunst*, vol. XIX, 1968, pp. 77-102).

The commission may have been a kind of compensation for the painting that had been turned down. In Ricci's letter containing Rubens' receipt, there was a highly complimentary reference to the artist: "...I did not want to give any specific recommendations on the composition or on any details regarding the execution or the characters because it is believed that everything should be left to his discretion as now he is on the threshold of great fame..." (Jaffé 1963).

Rubens executed the order with great promptness. On 17 May that year Ricci wrote to Fermo that great headway had been made in the work and as early as 7 June he reported: "The picture is completed and the artist is pressing me [for payment]..." (Jaffé, 1963). This sketch therefore dates from between 9 March and early May 1608.

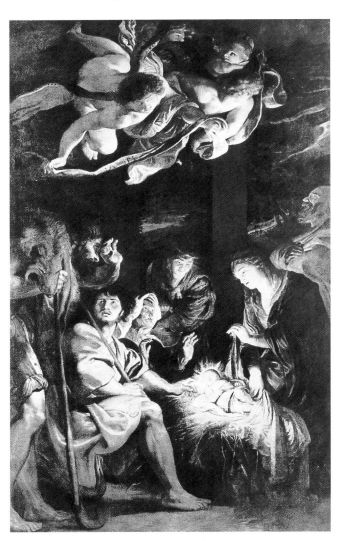

Rubens. *The Adoration of the Shepherds*.
Church of San Spirito, Fermo.

Provenance: Purchased for the Hermitage from the Brühl collection in Dresden in 1769 (the catalogue of 1902 contained erroneous data concerning the acquisition of the painting).

Preliminary works: Rubens, *Two Shepherds and a Turbaned Man*, Museum Fodor, Amsterdam; pen and ink, wash, 139 x 150 mm. Held (1959) and Burchard & d'Hulst (1963) assigned the drawing to the preparatory period of the work on the altarpiece in Antwerp.

Final version: Rubens, *The Adoration of the Shepherds* (or *The Nativity*), 1608, the Constantini Chapel of the Church of San Spirito (S. Filippo Neri), Fermo; oil on canvas, 300 x 192 cm.

Version: Rubens' studio, *The Adoration of the Shepherds* (a slightly modified copy of the altarpiece in Fermo), St. Paul's, Antwerp; oil on canvas, 401 x 294.5 cm.

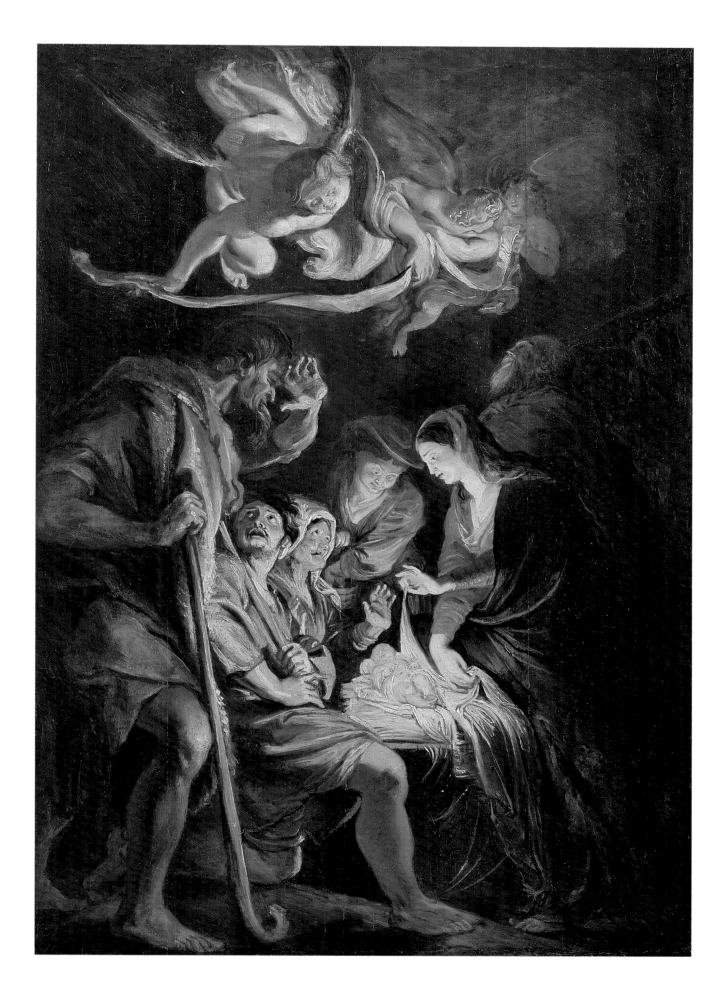

2. *HEAD OF AN OLD MAN*

Ca. 1609.
Oil on oakwood. 63.5 x 50.2 cm. Attached strips on all sides. The main panel is of irregular shape: *ca.* 46 x 25-30 cm. The added parts are of the whole, their wood matching impeccably.
The Hermitage, St. Petersburg. Inv. No. 4745.

From the moment of its acquisition until 1958 *(The Hermitage Catalogue* 1958) this painting was ascribed to the Rubens school. In 1959 Jaffé recognized it (verbally) as Rubens' own study for the head of Pilate in *The Crown of Thorns* from the Hermitage (see No. 5). This attribution was supported by Held (verbally in 1966 and in Held 1980); it has been borne out by all subsequent studies. The *Head of an Old Man is* without doubt a detail of Rubens' study, a drawing of which by an unknown artist is in the Louvre, Paris. Lught points out that the original painting (enlarged by added strips) sketched in the Louvre drawing is in the Gallerie Nazionale d'Arte Antica (Palazzo Corsini) in Rome (oil on wood, 59 x 52 cm: Rooses 1886-1892, No. 1123), and considers the original painting represented in the three-quarter-turn version to be lost.
Not only was the *Head of an Old Man* now in the Her-

Rubens. *Head of an Old Man.*
Galleria Nazionale d'Arte Antica (Palazzo Corsini), Rome.

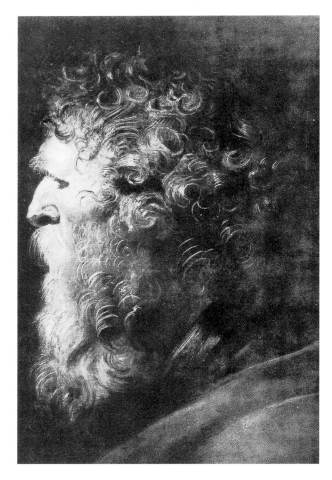

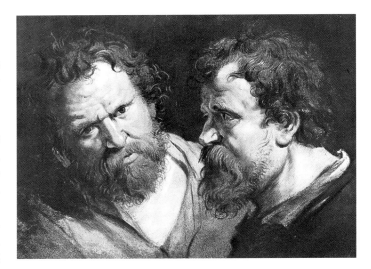

Rubens (or a replica). *Two Head Studies of a Bearted Man.*
Private collection, Madrid.

mitage painted from the same model as the study in Palazzo Corsini, but it is identical (except for its different profile — three-quarters to the right) with the left-facing head in the Louvre drawing (which probably did not reproduce the original with complete accuracy). The scale of the *Head of an Old Man* in the Hermitage is identical with that of the oil study in Palazzo Corsini. The two seem to have been one piece from which the Louvre drawing was done. Later the panel was cut into two and each part, with respective enlargements, was made into an independent picture.

This surmise is indirectly evidenced by a surviving unaltered painting by Rubens (or a copy) dating from the same period — *Two Head Studies of a Bearded Man* (oil on paper mounted on wood, 44.6 x 61 cm: *Weltkunst aus Privatbesitz. Ausstellung der Kölner Museen.* Kunsthalle, Cologne, 1968, pl. 15). The study also contains two profiles of the same head: to the left almost *en face* and to the right. There is an obvious connection between the Hermitage study and *The Crown of Thorns* where Pilate's head is posed exactly as in the study. But the somewhat coarse facial features of the model, which had been to a certain extent generalized even in the study, are more refined in the picture: the nose was made straighter, the mouth and moustache softened. Taking into account the fact that the study from the Palazzo Corsini was used for the Madrid *Adoration of the Magi* whose date is documented, the *Head of an Old Man* in the Hermitage should be assigned to *ca.* 1609, i.e. a date soon after the artist's return from Italy. It is hardly possible to consider it executed in Italy since it is done "in the Flemish manner": over a white ground without dark underpainting. In Held's opinion (Held 1980), the Hermitage study was created about 1611-13.

Provenance: Received by the Hermitage from the collection of V. D. Nabokov in Petrograd in 1919.

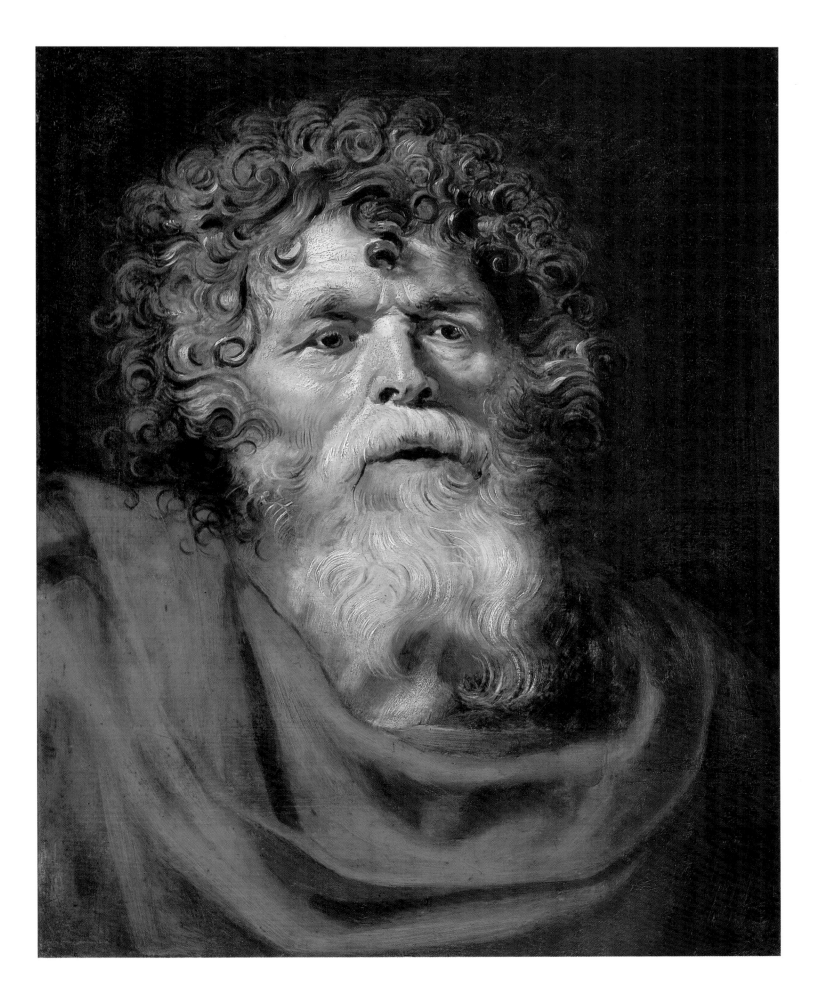

3. *THE CORONATION OF THE VIRGIN*

Ca. 1609-1611.
Oil on canvas. 106 x 78 cm. Transferred from wood by N. Sidorov in 1868. The transfer was accomplished with a considerable amount of the artist's original groundwork preserved.
The Hermitage, St. Petersburg. Inv. No. 1703.

The legend of Mary, which is not in the Gospels, originated as a parallel to the story of Christ. Gradually the Coronation and later the Ascension emerged from the general subject of the Assumption (*Aurea legenda sanctorum que Lombardika hystoria nominatur.* Compilata per fratrem Jacobum de Voragine, Lugdunum, 1507, fol. 106: "Veni de Libano, sponsa, veni coronaberis. Et illa. Ecce venio") ("Come, bride, from the Lebanon, and you will be crowned. And lo: Here I come"). These three subjects were generally combined with the depiction of the "miracle with the roses" — the Apostles and the three Mary (Magdalene, Salome and the wife of Cleophas) before the empty coffin of the Virgin where they found nothing but flowers (this corresponds to the story of the women with the spices and myrrh at Christ's sepulchre; for further details see Künstle 1928, p. 563; Réau 1955-1959, II, 2, pp. 602-626).

Rubens. Drawing from the ceiling painting by Pordenone in the Cathedral at Treviso. Count A. Seilern collection, London.

This Hermitage *modello is* Rubens' earliest composition on the subject. Its iconography is somewhat unusual, for one picture combines two themes: the Ascension and the Coronation, each repeatedly treated by the artist, who later, however, always painted them separately. Also, in his *Coronation* Rubens represented Christ alone rather than in the Trinity, as was the custom in the Netherlands from the fifteenth century onwards. As shown by Freedberg in 1978, this approach to the subject probably stemmed from the book *Adnotationes et Meditationes in Evangelia* by Ierônimo Nadal, a Jesuit writer, with engravings by Wierix, published in 1595. The book included four engravings on the subject of the Virgin's death, burial, ascension and coronation (engravings Nos. 150-153).

Freedberg believes that the third engraving in the group (No. 152), entitled *Suscitatur Virgo-Mater a Filio,* has been used by Rubens in the composition of the present Hermitage *modello,* at least in its upper part.

When acquired, the picture was entered as a Rubens. Waagen (1864) described it as an original designed by the master to be enlarged by his pupils. Rooses (1888) hesitated between attributing it to young Rubens and regarding it as a free copy or even a forgery. It was Dobroklonsky (1949) who unequivocally proved the painting to be authentic. He noted some repetitions of Rubens' Italian impressions in it and a similarity to a number of early works by the master.

Baudouin suggest (1968; 1972) that the Hermitage picture is one of the two *modelli* submitted by Rubens in April 1611 to the chapter of Antwerp Cathedral as a design for the proposed (but not then implemented) main altarpiece. Its subject presumably coincided with that of the Hermitage picture — *Christ Inviting the Virgin to Be Crowned.* The inscribed words "...Dominum Nostrum Sponsam suam de Libano provocantem ad coronam..." are an allusion, as pointed out by Held in 1980, to a phrase from Solomon's Song (4:8): "Veni de Libano sponsa mea, veni de Libano, veni: coronaberis de capite Amana..." ("Come with me from Lebanon, my spouse, with me from Lebanon: look from the top of Amana..."). At any rate, that was the subject of the *modello* submitted by Otto Venius and rejected by the chapter in March 1611 (Baudouin 1968; 1972). In 1626 Rubens painted for the altar of that church *The Ascension of the Virgin* (Antwerp Cathedral).

Provenance: Purchased for the Hermitage for 1732 florins in the sale of the F. I. Dufferin collection which began on 22 August 1770 in Amsterdam (Somov 1902).

Version: Rubens, *The Ascension of the Virgin* (1614-1615) from the Jesuit Church in Antwerp, now in the Kunsthistorisches Museum, Vienna; oil on wood, 458 x 297 cm (Burchard & d'Hulst 1963, I, p. 121; Baudouin 1968; Baudouin 1972).

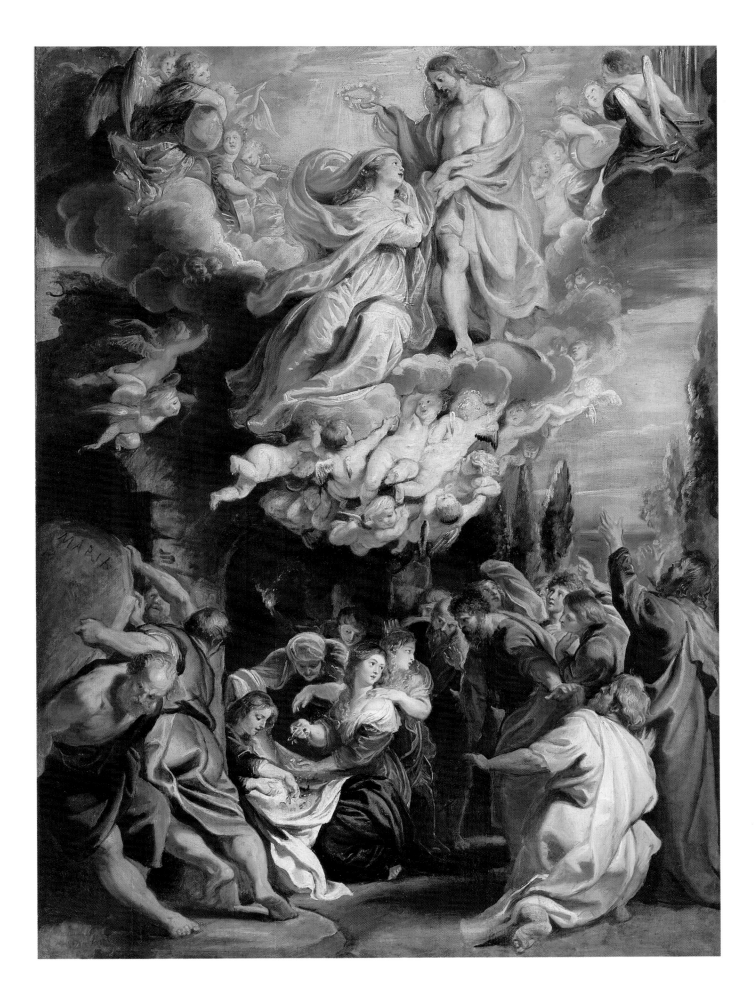

The Coronation of the Virgin, detail.
The Hermitage, St. Petersburg.

4. ROMAN CHARITY (CIMON AND PERO)

Ca. 1612.
Oil on canvas. 140.5 x 180.3 cm.
Transferred from wood by A. Mitrokhin.
The Hermitage, St. Petersburg. Inv No. 470.

The subject is borrowed from the book called *Remarkable Acts and Speeches* by Valerius Maximus, a Roman writer of the first century A. D. (Valerius Maximus, *Factorum dictorumque memorabilium,* libri IX), part 5, chapter 4: *De pietate erga parentes et fratres et patriam (On Love for Parents, Brothers and Fatherland).* Valerius Maximus' story about a young woman named Pero, who saved her father Cimon who was doomed to die from hunger by suckling him, was derived from earlier, Hellenistic sources. The Roman writer described the subject of a picture he had seen. Several Pompeian frescoes are known which are devoted to the same subject and are roughly contemporaneous with Maximus.

Rubens. *Jupiter et Callisto.* Gemäldegalerie, Cassel.

In European painting the subject of the *Roman Charity* became widespread from the sixteenth century (for further details see E. Knauer, "Caritas romana", *Jahrbuch der Berliner Museen.* vol. VI, 1964). Rubens returned to the subject several times, but at a later period, and the compositions of those pictures are entirely different.

At the time of its acquisition the picture was entered as a Rubens. In the old inventory of the Museum and in the works of Schnitzler (1828) and Labensky (*Livret* 1838) it was appraised as one of the artist's masterpieces. Smith (1842), however, and later, when visiting the Hermitage, Waagen (1864), relegated the painting to a copy and it was removed into the reserves, to remain there for a long time. In 1902 Somov, complying with the advice given by Bode in his letter of 16 July 1893 (Somov 1902), again put it on display in the Hermitage as a Rubens. Rooses, who had regarded the *Roman Charity* as a copy (1890), also recognized its authenticity in 1905.
The present picture is the artist's earliest treatment of the subject, and one of the finest examples of the so-called period of "Classicism" in Rubens' work. The forms are modelled in a statuesque style and are placed before a wall parallel to the foreground, in the manner of ancient reliefs. By subordinating the group of figures to the static shape of a triangle, the artist stressed both the dramatic quality of their vitality and the balance of masses at that instant.

In terms of composition, Rubens' painting *Jupiter and Callisto* (Gemäldegalerie, Cassel), signed and dated 1613, is fully analogous with the present Hermitage picture, although in the Cassel work the interplay of figures is somewhat more intricate and the group is included in a landscape. On the basis of this comparison Oldenbourg (1918) correctly assigned the Hermitage picture to the period immediately prior to the production of *Jupiter and Callisto,* i.e. ca. 1612. The dating is borne out by the brownish colouring characteristic of the first post-Italian works by Rubens (the impression is heightened by the yellowed varnish).

Roman Charity (Cimon and Pero), detail. ▶
The Hermitage, St. Petersburg.

Provenance: In the posthumous inventory of Rubens' property, item No. 141 is a picture described as *Story of a Daughter Giving Breast to Her Father in a Dungeon*; it is not known who bought it (Denucé 1932, p. 62).
According to the inscription on C. van Caukercken's engraving of the picture, the original was in the possession of Bishop Carl van den Bosch of Bruges.
A painting on the same subject by Rubens was sold to an unknown person in 1713, at the sale of the collection of the House of Orange in the Chateau de Loo; no description of this picture survives, nor is the date of its entry into that collection known (Hoet & Terwesten 1752-1770, p. 150). It is not clear whether the mentions refer to the present Hermitage picture or a copy.
Purchased for the Hermitage from the Cobenzl collection in Brussels in 1768.

Prints: By Cornelis van Caukercken (*ca.* 1625-*ca.* 1680) (V.-S. 1873, No. 48).

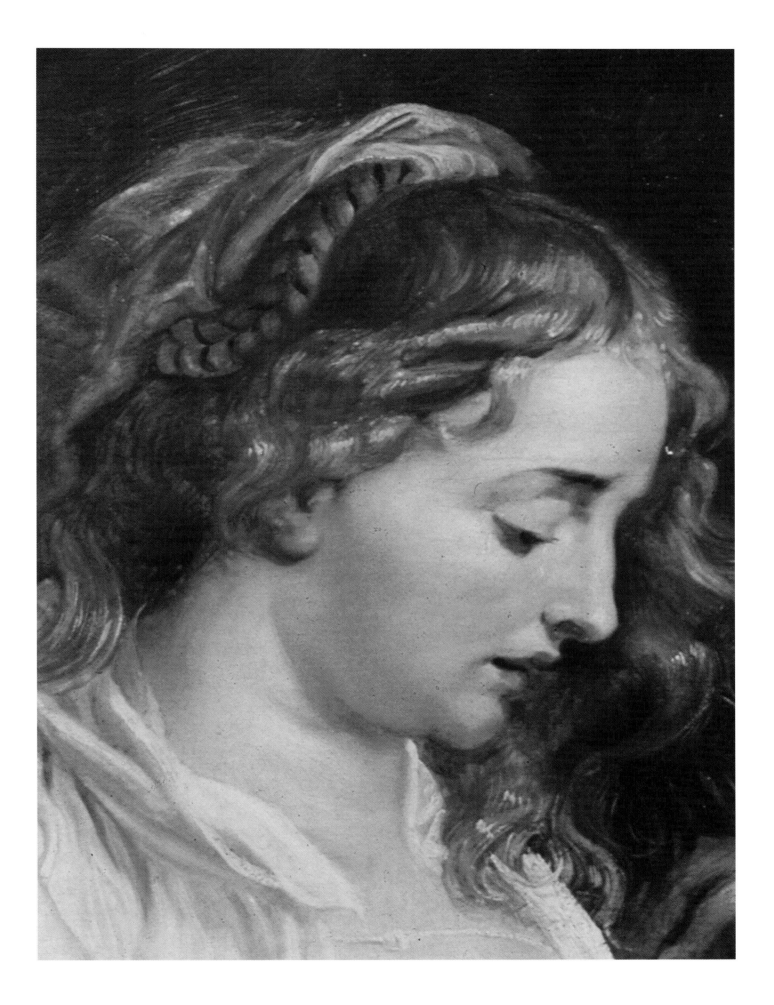

Roman Charity (Cimon and Pero).
The Hermitage, St. Petersburg.

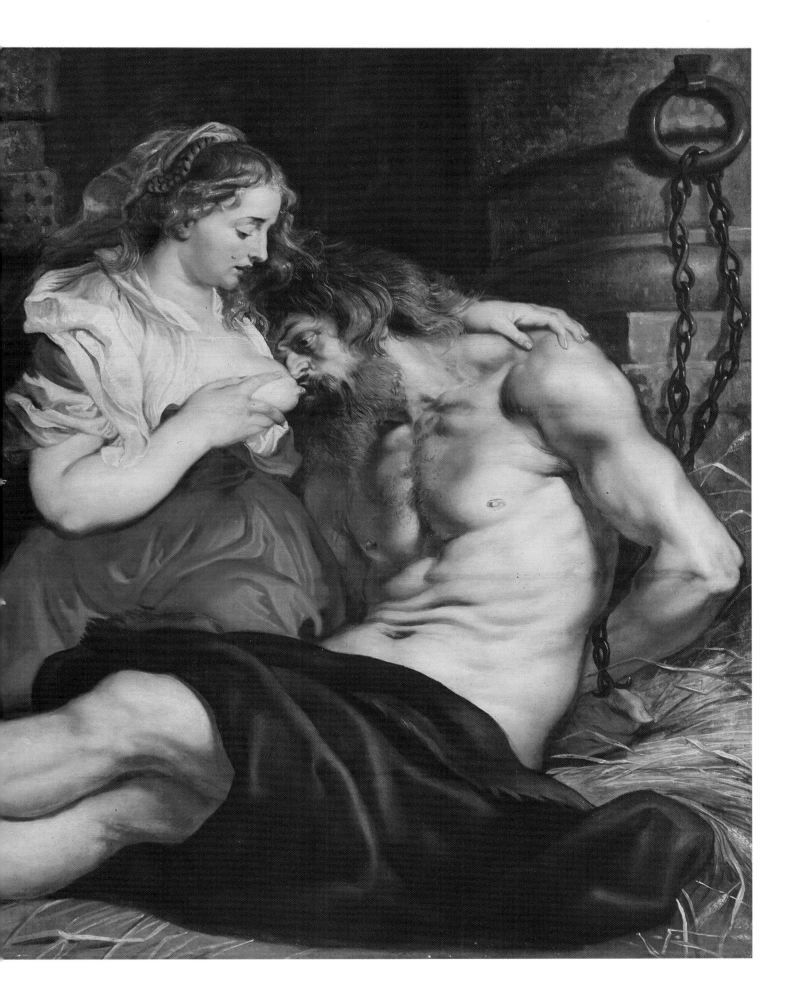

5. *THE CROWN OF THORNS ("ECCE HOMO")*

Ca. 1612.
Oil on oakwood. 125.7 x 96.5 cm.
The Hermitage, St. Petersburg. Inv. No. 3778.

The subject of the picture is derived from the Gospel according to St. John 19: 4-5 (for further details see Réau 1955-1959, II, 2, p. 460). In this Hermitage painting Christ's hands are tied behind his back. This particular detail distinguished the picture from all the earlier and contemporary compositions on the subject. As established by Linnik in 1977 (see Linnik 1981), in this case, contrary to his traditional practice, Rubens modelled his picture on the statue of the illustrious ancient *Centaur* from the Galleria Borghese in Rome. It is plausible that the present painting is a companion to Rubens' *Drunken Silenus* (Palazzo Durazzo-Pallavicini, Genoa; oil on wood, 118 x 98 cm). According to Evers (1942) the Genoese painting dates back to the artist's Italian period, whereas in 1938-1939 Kieser assigned it to a much later date of the Antwerp period. The Genoese picture is similar in composition, but symbolizes sensual life as opposed to the spiritual world represented in the Hermitage painting.

The picture shows evidence of the influence on it by the celebrated compositions on the same subject produced in 1606 in the contest of three artists executing the commission of Cardinal Massimi: Passignano (whose work is unknown), Caravaggio (Palazzo Communale, Genoa — R. Longhi, *"L'Ecce Homo* del Caravaggio a Genova", *Paragone*, vol. LI, 1953, pp. 3-13) and Cigoli (Uffizi, Florence). In the frontal arrangement of his composition, symmetrical about the centre, Rubens followed the example of Cigoli, repeating also the position of Pilate's hand (Friedländer 1964). The influence of Caravaggio is manifest in the fact that the figure of Christ is advanced to the foreground and the eyes of all three participants in the scene are turned

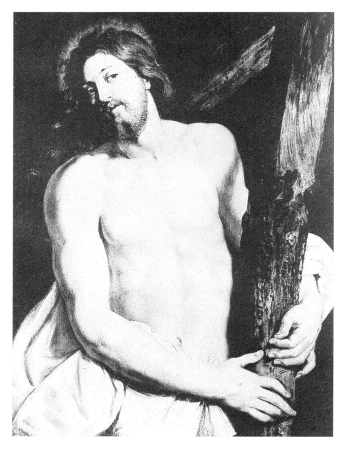

After Rubens. *Christ Holding the Cross.*
Canadian National Gallery, Ottawa.

to the viewer. Pilate's gesture seems to stress his appeal for participation in the act. In 1977 Linnik observed (see Linnik 1981) a considerable affinity of the characters with works by Otto van Veen (Vaenius), Rubens' teacher. Thus the Christ in the Hermitage piece has many features in common with the central character in Vaenius' *Carrying of the Cross* (Musées Royaux des Beaux-Arts, Brussels); also derived from the same picture is the figure of the warrior holding a cloak. Smolskaya (1986) established that Rubens had given the image of Christ his own facial features (cf., for example, Rubens' works: *Self-Portrait with Friends from Mantua, ca.* 1606, Kunstmuseum Wallraf-Richartz, Cologne, and *Self-Portrait with Isabella Brant, ca.* 1609 Bayerische Staatliche Sammlungen, Munich).

Despite the obvious dependence of the picture on the artist's impressions of Italy and despite its affinity with some of Rubens' very early works (in 1888 Rooses assigned the painting to Rubens' Italian period), the fact that Rubens used for it his study, the *Head of an Old Man*, executed around 1609, indicates a post-Italian date. This is borne out also by the intensity of local colours (especially in the combination of the light coloured flesh tints, the white kerchief and the red mantle) and the enamel-like texture of brushwork. Considering, however, that it was engraved by Cornelis Galle I, the painting should be dated not later than 1612.

Provenance: In the late nineteenth-century the picture was in the collection of A. A. Bezborodko in St. Petersburg. It was received by the Hermitage from the Kushelev Gallery in the Academy of Fine Arts in Petrograd in 1922.

Preliminary works: The study *Head of an Old Man* (No. 2).

Prints: 1) By Cornelis Galle I (1576-1650) (V.-S. 1873, No. 250); inscribed: *Ecce Homo Egredimini et videte Filiae*; undated. Cornelis Galle I is known to have returned from Italy in 1610. He worked largely in the old-fashioned manner of his father, which could not satisfy Rubens (see No. 18). Soon after his return from Italy Rubens no longer engaged him; thereafter Cornelis Galle I mainly did engravings of title-pages after Rubens for the Plantin Press. 2) By Johannes Schmidt, active around 1700 (V.-S. 1873, No. 251). 3, 4) By unknown artists (V.-S. 1873, Nos. 252, 253).

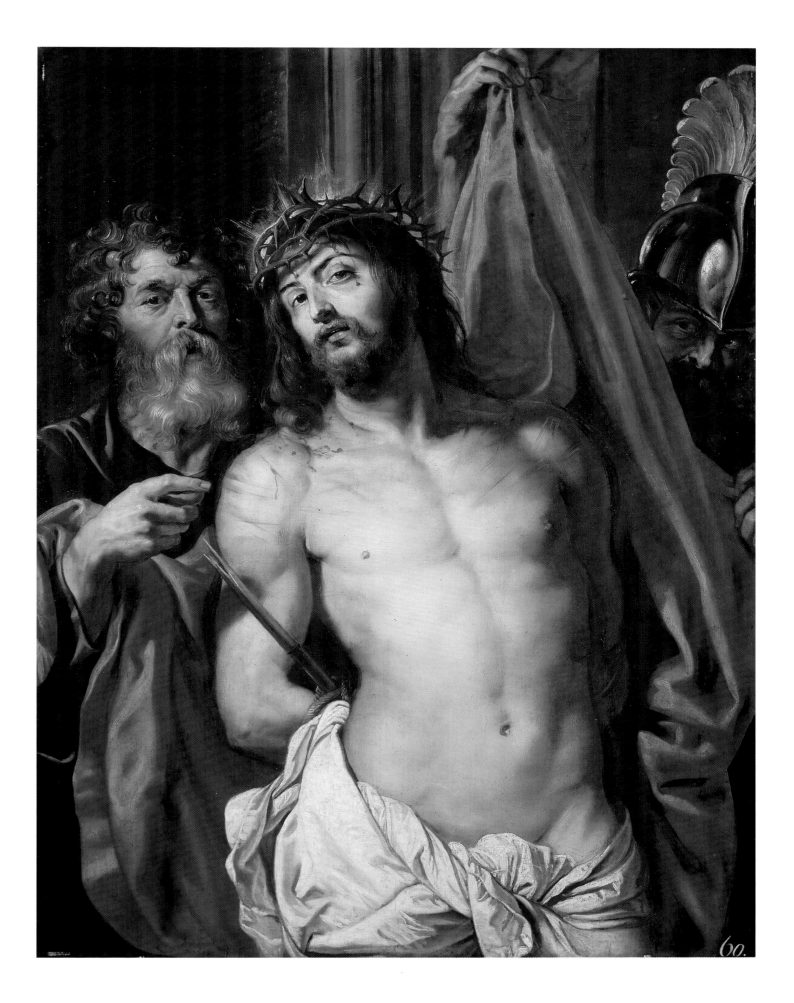

60.

6. *THE DESCENT FROM THE CROSS*

Ca. 1612-1614.
Oil on oakwood. 48.7 x 52 cm.
Enlarged by strips about 6 cm wide (top)
and about 2.5 cm wide (bottom).
The Hermitage, St. Petersburg. Inv. No. 7087.

Subject: See the annotation for the picture *The Descent from the Cross* (No. 13).

This is an authentic oil sketch for a *Deposition,* never executed (1611-1612, Antwerp Cathedral). The sketch was published for the first time as a Rubens by Schmidt (posthumously in 1949). In 1964 Bialo-stocki doubted the genuineness of the sketch. In 1980 his view was supported by Held, who published the sketch among works of doubtful attribution to Rubens. The authenticity of the sketch, however, is convincingly proved by the affinity of its characters with their counterparts in such undoubted works by Rubens as his drawing *The Descent from the Cross* (Hermitage, inv. No. 5496 — the figures of Nicodemus and Magdalene) and the altarpiece *Deposition* (Ant-werp Cathedral — the figure of a turbaned man on the ladder on the left), as well as by the material charac-teristics of the paintings.

According to Held (1980), the horizontal format of the sketch, somewhat unusual for Rubens' works on the subject of the Deposition, may be accounted for the fact that the composition was intended by the artist for an altar predella. Though this explanation is pos-sible, it should be noted that such an arrangement was a logical result of the artist's intention to combine two subjects — *The Descent from the Cross* and *The Lamentation* — in one piece. The Hermitage sketch emphasizes the human aspect of Christ, his earthly mortality and his affinity with the people. The motif of taking the body down to the ground is central to the whole sketch.

This mundane approach was apparently one of the reasons why the sketch was never implemented in a full-scale painting. This is the earliest known variant of the composition.

Executed *ca.* 1612-1614 (see No. 13).

Provenance: Received by the Hermitage from the Shuvalov Palace-Museum in Leningrad in 1925.

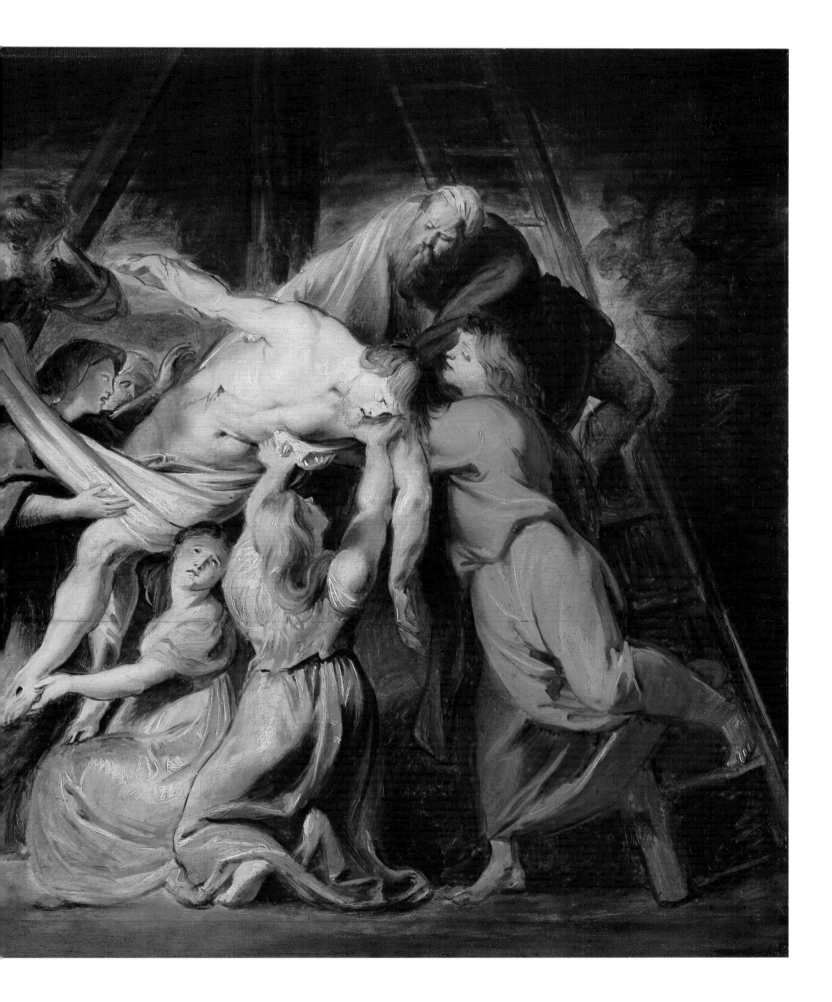

7. *VENUS AND ADONIS*

Ca. 1614.
Oil on oakwood. 83 x 90.5 cm.
The Hermitage, St. Petersburg. Inv. No. 462.

The subject derives from Ovid's *Metamorphoses* (X, 529-559), where, however, there is no scene of parting (H. von Einem, "Rubens' *Abschied des Adonis* in Dusseldorf", *Wallraf-Richartz-Jahrbuch*, vol. XXIX, 1967, pp. 141-145). But the episode with Venus trying

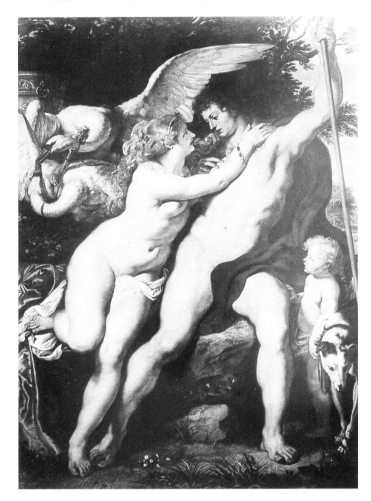

to keep Adonis from the fatal hunt which is a subject that frequently recurred in literature and in the visual arts ever since antiquity (A. Pigler, *Barockthemen...*, vol. II, Budapest, 1956, p. 239).

At the time of its acquisition by the Hermitage and in the Museum's subsequent inventories the present painting was listed as a Rubens. In 1864 Waagen recognized only the human heads and the animals as Rubens' work. In 1890 Rooses ascribed the figures to Rubens but the accessories and the dogs to Jan Wildens; in 1905 he added that the landscape was by Lucas von Uden. In 1910 Benois ascribed the landscape to Jan Wildens. In 1909 and 1916 respectively

Bode and Oldenbourg designated the present painting (as well as some other smaller-scale versions, see below) as works by Rubens' pupils with very little participation by the master. In 1968 Müller-Hofstede asserted (verbally) that the entire picture was by Rubens. At present it is believed to have been produced jointly by Rubens and his pupils.

The picture is one of the versions of the composition produced by Rubens around 1609 (Kunstmuseum, Dusseldorf: Oldenbourg 1916) and celebrated in a poem by Professor Dominicus Baudius from Leiden (see his letter to Rubens of 11 April 1611, *CDR* 1887-1909, II). The later-date versions, while retaining the design of the prototype, lost some of the succinct dramatism of the monumental early work: the treatment of the subject became increasingly entertaining, as characteristic of "cabinet" pictures.

Instead of the original vertical format the Hermitage painting has a horizontal composition, which enabled the artist to elaborate the landscape background, which even in the earlier, Berlin version (from where the dogs were borrowed) had already replaced the original dark rock. In place of the bench appearing in the Dusseldorf prototype there is a gold chariot. The profusion of detail distracts the viewer's attention from the focal point of the scene and thus diminishes the effect of the group of figures. Cupid, who is shown standing quietly in the Dusseldorf and Berlin compositions, here clings to Adonis' thigh, imparting a well-nigh comic note to the composition. Adonis, who is shown rising from the bench in the Dusseldorf picture, is parting from Venus in the Hermitage version and his pose, derived from the ancient statue of Laocoön (Oldenbourg 1916), appears somewhat incongruous. Moreover, Adonis' leg, overlaid by the leg of Venus, loses its value as a solid support of the group

Rubens. *Venus and Adonis*. Kunstmuseum, Düsseldorf.

and the motif gives the impression of being purely ornamental. It is hardly plausible that Rubens, after deciding to alter the content of the composition (instead of Adonis breaking loose from the embrace of Venus seated next to him, here we have Venus in a swan-drawn chariot setting out in the wake of Adonis), should have merely copied the figures from his earlier work. The incongruity of the main characters' figures and movements, so uncharacteristic of Rubens, coupled with a certain anecdotal quality in the treatment of the subject, supports the theory that Rubens' pupils participated in this cabinet picture, a variant of the Dusseldorf composition.

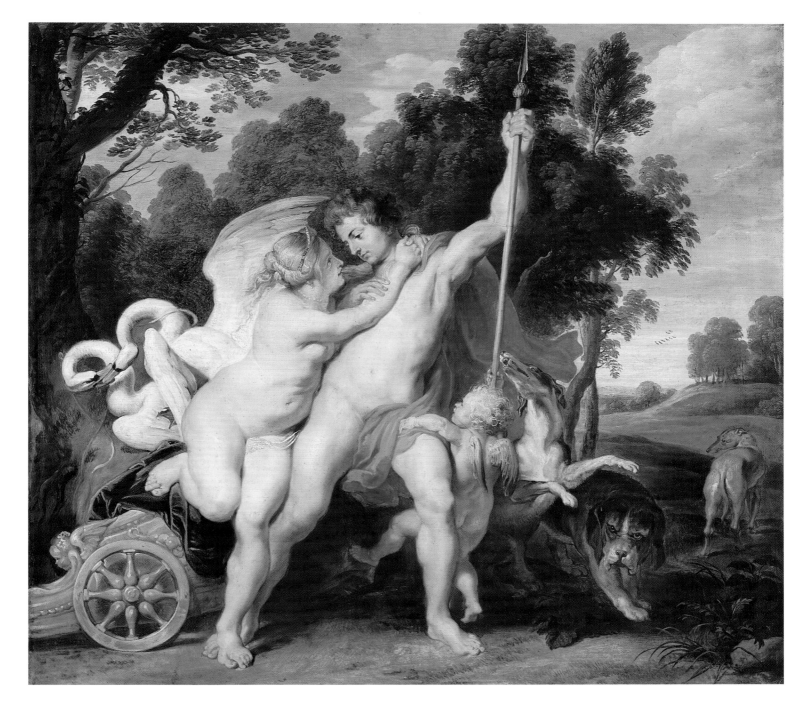

The figures, however, were most probably painted by Rubens himself. This is manifest in the masterly moulding of shapes and in the transparency of texture, as well as in the expressive rendering of the Muses and of the subtlest hues of the flesh tints.

Judging by certain stylistic differences from its prototype, which were a reflection of the artist's new stage (instead of a elongated figures and the warm, saturated colouring, this painting has normal, even somewhat squat proportions and rather cold colours with bluish shades on the white-pink flesh and an enamel-like texture), the present painting appears to have been produced around 1614 (Oldenbourg 1916).

Venus and Adonis.
The Hermitage, St. Petersburg.

Provenance: Purchased for the Hermitage from the Cobenzl collection in Brussels in 1768.

The Main Prototype: Rubens, *Venus and Adonis* (ca. 1609), Kunstmuseum, Düsseldorf; oil on canvas, 276 x 183 cm.

Versions: Rubens (assisted by pupils), *Venus and Adonis*, the first modified version of the composition — formerly in the Kaiser-Friedrich-Museum, Berlin (lost during World War II); oil on canvas, 114 x 111 cm.

Prints: By P.-I. Tassaert (1732-1803) (V.-S. 1873, No. 56); inscribed: *Dédié à S. E. Monseigneur le Comte de Cobenzl etc.*

8. *STATUE OF CERES*

Ca. 1615.
Oil on oakwood. 90.5 x 65.5 cm.
The Hermitage, St. Petersburg. Inv. No. 504.

This decorative picture is symbolic in character. The explicit subject is mythological: an offering to Ceres, the Roman goddess of fertility. Implicit in the motif is the idea of unity of life and art and of the past and future: the statue in its architectural setting is being adorned with gifts of nature, whereas the ancient monument is surrounded by playing *putti* symbolizing "the happiness of nations", "the age of felicity", "the cherished bliss in the centuries to come" (as explained by Rubens himself — see No. 31). The dragonfly (or butterfly) wings, which allegorically represent hours, presumably signify immortality (see No. 18).
The nearest thematic and compositional analogy is the picture *Three Graces Adorning Nature* (1615-1616, Art

(Louvre, Paris). On an engraving by C. Galle I the same setting surrounds a statue of the Virgin and Child with the following inscription from the Old Testament: *Ego quasi vitis fructificavi* ("Like a vine I bear fruit"). Characteristically, not only was the decorative motif of the painting used in the engraving, but the treatment of the Virgin was similar to the image in the picture.
It has never been doubted that the painting is that of Rubens, except for the garland of fruit, which was most probably executed by Frans Snyders (1579-1657), as suggested for the first time in a publication of 1922 by Oldenbourg. At present this viewpoint is shared by many experts. In the old inventories and catalogues of the Hermitage the garland was generally ascribed to Jan Bruegel I, called "Velvet Bruegel" (1568-1625), who often collaborated with Rubens.
The statue of Ceres represents the type of image (fairly common in Rubens' works) that derives from the antique "draped statues" (Ceres shows some resemblance

Rubens. *Portrait of Albert.*
Drawing. Albertina, Vienna.

Rubens. *Portrait of Nicolas.*
Drawing. Albertina, Vienna.

Museum and Gallery, Glasgow; oil on wood, 108 x 72 cm). It is also close in type to a group of Rubens' paintings dating from 1615-1621 which includes such pictures as *The Infants Christ and John the Baptist* (Kunsthistorisches Museum, Vienna), *The Garland of Fruit* and *The Virgin in a Garland* (both in the Alte Pinakothek, Munich) as well as *The Virgin in a Garland*

to the statue of Good Hope in the sketch *Felicitations on the Arrival of the Infante Ferdinand in Antwerp*, No. 31). Haberditzl (1912) regarded the statue of Ceres as modelled on the ancient sculpture of Demeter from the Museo e Galleria Borghese in Rome, which Rubens might have seen. Kieser (1933) discovered a still closer prototype — one of the versions of the Borghese Deme-

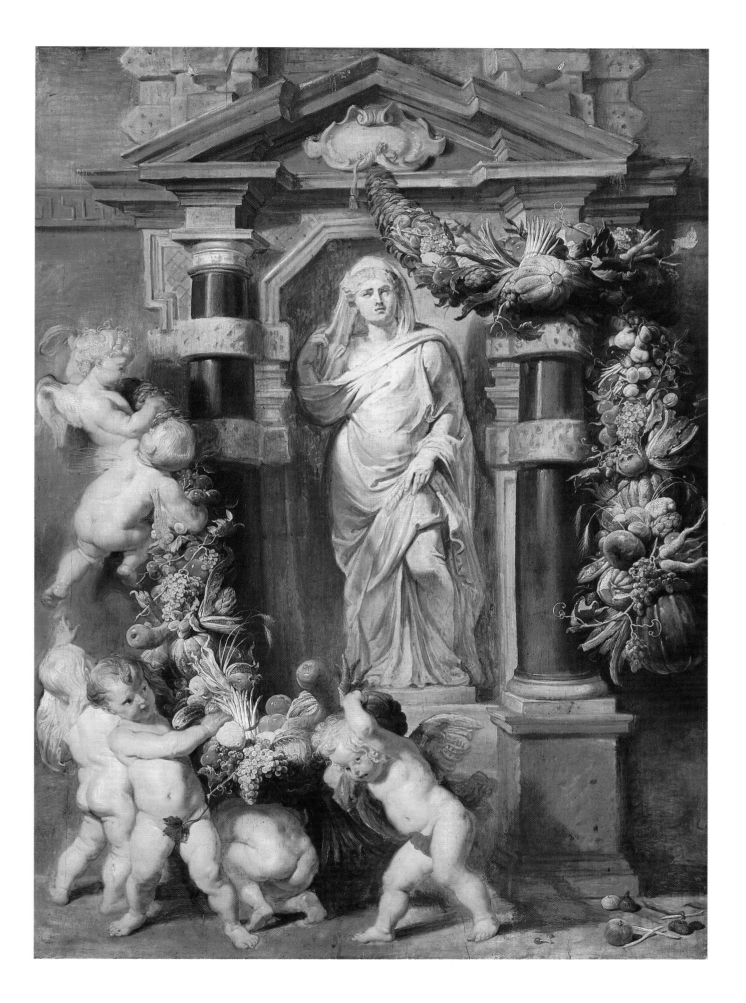

ter (W. Amelung, *Die Sculpturen des Vaticanischen Museums*, vol. I, Berlin, 1903, p. 164), which differs from the figure in the Hermitage painting only by the different gesture of the right arm (restored). In Kieser's opinion, Rubens must have seen the statue before its restoration and reconstructed what was missing from the version in the Borghese collection.

Haberditzl found the prototypes of the two central *putti* in the central foreground in Hellenistic fountain statuary: the left-hand, nearly *en face* figure is modelled on the well-known group *Boy with a Goose* whose numerous copies survive, and the figure almost in profile on the right is based on the popular motif of ancient sculpture — a boy with a jug on his shoulder; the profile is reminiscent of similar images in ancient reliefs. In 1918 Oldenbourg observed a resemblance between the head of the upper left *putto* and Cupid's head in Correggio's *Mercury Instructing Cupid before Venus* (National Gallery, London), which Rubens had copied for Emperor Rudolph II in Mantua.

On the other hand, the same head is close to Rubens' study *Child with a Bird* (Gemäldegalerie, Berlin-Dahlem), which is regarded as a portrait of Rubens' second son Nicolas, whereas in the head in the left foreground Kieser (1950) noticed some facial features of Rubens' elder daughter Clara Serena (b. 1611; see No. 25).

Rubens' elder children, especially his sons Albert (b. 1614) and Nicolas (b. 1618), are often identified as the models of infants' faces in a number of Rubens' works dating from the 1610s. Naturally, this supposed resemblance is no documentary proof since some amount of generalization and idealization is involved. At the same time one cannot ignore the fact that Rubens' images were marked by a life-like quality and were indeed based on the artist's impressions of reality, often enough on certain features of living people, which can give grounds for using the likenesses in verifying or ascertaining the date of the picture. This is the case with the *Statue of Ceres*. It is believed that the drawing of a child's head with a coral necklace (No. 394/451, Albertina, Vienna) portrayed Nicholas, whereas both drawings in the Hermitage Museum (inv. Nos. 5455 and 5426) and the profile drawing in the Albertina (inv. No. 395/459) show Albert. Nevertheless, since it is beyond doubt Nicholas (because of the resemblance of the face to that in Rubens' *Portrait of the Artists' Sons* in the Liechtensteinische Staatliche Kunstsammlung, Vaduz) who is represented in the later drawings from the Albertina (inv. Nos. 453 and 392/449), it is hardly possible to identify the boy with corals as Nicholas, who had a distinctly protruding lower jaw. Rubens cannot have portrayed

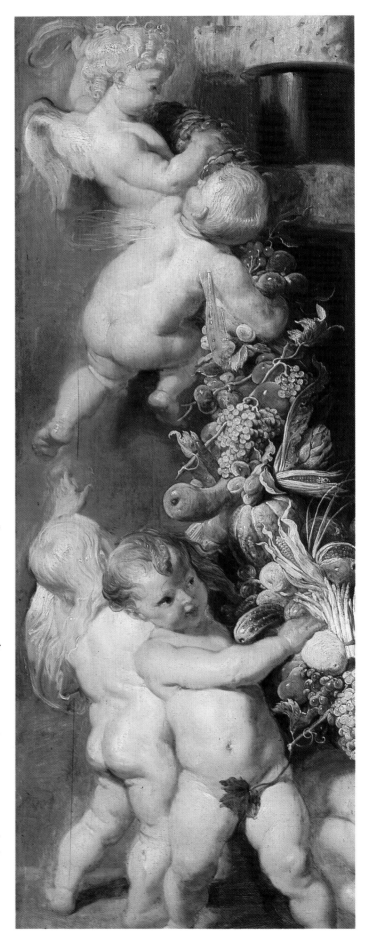

Statue of Ceres, detail.
The Hermitage, St. Petersburg.

Rubens. *Child with a Bird.*
Gemäldegalerie, Berlin-Dahlem.

Rubens. *Cupid and Psyche.*
Drawing. British Museum, London.

his younger son with his upper lip pouting, as he had shown his eldest son in the profile sketch in the British Museum, inscribed by the artist himself: *Cupido ex Albertuli mei imagine* ("Cupid drawn after my little Bertie"), or as we see Albert in other sketches recognized as his portraits. In all likelihood, the Berlin study *Child with a Bird,* which may have been used for the Hermitage picture, also shows Albert *(Beschreibendes Verzeichnis der Gemälde im Kaiser-Friedrich-Museum....* Berlin, 1931, p. 407) rather than Nicholas (Rosenberg 1905, p. 475). The age of the child in the Berlin study narrows its datability to 1614-1616.

It is true that the artist may have used the study many years later. Nevertheless, a date not later than the mid-1610s is indicated by a number of other iconographic

Rubens' house in Antwerp.
Arch between the courtyard and garden. Photograph.

and stylistic features of the picture. The central element of the composition, the niche for Ceres' statue, is an almost exact copy of the archway between the inner court and the garden of the artist's new house (now the Rubenshuis, Antwerp); the lights over the pediment of the niche reproduce identical details on the roof of the house (see Jacobus Harrewyn's engravings of 1684 and 1692).

As appropriately pointed out by Evers (1943), the dominant position of the arch in the picture and the artist's keen interest in the architecture of the house must have been connected with the initial period of the construction undertaken in 1611. The decorative nature of this symbolic composition invites comparison with Rubens' title-pages (see No. 18), where architectural motifs predominate only in the earliest works dating from 1617 at the latest. Afterwards Rubens' combinations of architectural elements became increasingly free, and eventually he abandoned them altogether. On the other hand, it can be observed that in a number of works dating from this period and involving the motif of a garland surrounding the central image, the growing complexity of the main theme was accompanied by a lessening of the role of architecture.

The latest of these works, *The Virgin in a Garland* in the Louvre, is dated 1621 on documentary evidence. It no longer has any architecture. The garland around the central medallion merely marks a border between the real and the ideal. The Virgin is shown rising into Heaven with *putti* hovering round Her. The Munich *Virgin in a Garland* (Alte Pinakothek, Munich), which is dated between 1616 and 1618, is the preceding stage in the development of the composition. The Virgin's image is presented as a framed, lavishly cartouched picture built into the wall. The garland demarcating the distance between the divine presence and the viewer is carried by *putti*, who appear to be in real space, the space where the viewer is. As for the Hermitage picture, the group of *putti* stand on the ground in front of a real building, decorating a real historical monument. The Hermitage painting undoubtedly originated as the initial step in the evolution of the concept, i.e. before 1616. Its nearest version, the composition *Three Graces Adorning Nature* in Glasgow (1615-1616), constitutes, by virtue of including a landscape, a further development of the motif. The painterly features of the picture, such as its molten, enamel-like texture coupled with an exceptional warmth of colour, sharply contrasting with the cold colour schemes of the early 1610s (for example, *Venus and Adonis, ca.* 1614; No. 7), make it possible to give it a more accurate date — *ca.* 1615.

Provenance: In the Gerard Hoet sale in the Hague on 25 August 1760 a painting was sold as lot 30, described as follows: "A few children, playing with fruit, in the middle a statue in grisaille, placed in a niche, by the same artist, Rubens, also superb, 34 inches high, 25 inches wide [86.3 x 62.5 cm]. *Nota.* This piece was engraved. 1210 guilders" (Hoet & Terwesten 1752-1770, III). It is not clear whether the reference is to the present Hermitage painting or a version of it. Purchased from the Cobenzl collection in Brussels for the Hermitage in 1768.

Prints: By Cornelis Galle I (1576-1650) (V.-S. 1873, No. 156); instead of Ceres the Virgin and Child are shown, with the following words: *P. P. Rubens inventor*; inscribed in the cartouche over the Virgin: *Ego quasi vitis fructificavi. Eccl. 24.*

Rubens.
The Virgin in a Garland.
Alte Pinakothek, Munich.

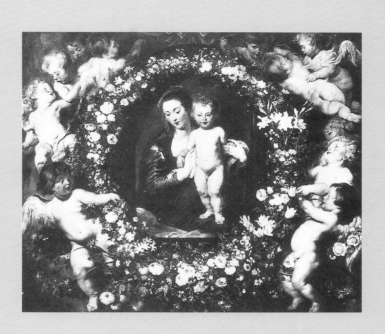

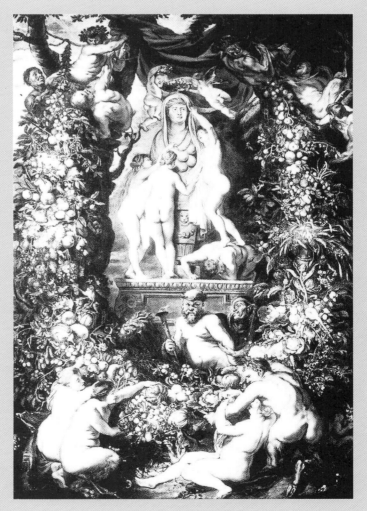

Rubens.
Three Graces Adorning Nature.
Art Museum and Gallery, Glasgow.

9. *BACCHANALIA*

Ca 1615.
Oil on canvas. 91 x 107 cm.
Transferred from wood by A. Sidorov in 1892. Three horizontal strips of filled spaces where the planks were once joined.
The Pushkin Museum of Fine Arts, Moscow. Inv. No. 2606.

The painting represents such mythical companions of Bacchus (Dionysus) as Silenus and satyrs. In Euripides' satyr drama entitled *Cyclops* (v. 13, 100, 169, 420) satyrs are said to be old Silenus' children. In Rubens' days they were thought to personify the bestial, carnal side of human nature, uncontrollable natural instincts and passions. In addition to Silenus and the satyrs, Bacchus' retinue included wild animals (a tigress here), people that worshipped him and the nations he had conquered (here a Negress with a tambourine).

Bacchus and his companions were often depicted on ancient Greek vases, on reliefs of late antique sarcophagi and other objects. Bacchanalia — a festival in honour of Bacchus — once again became a subject of European art at the time of the Renaissance. An important aspect of the depiction was its connection with the tradition of antiquity.

Rubens repeatedly turned to the Bacchic theme. The Moscow *Bacchanalia is* part of a group of paintings and drawings executed between 1612 and 1618. The painting *Drunken Heracles* (Gemäldegalerie, Dresden) in which a nymph and a satyr lead the staggering hero, belongs approximately to 1612-1614. This must have been followed by a lost composition with young Bacchus supported by two satyrs, which is known from an engraving by Jonas Suyderhoef *(ca.* 1613-1686)

(V.-S. 1873, p. 133, No. 124). In the Moscow *Bacchanalia*, instead of the satyrs a blonde satyress and a Negress, similarly posed, flank the drunken Silenus. A family of satyrs is added on the right side, where particular prominence is given to the satyress suckling her young. The same image, with the animal element heightened and the posture modified, was included by the artist in his famous *Procession of Silenus* (*ca.* 1618, Alte Pinakothek, Munich).

The works in the series allow us to see the artist repeat and modify the types, poses and gestures of his characters, producing more and more combinations based on the same motif. Some of them were transferred from one picture to another, evidently because the artist valued them These motifs derive from the art of antiquity. The group with drunken Heracles supported by a nymph and a satyr in the above-mentioned painting from Dresden is a quotation as it were from an ancient bas-relief (see Kieser 1933). Afterwards it became the compositional nucleus of some other works, including the Moscow *Bacchanalia*. Similar images are frequently found on sarcophagi connected with the cult of Bacchus-Dionysus and dating from late antiquity. By good fortune, the same museum in Moscow has, in addition to the picture, a fine Roman marble sarcophagus with images of Bacchus, satyrs, maenads, and a drunken Heracles (*ca.* 210 A.D., Pushkin Museum of Fine Arts, Moscow, inv. No. II, Ia 231). Rubens knew it, as evidenced by his drawing *Intoxicated Heracles and Faun* housed in the Hermitage Museum (inv. No. 5512) reproducing the reverse of the sarcophagus. The drawing has been assigned to the artist's Italian period: by Dobroklonsky (1940; 1955) to *ca.* 1606-1608; by Kuznetsov (1965)

Rubens. *Drunken Heracles*. Gemäldegalerie, Dresden.

to between 1600 and 1608; by Kuznetsov (1974) to *ca.* 1601-1604. Rubens probably possessed sketches of the other decorations of the sarcophagus. Thus, the figure of Heracles with a small jug in his hand on the left end of the sarcophagus was used to show Silenus spilling wine in the *Bacchanalia*. Of great importance for the master's work at the composition was the front part of the sarcophagus. Its centre is occupied by Dionysus naked supported by a satyr; to the right is Ariadne recumbent on the ground. Also important was the general design of the relief with the figures amidst plants. Among the pictures discussed here the Moscow *Bacchanalia* is compositionally closest to the ancient relief. Half its background is filled by a thick growth of vine creeping round a tree, a satyr is visible through the foliage and another is swaying on the

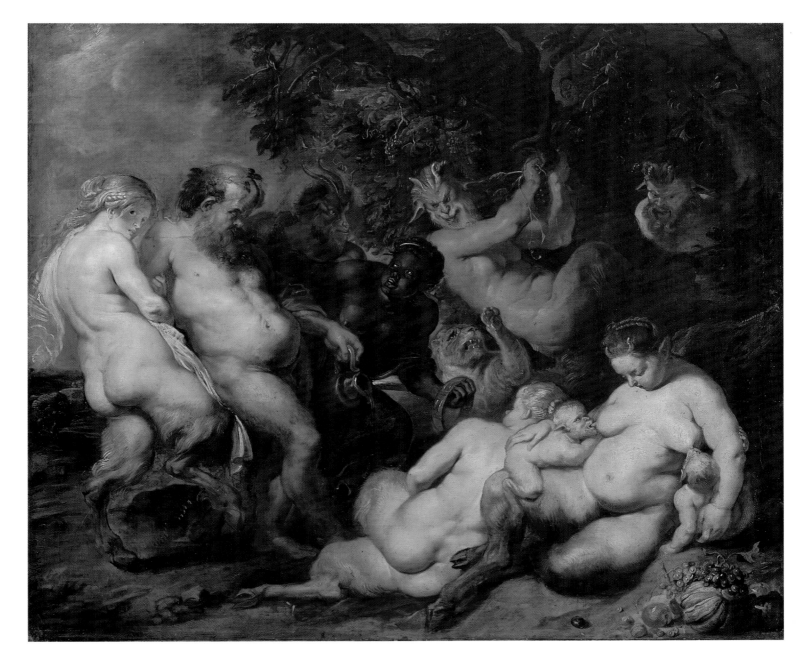

branches. Next to them two satyresses lie on the ground, one of them suckling her young. On the left the drunken old Silenus approaches with his companions. The artist in fact repeated all the basic elements of the relief on the sarcophagus, although he substituted the bald fat Silenus for Bacchus and a satyress for Ariadne. The substitution implied an ironic treatment of the subject. Rubens departed from the lofty spiritual aspect of the myth in favour of the theme of Nature as a powerful force that unites and creates all living things. Nature is incarnated in the characters of the picture — full-blooded, brimming over with health, joy and abandon.

Silenus' figure was modelled by the artist on a study of an antique statue belonging to the British Museum

Bacchanalia.
The Pushkin Museum of Fine Arts, Moscow.

in London (inv. No. 5211-58; Hind 1923, No. 51; *Rubens' Drawings and Sketches at the British Museum* [Exhibition Catalogue], by J. Rowlands, London, 1977, p. 28, No. 13, ill. — through error of omission, the Moscow picture is not mentioned among the works quoted as those based on the drawing from the British Museum).

Rubens held the artistic heritage of Antiquity in high esteem, yet he believed that contemporary painting was capable of portraying life with greater veracity than ancient sculpture could. In the *Bacchanalia* he no longer reproduced an ancient relief, but freely

combined motifs derived from various sources and included them in the composition full of vitality and dynamism. In doing so, the artist also made use of life drawings. Thus the figure of Silenus is evidently connected with the half-length study of a bearded burly model in the Museum Boymans-van Beuningen, Rotterdam. Maria Varshavskaya links the drawing with the Moscow painting (see the exhibition catalogue: Leningrad 1964). Compared with Rubens' other works on similar subjects, the Moscow painting appears restrained and serene. The group with Silenus advances slowly, and the young satyress to the left seems to stop in her tracks. Mechanically supporting Silenus, she turns away from him, giving the viewer an inquiring stare from under her drooping locks of fair hair. Her head seems to be modelled on a beautiful antique cameo and the background of the greyish-blue sky emphasizes, by contrast, the warmth of the flesh tints, the lustre of her hair and the whiteness of her transparent draping.

The painting is devoid of Bacchic frenzy. It has no action, no incident — what it does have is a peaceful, nearly idyllic presence of the mythological characters in a landscape, in full harmony and union with Nature. At the same time, Nature itself, according to Rubens, is in perpetual motion and is always teeming with life. The painter's artistic idiom serves to give fuller expression to this dynamism. The forms created by Rubens' brush are invariably organic and natural, his brushwork supple and fluid. There are parts of the picture where the greyish-sandy ground was left as it was or only in part covered with long, transparent strokes — this is the case with the lower left-hand corner. This deliberate unfinished effect is a kind of display of virtuosity on the part of the artist.

The *Bacchanalia* was an extraordinary success among the artist's contemporaries. It was repeatedly reproduced in copies, both full-size and smaller size. Rubens' pupil, the sculptor Lucas Faydherbe (1617-1697), used Rubens' composition for his ivory bas-relief which decorated a goblet (Kunsthistorisches Museum, Vienna; see Glück 1933). Of interest are a number of Flemish paintings that show the imaginary ideal collections of natural rarities and art masterpieces. Such a collection, including the Moscow *Bacchanalia*, is portrayed in the *Picture Gallery* (Musées Royaux des Beaux-Arts de Belgique, Brussels), ascribed to Frans Francken the Younger (1581-1642). Particularly important in this respect are Jan Bruegel I's painting *Allegory of Sight* (signed and dated 1617, Prado, Madrid) and his large *Allegory of Sight and Smell* (Prado). The latter is a replica of a painting executed by Jan Bruegel I and his assistants between

1615 and 1618 to the order of C. van der Geest as a present to Archduke Albert and the Infanta Isabella, who ruled over the Southern Netherlands. All this confirms the dating of the Moscow picture on stylistic grounds to *ca.* 1615. In the *Allegory of Sight* of 1617 the *Bacchanalia* is placed in the forefront as a work of exceptional artistic value. Jan Bruegel I was Rubens' close friend and, on several occasions, his collaborator. Padron (1975) suggests that it was Rubens himself who painted the figures in the *Allegory of Sight*. Thus, the implied high estimation of the *Bacchanalia* reflects the view of its creator and his circle. Rubens' contemporaries were, without doubt, attracted by the brilliant technique and characteristic poetic quality of this work, but they were no less impressed by the artist's profound understanding of ancient culture, which was particularly evident on this occasion. It has always been believed that the entire picture was executed by Rubens himself despite on one occasion being ascribed to Rubens' workshop (Martin 1970).

Provenance: According to the inventory of 1722-1735 (Cholmondely archives, Houghton Hall, England) the painting was in the collection of Robert Walpole, first Earl of Orford (1676-1745) in his Houghton Hall estate in England. Purchased for the Hermitage from the Walpole collection in Houghton Hall, England, in 1779. Transferred from the Hermitage in Leningrad to the Pushkin Museum of Fine Arts in Moscow in 1930.

Preliminary works: 1) *Silenus*, drawing of an ancient statue; black chalk, 41.9 x 25.6 cm; British Museum, London, inv. No. 5211-88 (Hind 1923, pp. 21-22, No. 51; Cat. exhib.: *Rubens Drawings and Sketches at the British Museum*, by J. Rowlands, London, 1977, p. 28, No. 13, ill. — by error the Moscow painting is omitted among the works based on the drawing. 2) *Silenus' Head*, drawing of an ancient statue; black chalk, 29.3 x 19.5 cm; Pushkin Museum of Fine Arts, Moscow, inv. No. 6208 (Kuznetsov 1965, p. 17, No. 9, pl. 2; Kuznetsov 1974, pl. 4). A different sketch from the same statue may have been used. 3) *A Bearded Model* (half-length), drawing; black chalk, heightened with white, 43.6 x 36.5 cm; Museum Boymans-van Beuningen, Rotterdam, inv. No. V. 82 (Evers 1943, ill. 241; *Tekeningen van P. P. Rubens. Tentoonstelling. Antwerpen. Rubenshuis*, 1956. Catalogue: L. Burchard, R.-A. d'Hulst, p. 61, No. 56). The model is shown in a similar pose, but in the opposite direction to Silenus in the Moscow painting. 4) *Figure of Silenus*, represented twice; pen and ink drawing, 19 x 19.5 cm; formerly in the collection of Mrs. G. W. Wrangham, England (Evers 1943, p. 244; Held 1959, No. 42). The drawing may have been done after the Moscow painting rather than before it. Datable *ca.* 1616-1618.

Prints: 1) By Pieter Soutman (ca. 1580-1657), 1642; inscribed: *Silenum patrem... tabella haec exhibit*; alteration: Silenus' naked body is covered with a tiger skin (V.-S. 1873. p. 134, No. 135, with an erroneous statement that Bacchus is represented). 2) By Richard Earlom (1742/48-1822); mezzotint in the opposite direction (V.-S. 1873, p. 134, No. 136). 3) Anonymous engraving in the opposite direction, with minor modifications (V.-S. 1873, p. 134, No. 137). 4) Anonymous engraving in Soutman's manner, the composition considerably expanded (Rooses 1886-1892, III, p. 162).

Bacchanalia, detail.
The Pushkin Museum of Fine Arts, Moscow.

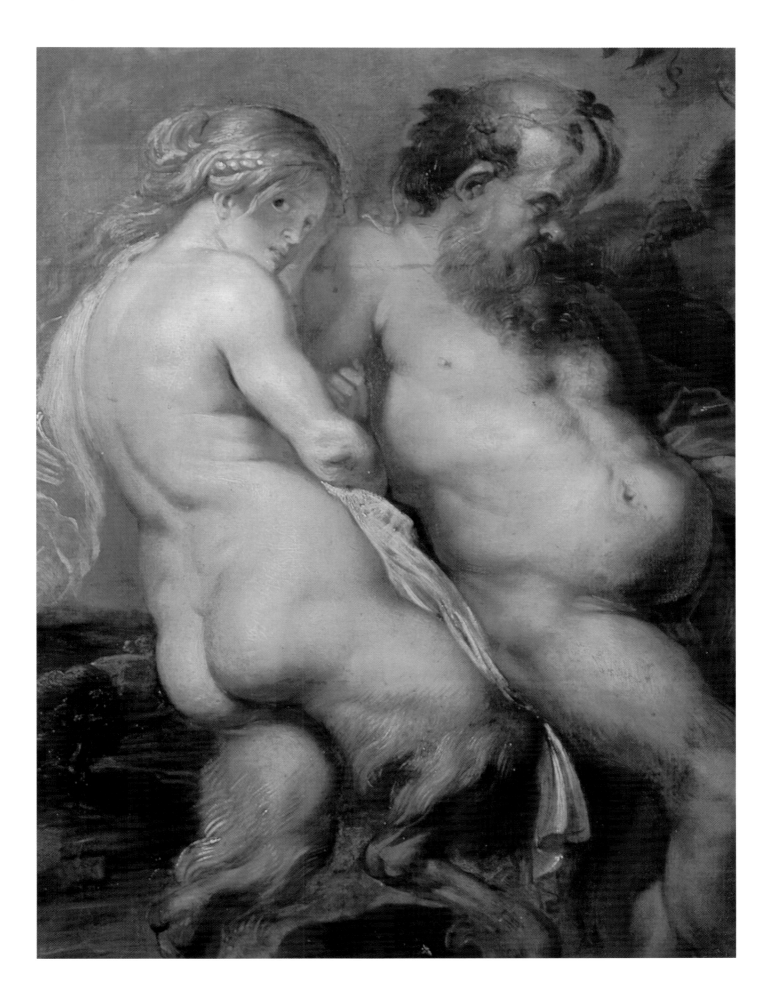

10. *HAGAR LEAVES THE HOUSE OF ABRAHAM*

1615-1617.
Oil on oakwood. 62.8 x 76 cm.
The Hermitage, St. Petersburg. Inv. No. 475.

The subject is derived from the Old Testament, Genesis 16, 1-6. The treatment is characteristic of narrative cabinet paintings. In his letter to D. Carleton, the British Envoy in the Hague, dated 12 May 1618, Rubens discusses the terms of exchanging some paintings by him for Carleton's collection of ancient marbles and offers for "the last 100 florins a pleasing little picture *(una galanteria)* by my brush". In his letter of 26 May in the same year he characterizes the picture as follows: "Its subject is truly unusual; it is, so to speak, neither secular nor religious (although taken from the Old Testament). The picture shows Sarah showering rebukes upon the pregnant Hagar, who leaves home, with womanly dignity, in the presence of and with the participation of patriarch Abraham..." (*Masters of Art on Art*, vol. III, Moscow, 1967, p. 189; *CDR* 1887-1909, II). The Hermitage picture is undoubtedly the original of the replica acquired by Carleton. The latter painting can be identified with the canvas in the collection of the Duke of Westminster in London (Eaton Hall); it is done in the same medium and its dimensions (70 by 100 cm) are nearly equal to those mentioned in Rubens' letter: "...it is painted on panel 3 ½ feet wide and 2 ½ feet high [75 x 105 cm]" (*Masters of Art on Art*, vol. III, Moscow, 1967, p. 189; *CDR* 1887-1909, II).
In 1943 Evers noted compositional affinity between the painting *Hagar Leaves the House of Abraham* and an engraving on the same subject by the German master Botias Stimmer (1539-1584) in the book *Neue künstlische Figuren Biblischer Historien grüntlich von Tobias Stimmer gerissen...*, Basle, 1576.
Evers recalls in this connection Joachim von Sandrart's account of his meeting Rubens in Holland in 1627, when Rubens said that in his youth he had copied from Stimmer's book (see *J. von Sandrarts Academie der Bau-, Bild- und Malerei Künste von 1675*, hrsg. und komment. von A. R. Peltzer, Munich, 1925, p. 106).
While largely retaining the appearance of Sarah's and Hagar's figures, and partly of the setting, including the dog, Rubens invested the figure of Abraham, whom Stimmer had shown seated solemnly on the throne, with expressive realistic features.
In 1864 Waagen collated this Hermitage picture with the *Flight of Lot from Sodom* (1625, Louvre, Paris)

and assigned it to the same period. In 1886 Rooses dated it 1612. Considering the fact that in May 1618 Rubens was offering Carleton its replica or repetition, *Hagar Leaves the House of Abraham* ought not to be dated later than 1618. Some stylistic features of the picture (the sparse arrangement of the figures, the warm palette, the soft light and shade and aerial effects) indicated a date when the artist was approaching maturity, i.e. the 1620s. Yet the characteristic tonality of Sarah's lilac dress evokes parallel with the artist's early works, such as his oil sketch *The Descent from the Cross* (1612-1614, No. 6 in this book). Evidently, appropriate dates were proposed by Oldenbourg in 1921 and Schmidt in 1926, who assigned them, respectively, to "about 1618" and "in between *The Crown of Thorns* (No. 5) and the *Feast in the House of Simon the Pharisee* (No. 15). The pictures should therefore be dated between 1615 and 1617.

Rubens. *Hagar Leaves the House of Abraham.*
Duke of Westminster collection, London.

Hagar Leaves the House of Abraham. ▶
The Hermitage, St. Petersburg.

Provenance: Purchased for the Hermitage from the Crozat collection in Paris in 1772.

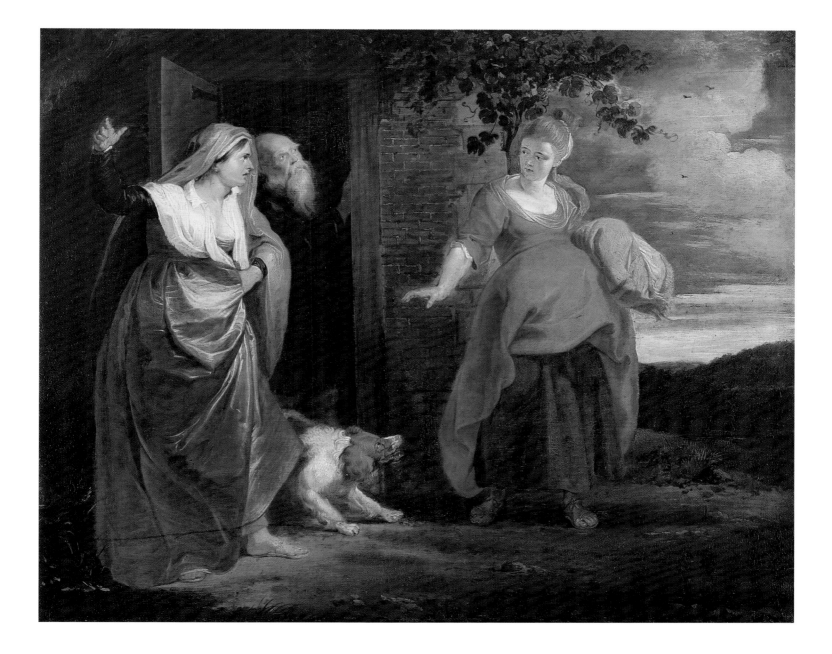

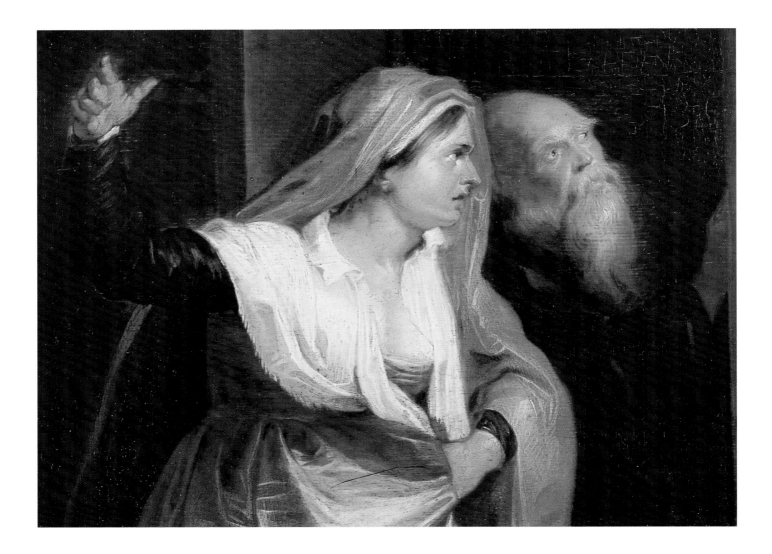

Hagar Leaves the House of Abraham, detail.
The Hermitage, St. Petersburg.

Hagar Leaves the House of Abraham, detail.
The Hermitage, St. Petersburg.

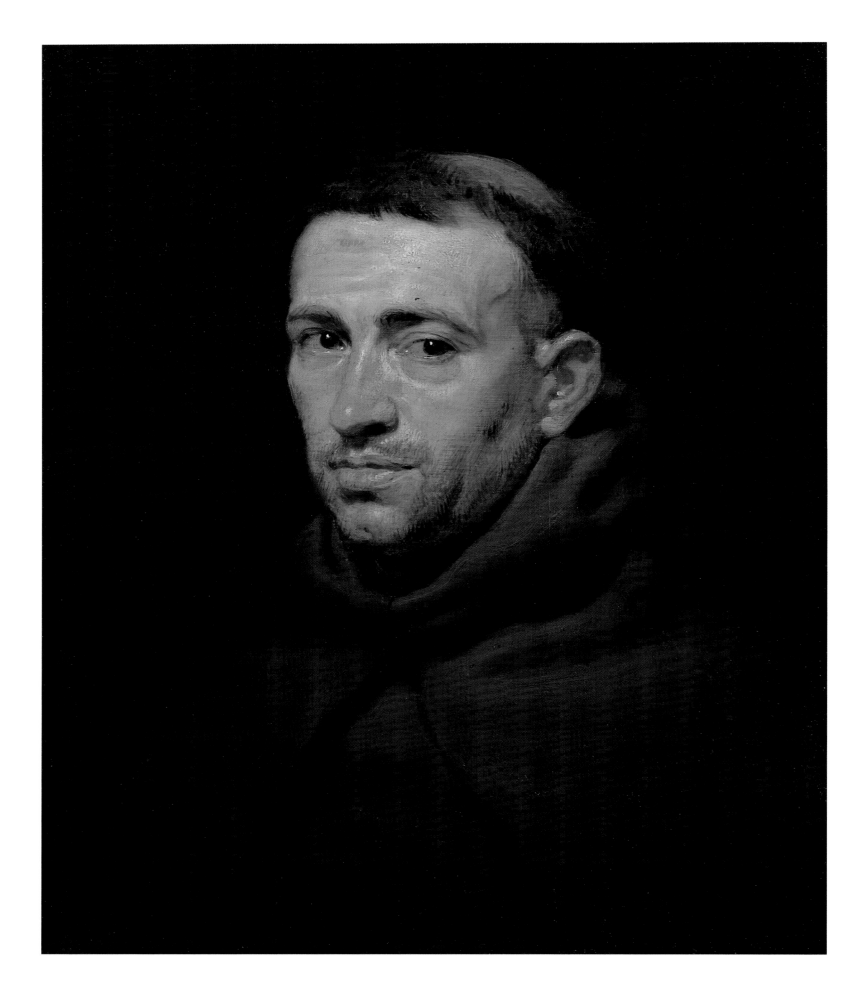

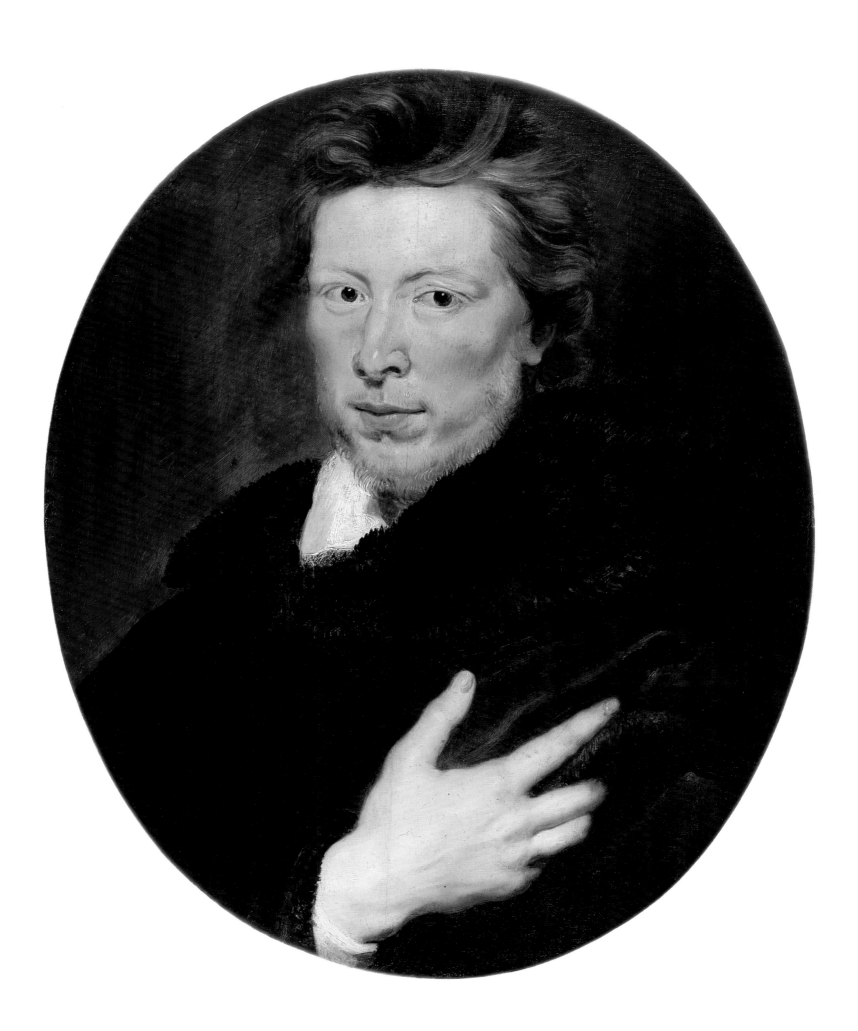

11. *PORTRAIT OF A FRANCISCAN FRIAR*

1615-1617.
Oil on canvas. 52 x 42 cm.
Transferred from wood by F. Tabuntsev in 1842.
The Hermitage, St. Petersburg. Inv. No. 472.

Although the study is undoubtedly a portrait, it has not been possible to identify the sitter.

The dynamism and emphatic individualization of the portrait, the expressive modelling of form by means of large masses, the broad handling in the rendering of the Venetian-red flesh tints, the bluish whites of the eyes — all these features have parallel in the painting *Two Satyrs* (Alte Pinakothek, Munich), especially in the head shown in profile, which leads one to believe that both pictures date from the same period — between 1615 and 1617.

Rubens, *Portrait of a Man.* ▶
Institute of Art, Dayton, USA.

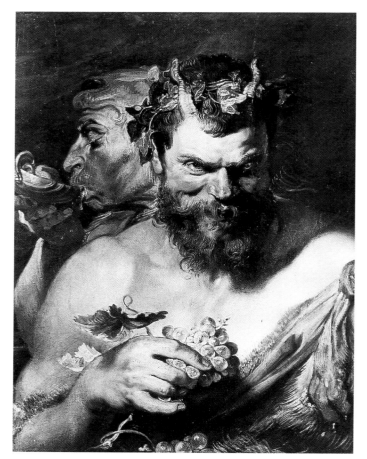

Rubens, *Two Satyrs*.
Alte Pinakothek, Munich.

Provenance: Between 1722 and 1735 the painting was already in the Walpole collection (see the manuscript catalogue in the Cholmondely collection in Houghton Hall). Purchased from the Walpole collection in Houghton Hall, England, in 1779.

Prints: By Valentine Green (1739-1813) in 1774 for Walpole's publication of 1775-1788: *A Set of Prints Engraved after the Most Capital Paintings... Lately in the Possession of the Earl of Orford, the Houghton Hall in Norfolk...*, vols. I-II, London, 1788 (1st ed. 1775), henceforth referred to as the Walpole *Set*.

Rubens, *Portrait of a Young Man.* ▶
Gemäldegalerie, Cassel.

12. *PORTRAIT OF A YOUNG MAN (GEORGE GAGE?)*

1616-1617.
Oil on oakwood. 60 x 49 cm (oval).
Shoulder-length portrait.
The Hermitage, St. Petersburg. Inv. No. 473.

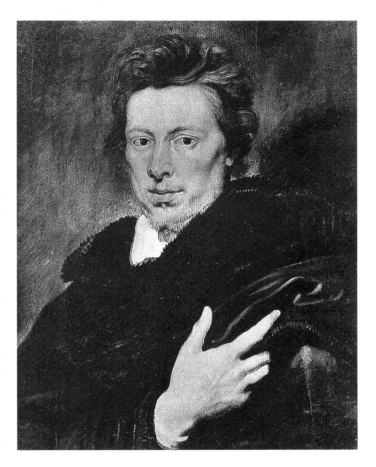

When in the Baudouin collection and until 1838 in the Hermitage the portrait was, quite groundlessly, believed to represent Frans Snyders. It is indisputable, however, that its subject resembles the face in the *Portrait of a Collector* by Anthonis van Dyck in the National Gallery, London (Goris & Held 1947). Evers (Evers 1943, p. 342) regarded the London portrait as a representation of Rubens painted by Van Dyck, and Puyvelde (L. van Puyvelde, *Van Dyck*, Brussels and Amsterdam, 1950, pp. 113, 141-142) thought it to be Van Dyck's self-portrait. In 1969 Millar (O. Millar, "Notes on Three Pictures by Van Dyck", *The Burlington Magazine*, July 1969, pp. 404, 417) identified the arms on the statue depicted in the London portrait as the family crest of the Gages in England and suggested that the sitter was George Gage (*ca.* 1582-1638), an English diplomatic agent. His name occurs in Rubens' correspondence in 1616-1617 in connection with the master's works for Dudley Carleton, the English envoy in the Hague; in those years Gage quite often visited Antwerp as Carleton's representative.

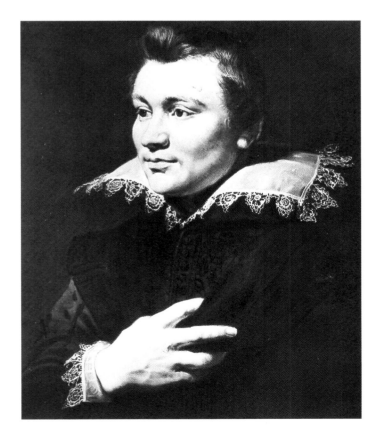

Oldenbourg (1921) ascribed the present portrait to Van Dyck, evidently by analogy with the *Portrait of a Collector* in London. There have been no other doubts about Rubens' authorship.

Rubens' other *Portrait of a Young Man* (1612-1614, Gemäldegalerie, Cassel), which has a similar composition, displays a more detailed and more static treatment. The light pink flesh tints with bluish shades and the enamel-like transparence of the impasto texture of the Hermitage portrait are characteristic of Rubens' work dating from around 1615. At the same time, its dynamic moulding of generalized forms and the dramatic concept of the portrait align it with such works as the *Portrait of a Scholar* or the *Portrait of Doctor Thulden* (1616-1618, Alte Pinakothek, Munich), which suggests a date in 1616-1617. George Gage's contacts with Rubens may have taken place just then.

Provenance: Purchased for the Hermitage from the Baudouin collection in Paris in 1783.

13. *THE DESCENT FROM THE CROSS*

1618.
Oil on canvas. 297 x 200 cm.
The Hermitage, St. Petersburg. Inv. No. 471.

The scene of deposition is described in all the four Gospels: St. Matthew 27: 57-60; St. Mark 15: 42-47; St. Luke 23: 50-54; St. John 19: 38-40. Joseph of Arimathea, Christ's secret follower, a rich man and a member of the Sanhedrin, is mentioned in all the four Gospels as the man who saw to the burial. He was usually painted in rich clothes, performing honorable duties, such as supporting Christ's head. The participation of Nicodemus ("Which at the first came to Jesus by night") is mentioned only in St. John. Nicodemus was traditionally shown in common clothes at the feet of Christ. In many instances it is difficult to distinguish between Joseph and Nicodemus (W. Stechow, "Joseph of Arimathea or Nicodemus?", *Studien zur toskanischen Kunst. Festschrift für D. H. Heydenreich...*, Munich, 1964, pp. 289-302). Mary and John had been present at the crucifixion and it was assumed that they had participated in the deposition as well.

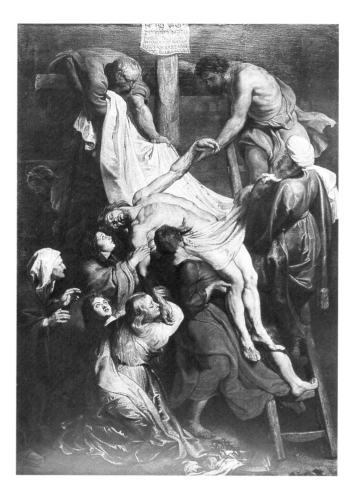

Rubens, *The Descent from the Cross*.
Musée des Beaux-Arts, Lille.

Rubens, *The Descent from the Cross*.
Antwerp Cathedral.

By the end of the Middle Ages the participants in the scene had become more or less established and included Mary Magdalene and Mary the wife of Cleophas (for further particulars see Réau 1955-1959, II, 2, pp. 513-518).

In addition to its literal meaning — as an account of the end of Christ's earthly life — the subject represented one of the main dogmas of Christianity (the redemption of original sin by the martyrdom of the Saviour) and symbolized the sacrament of the Eucharist. The cult of the suffering body of Christ originated in the Netherlands as early as the thirteenth century; by the fifteenth century the Deposition became a favourite subject for altarpieces (N. Verhaegen, "La descente de Croix. Iconographie", *Bulletin de l'institut royal du patrimoine artistique*, vol. V, 1962, pp. 17-26).

After the Council of Trent (1547-1563) the counter-reformational Catholic Church put forward a demand to ban any lifelike treatment of the scene, any increase in the number of participants or presentation of Mary

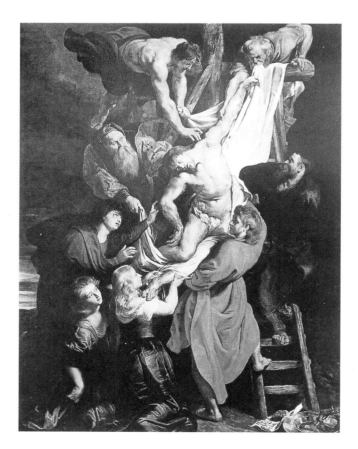

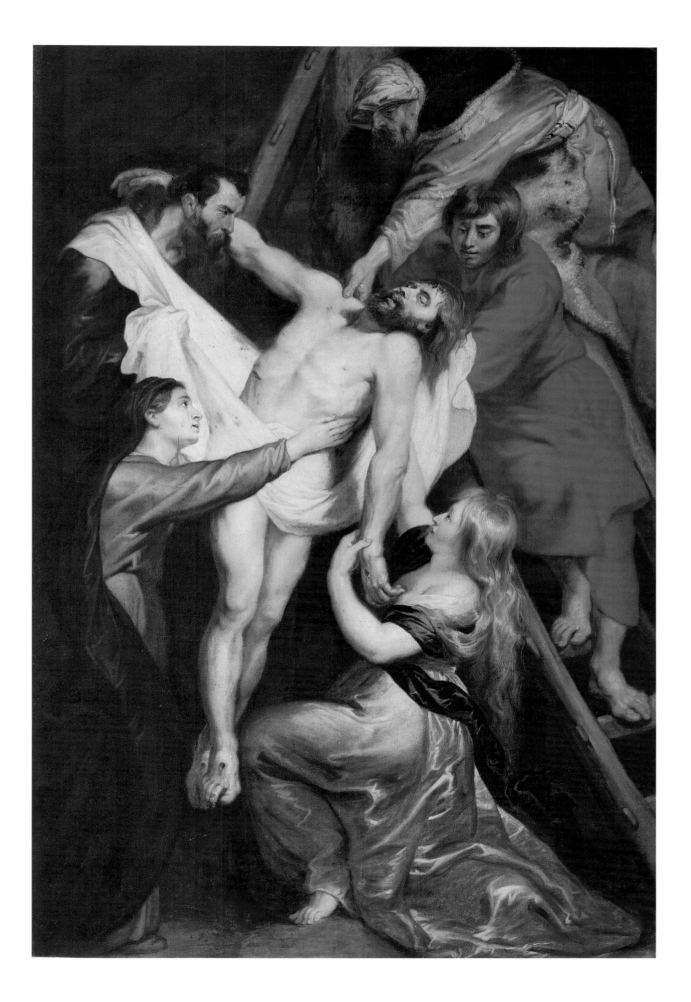

as the earthly mother bereft of reason and consciousness by her grief. She was to be shown firm, not vulnerable to human sorrow.

The painting was executed jointly with the pupils. The faces of Christ and the old man at the top display a swift, dynamic, almost sketchy handling; the body of Christ and the clothes of the old man at the top are painted in a free, broad manner — suggesting Van Dyck's participation in their execution. In the painting of the other figures, showing a greater plasticity and smoothness of texture, certain variations in workmanship are notable: thus Mary's face is painted with greater facility, whereas the faces of John, of the old man on the left and of Magdalene are of mediocre quality; rather inferior are the clothes, especially in the lower part of the painting. But the general design is undoubtedly Rubens' own.

In 1611 Rubens received from the Antwerp guild of St. George's Arquebusiers a commission for a monumental altar triptych for Antwerp Cathedral. Inaugurated in 1614, the altar was such a great success that in the few subsequent years the artist painted for some Flemish churches several versions of the central piece of the triptych, *The Descent from the Cross*, executed in 1612. The Hermitage sketch and picture were among those versions. In the Antwerp *Descent* Rubens decisively broke with the traditional design used by his predecessors by uniting all the characters round one centre — the body of Christ carefully lowered to the ground. The deep humanism in the rendering of the sorrow, the dynamism and drama of the act performed are combined with the requisite ritual solemnity characteristic of an official painting.

Compositionally, the altar of the Capuchin Church in Lille is the nearest analogue of the Antwerp *Descent from the Cross*. On 10 March 1617 the altarpiece for the Capuchin Church was not yet completed (Burchard 1950, p. 58). It is not known, however, whether the composition had been designed by Rubens earlier (the sketch in the Musée des Beaux-Arts, Lille, may represent precisely that early stage), to be executed only in 1617 with the assistance of his pupils. The Lille composition is essentially based on the Antwerp prototype.

There are two novel points: the motif of the lowering of the body was brought to a further stage (the shroud taken down from the cross-bar, the half-naked workman climbing down following Christ's hand, which is slipping away) and the scene was made less concentrated (the number of characters is increased; one of the men is climbing down the ladder with his back turned towards the viewer; Mary the wife of Cleophas

has turned away and looks back over her shoulder). In 1964 Bialostocki was the first to give a survey of the evolution of Rubens' composition on the subject of the Deposition. He regards the Hermitage oil sketch (No. 6) as immediately succeeding the Lille version. The same sequence was suggested by Schmidt in his publication of 1949. There are, however, reasons to believe that the Hermitage sketch was produced before the Lille version or concurrently with it. A number of elements in the Hermitage sketch show affinity with the earliest variant (the drawing in the Hermitage, inv. No. 5496), as well as with the Antwerp prototype.

The light colour range (the clothes are painted in tints of lilac, pink and gold) is very close to that in the early works of the Antwerp period, such as *The Coronation of the Virgin* (No. 3). The general concept of the scene focused round one centre is a development of the approach seen in the Antwerp composition and it may have emerged soon after the completion of the Antwerp *Descent from the Cross* — between 1612 and 1614. But the religious approach to the subject differs a great deal from the Antwerp concept.

The Antwerp composition has more in common with the official dogmatic interpretation of the subject: the Lord's body is solemnly displayed before the worshippers in all its ideal divine glory, floating over the people, as it were. Only some nameless workmen can be seen standing above Christ. The characters of the Gospel story raise their hands towards the Saviour, hurrying not only to pay the last homage to the deceased, but also to receive His Grace by touching the Lord's body, arms, legs or shoulder.

The Hermitage sketch is centred round the human aspect of Christ, his earthly mortality and his affinity with the people. The motif of lowering the body to the ground is central to the whole sketch. For the first time in the series the cross-bar of the crucifix is not visible, nor are the workmen, who are redundant now that the body has almost reached the ground — only one of them can be seen in the background behind Mary. The now heavy corpse supported by Mary is arched and Christ's face is turned to the ground. Also for the first time, Joseph and Nicodemus are shown standing over the body symmetrically flanked by Mary and St. John in the foreground. The composition as a whole, extended lengthwise, became more static.

This approach evidently gave the impression of being too mundane. Possibly, the Lille version, where the body is also bent, but the face is turned upwards, was evolved expressly to oppose the concept seen in the sketch, which was never implemented in a full-scale painting. But, on the other hand, the Hermitage sketch

Rubens, *The Descent from the Cross*.
Drawing.
Musée des Beaux-Arts, Rennes.

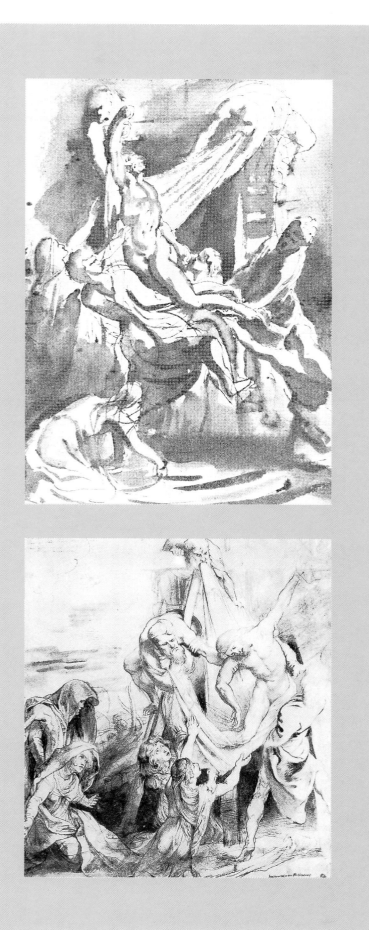

Rubens, *The Descent from the Cross*.
Drawing.
The Hermitage, St. Petersburg.

served as a foundation for a new line in the treatment of the subject, different from the Antwerp prototype. The sketches on the sheet from the former Wranham collection (at present in the Thaw collection, New York), which Held (1959) assigned to 1617-1618, constitute a further development of the present Hermitage sketch. On the sheet the composition of *The Descent from the Cross* was sketched twice and the way Christ's body is treated evidences a search for an expression more perfect than in the oil sketch, of both the carnal and the spiritual. The kneeling female figure holding Christ's feet in the upper part of the drawing almost repeats the figure of Mary, the wife of Cleophas, present in the oil sketch. The corresponding figure in the lower group of the drawing is a variation. The female figure in the upper group of the drawing, with her hand stretched towards Christ, is identical with the figure of Mary in the oil sketch, only shifted from left to right. In the lower drawing, where the artist seems to return to the oil sketch, the same posture is given to a male figure, apparently St. John. As in the oil sketch, two old men stand on the ladder above Christ. The drawings in the Thaw collection are

undoubtedly preparatory to the present picture housed in the Hermitage. It took just a few minor alterations to arrive at the Hermitage composition: Mary with her hand raised towards Christ was moved back from right to left, the kneeling Magdalene in the lower group of the drawing was shifted from left to right; the movement of the old man's hand at the top was heightened and St. John's pose altered. The shroud in the painting goes across the body, as it does in both groups of the drawing, and is thrown across the shoulder of the old man on the left, just as in the lower group of the drawing. Like the oil sketch, the drawing contains no figures of workmen and no cross-bar; the artist also abandoned the figure of Mary the wife of Cleophas. The body of Christ is surrounded only by the five main characters; these stand out from the dark neutral ground. The figures display a sculpted, monumental quality and are to an even greater extent shifted to the foreground than in the Antwerp composition. The vibrant colourful spots of their clothes fill the entire surface of the painting. Further developing the motif of the oil sketch, of Barocci's picture and of the drawing, Rubens shows Christ's body still more straight-

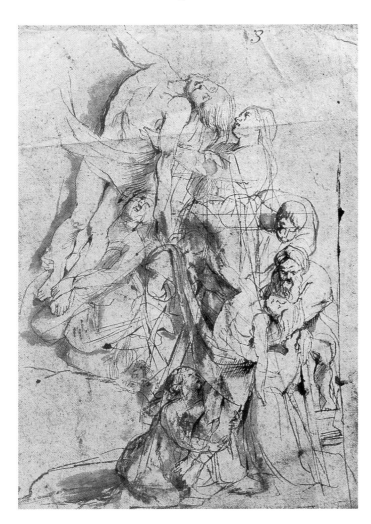

Rubens, *The Descent from the Cross*.
Drawing. Mr. and Mrs. E. V. Thaw collection, New York.

ened, almost erect — it is a stiffened corpse with heavy, hardened legs.

Christ's face is turned upwards. And it is this inspired face rather than the body that forms the iconographic, compositional and moral focus of the picture. Jesus is shown among the people, his face is surrounded, in a star-like fashion, by hands stretched out to him and eyes riveted on his face, for in death he is a source of inspiration for the living. It is not so much the drama and dynamism of the situation as this idea that overrides the artist's attention, and quite in keeping with this is the fact that the present composition has a greater conventional and ritualistic quality in the depiction of the hands than the Antwerp prototype, since the motion of the hands that support rather than carry the body is purely formal. The Hermitage version of *The Descent from the Cross* displays a novel and original approach to the theme, expressed in terms exceedingly concise and yet broadly philosophical. The austere rigidity of the design held together by the main elements of the picture's moral and formal content and the somewhat restrained expression of sentiments correspond to a mature phase in the "Classical" trend of Rubens' work, i.e. the mid-1610s, to which period the painting has been assigned until recently.

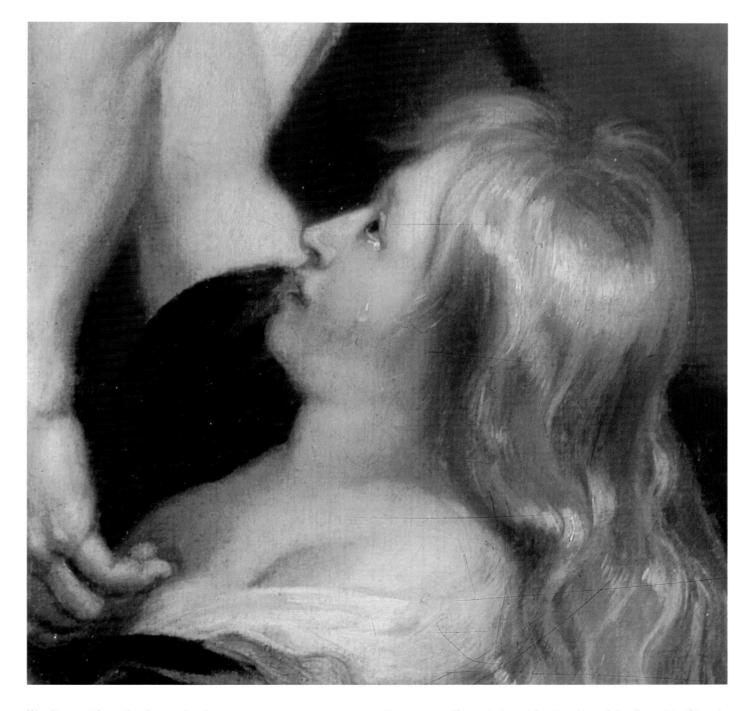

The Descent from the Cross, detail.
The Hermitage, St. Petersburg.

But the broad handling and the plasticity with which the figures, and especially their faces, are painted indicate a transition to the artist's next period and hence a date around 1618. This is compatible with the dating of the drawing in the Thaw collection in New York. Moreover, the expression of Christ's face and its execution show affinity with the face in the picture *Le Christ à la paille* (Koninklijk Museum voor Schone Kunsten, Antwerp), which is documented as dating from 1617-1618 (and in which Van Dyck participated).

Provenance: Commissioned for the altar of the Capuchin Church at Lierre near Antwerp (Michel 1771), where it remained until the end of the eighteenth century. During the invasion of Belgium by the French in 1794 it was hidden by the monks (Grimbergen 1840). Afterwards it appeared in the collection of Empress Josephine in her Malmaison Castle (according to some sources it had been presented to her by the town of Bruges — see Livret 1838). Purchased for the Hermitage as part of that collection in 1814.

Preliminary works: 1) A sheet with drawn sketches (formerly in the Wrangham collection in England, now in the E. V. Thaw collection, New York); pen and brown ink with wash, 34.5 x 23.3 cm. 2) Drawing, Museum of Fine Arts, Boston; pen and ink, 35.7 x 21.6 cm.

The Main prototype: Rubens, *The Descent from the Cross*, 1612-1614, Antwerp Cathedral; oil on wood, 240 x 310 cm.

14. *THE UNION OF EARTH AND WATER (THE SCHELDT AND ANTWERP)*

Ca. 1618.
Oil on canvas. 222.5 x 180.5 cm.
The Hermitage, St. Petersburg. Inv. No. 464.

The earliest surviving reliable reference to this painting is in Michel's book of 1771, where it is described as an allegoric representation of the Tiber River. Later on, only Smith (1830) retained this title. All other writers on Rubens, up to Waagen (1864), called the picture *The Tigris River and Abundance*. The change of name seems to have been a slip of the pen — in the 1797 manuscript catalogue of the Hermitage collection the third Russian letter in the name of the river was erroneously altered (*Tiger* instead of *Tiber*). Rooses (1890), following C.G. Voorhelm-Schneevoogt's catalogue of 1873, made an addition to the title: *The Tigris River and Abundance: Neptune and Cybele, or The Union of Earth and Water*. The composition had already been given the title *The Union of Earth and Water* in the caption to Vangelisti's engraving which was produced no later than 1775. The

Cybele (whose other attributes are tigers or lions — see G. de Tervarent, *Attributs et symboles dans l'art profane...*, Geneva, 1958, pp. 129-130, 246). The urn with pouring water is not only a symbol of Neptune, but of the river god as well. A group with Neptune holding a trident and Amphitrite with a horn of plenty, which is flanked by tritons blowing their shells and urns with pouring water, is shown in the oil sketch *Mercury Departing* for a decorative portico to be erected on the occasion of the ceremonial entry into Antwerp of the new Governor in 1635 (No. 36); in this case Antwerp and its sea trade were undoubtedly implied. Similar images symbolizing the prosperity of Antwerp as a sea port had repeatedly recurred in the decorations to greet other new Governors arriving in Antwerp (see No. 36).

The allegoric theme of the beneficent union of the two elements, i.e. of the dependence of Antwerp for its prosperity on the use of the Scheldt river, became particularly momentous after the signing in 1609 of a twelve-year armistice with Holland when hopes were revived that the Dutch blockade of the Scheldt estuary could be lifted. Abraham Janssens' allegory *The*

The God of the Scheldt River, Cibel and the Godess of Antwerp.
Rubens. Museum of Western and Eastern Art, Kiev, Ukrainia.

Rubens. *Four Parts of the World.*
Kunsthistorisches Museum, Vienna.

present name has become firmly established as the subject is undoubtedly allegorical. In a handwritten note by Schmidt, in French (on the margin of page 168 of the Hermitage copy of Rooses' book of 1890), it is appropriately remarked concerning the mauercrone over Cybele's head in Pieter de Iode's engraving, that the crown of towers must symbolize Antwerp. Thus the "sea god" may in fact represent the Scheldt.

The crown of towers and the cornucopia may equally well symbolize goddesses patronizing towns (Tyche) and the goddess of Earth, the great mother-goddess

Scheldt and Antwerp (Koninklijk Museum voor Schone Kunsten, Antwerp), which is iconographically close to the present Hermitage picture, was commissioned precisely in 1609 for the auditorium of the Town Hall in Antwerp. The nearest thematic and iconographic analogues of the Hermitage sketch among Rubens' works are the sketch *The God of the Scheldt River, Cybele and the Goddess of Antwerp,* or more precisely, *The Scheldt, Antwerp and a Nymph with Gifts of Earth* (Museum of Western and Eastern Art, Kiev), the pictures *Neptune and Amphitrite* (or *The*

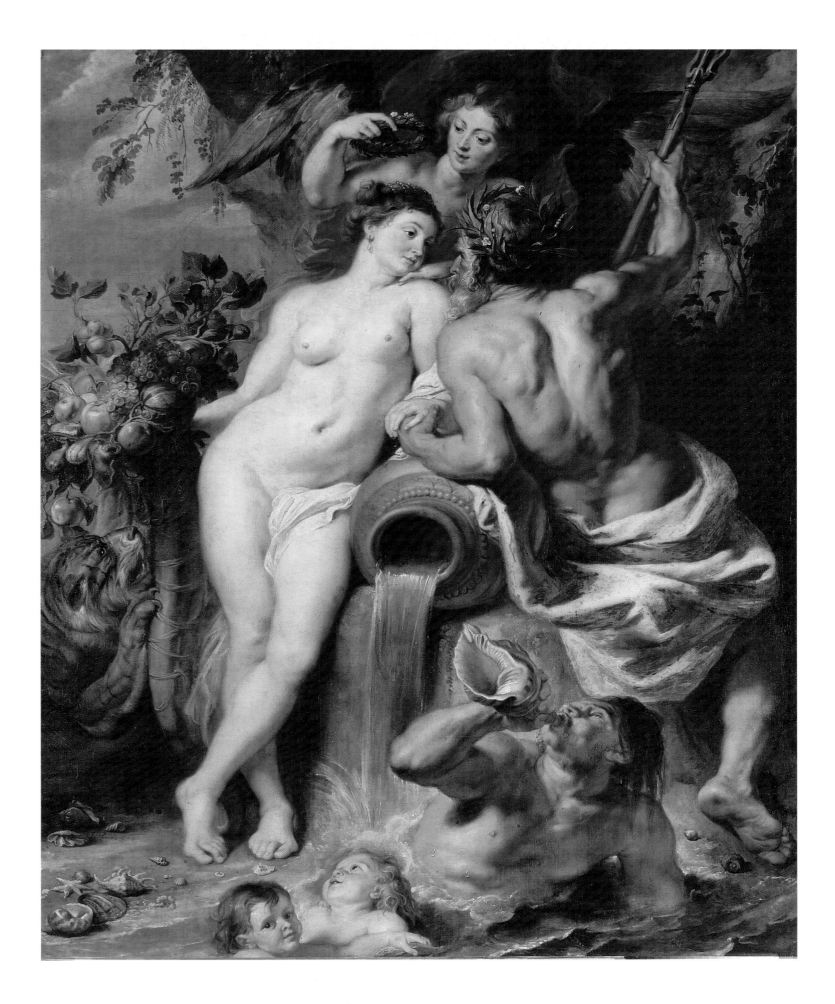

Ocean and Thetis — formerly in the Kaiser-Friedrich Museum, Berlin; destroyed in World War II) and the *Four Parts of the World* (Kunsthistorisches Museum, Vienna). The present sketch is authentic, except for the cornucopia and the tiger. It is possible also that the *putti* in the foreground are not Rubens'.

Cybele seems to be modelled on the statue of *Resting Satyr* by Praxiteles (Vatican, Rome). The posture of Cybele, as Held pointed out (Held 1980, p. 326), standing as she does with her legs crossed and leaning on a support, in this case a vessel with water, is reminiscent also of Peitho's figure from the frieze-painting known as *Aldobrandini Wedding* (late first century A.D., Vatican, Rome). This posture of a female figure in a state of repose and relaxation occurs fairly frequently in Rubens' work. Notably, in the artist's early picture *Adam and Eve, or The Fall* (Rubenshuis, Antwerp — see Baudouin, 1972, pp. 32-37, pl. 5), the pose of Eve is derived from a composition by Raphael which Rubens knew from Marcantonio Raimondi (see M. Jaffé, "Rubens and Raphael," *Studies in Renaissance and Baroque Art Presented to Anthony Blunt,* London, 1967, p. 98).

For the figure of Neptune, Rubens may have used his drawing *Studies of the River God* (Museum of Fine Arts, Boston; black chalk, 41.4 x 24 cm), which Held (1959) dated *ca.* 1612-1615 and related to the paintings *Four Parts of the World* (Kunsthistorisches Museum, Vienna) and *Neptune and Amphitrite* (1614-1615, formerly in the Kaiser-Friedrich Museum, Berlin).

Some distinctive features of style evidence a transition in the present sketch from the "Classicist" austerity of the 1610s to the freedom and dynamism of the '20s: the painting has a balanced composition with a pyramid-like structure in the foreground and the artist's interest in the fashioning of plastic forms by means of line is combined with a desire to extend the compositional movement beyond the picture plane. The powerful effect created by the light local colours of the central group is matched by a broad and free handling. The picture evidently dates from around 1618.

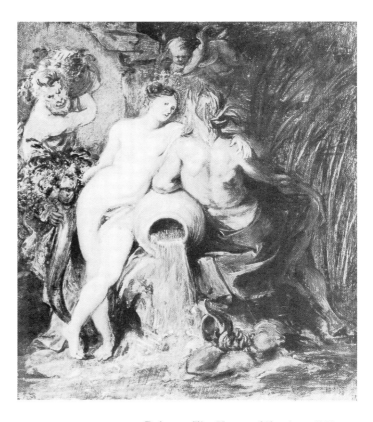

Rubens. *The Union of Earth and Water.*
Fitzwilliam Museum, Cambridge.

Provenance: In the eighteenth century, in the Chigi collection in Rome; an old inventory of the Hermitage reads: "The present picture comes from the collection of Prince Chigi..." It is thus identified with the picture mentioned by Michel in 1771. Purchased for the Hermitage between 1798 and 1800.

Preliminary works: A sketch in the Fitzwilliam Museum in Cambridge, England, No. 267, oil on wood, 34.5 x 30 cm (no *putti* and no tiger, in whose place there is a satyr with gifts of Earth; instead of the female figure crowning Neptune and Cybele there is a flying cupid); originally in the Crozat collection, sold in 1751 (see Rooses 1886-1892, III, No. 685; Jaffé 1960).

Prints: By Pieter de Iode II (1606-*ca.* 1674) (V.-S. 1873, No. 30), with certain modifications: the tiger and the *putti* are absent, Cybele has a crown of towers over her head.

The Union of Earth and Water, detail. ▶
The Hermitage, St. Petersburg.

A. Janssens. *The Scheldt and Antwerp.*
Koninklijk Musem voor Schone Kunsten, Antwerp.

15. *FEAST IN THE HOUSE OF SIMON THE PHARISEE*

1620 (?).
Oil on canvas. 189 x 254.5 cm.
Transferred from wood by A. Mitrokhin in 1821.
The Hermitage, St. Petersburg. Inv. No. 479.

The subject is derived from the Gospel according to St. Luke 7: 36-38. The picture centres upon Christ's conflict with the Pharisees: in response to rebukes for leniency to the sinner, who is usually identified with Mary Magdalene, Christ says: "Her sins, which are many, are forgiven; for she loved much."

The content of this painting fully accords with the inscription on the drawing *Superbia* by Pieter Brueghel the Elder (1555, the Fritz Lugt collection, Paris) which reads: "God hates pride more than anything else. But pride too is hostile to God." The conflict of Good and Evil, of Virtue and Vice, is expressed in the picture even in the still-life details — there is a bowl of fruit in front of Christ containing apples and grapes which, in combination, signify the Fall and the Redemption, while the dish carried above the Pharisees' heads con-

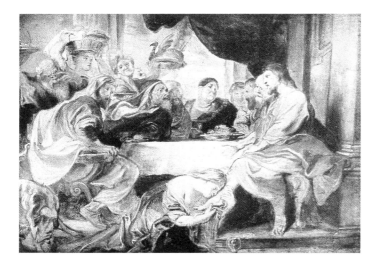

Rubens. *Feast in the House of Simon the Pharisee.*
Sketch. Akademie der Bildenden Künste, Vienna.

tains a peacock pie, a symbol of pride. The dog with a bone in its teeth probably stands for greed. The tasselled prayer-shawl worn by Simon the Pharisee and the philactery on his forehead are an allusion to Christ's words denouncing the hypocrisy of the Pharisees, their inner impurity and ostentatious piety (Matthew 23: 5). The spectacles on the nose of the Pharisee seated behind Simon hint at the shortsightedness of the Pharisees who were "blind guides" (Matthew 15: 14; 23: 16, 19, 24, 26). Spectacles were a popular symbol of blindness, disbelief and mendacity

in Netherlandish art. In the seventeenth century this picture was acclaimed as one of the greatest works by Rubens (Roger de Piles 1681). Waagen (1864) believed that the artist was responsible for the entire painting. But in 1888 Rooses described it as painted by Rubens' pupils after his sketch and only touched up by the master. In 1902 Somov also made reference to the participation of the pupils, especially of Anthonis van Dyck. In 1906, however, W. von Bode doubted Van Dyck's participation (W. von Bode, *Rembrandt und seine Zeitgenossen,* Leipzig, 1906), which he reiterated in 1921.

Schmidt was right when he wrote of the Hermitage painting: "This is a product of Rubens' studio, of a vastly varying character and quality. Christ is very well done: soft colours, except his right hand... the fused texture, the hair painted with light strokes, the heavy masses of the clothes, well modelled... the seriously restored Magdalene (face) is similarly treated. Christ's right arm and the four next heads in broad manner, the red flesh tints, the thorough treatment of hair — by Van Dyck? The four figures on the left are much inferior: the mannerist, rigid lines, the harsh colours; the right arm and the face of the spectacled old man are crooked; the red one on the right is very bad. The dog [one word illegible] is by Snyders? The still life is too bad to be by him." (Schmidt's handwritten note in German in the Hermitage Archives, XVI-A, No. 9). The picture was indeed executed in Rubens' workshop after the master's sketch which is now in the Gemäldegalerie, Akademie der Bildenden Künste, Vienna. The sketch gives not only the general design of the picture, but also the characterization of nearly all the figures the Hermitage picture contains. Nevertheless, the heads of the three Apostles shown on Christ's right are different from those in the sketch. The heads are reminiscent of the following authentic studies by Van Dyck: 1) an *en face* in the Gemäldegalerie, Berlin-Dahlem; 2) a lowered head, with a kerchief — in the Staatsgalerie, Augsburg (see Glück 1918, p. 302). Evidently Rubens entrusted a detailed portrayal of these characters in the composition he had conceived to "the best" of his pupils, as he refers in his letter of 28 April 1618 (*CDR* 1887-1909, II), to Van Dyck. These heads were most certainly painted by Van Dyck in the picture itself (this is evidenced by a complete identity of handling with the *Doubting Thomas* in the Hermitage, inv. No. 542). He may also have painted (after the Vienna sketch by Rubens) the head of the fat man wearing a cap. It should be observed that the execution of the servants in the background is even less adequate than that of the Pharisees' figures, whose

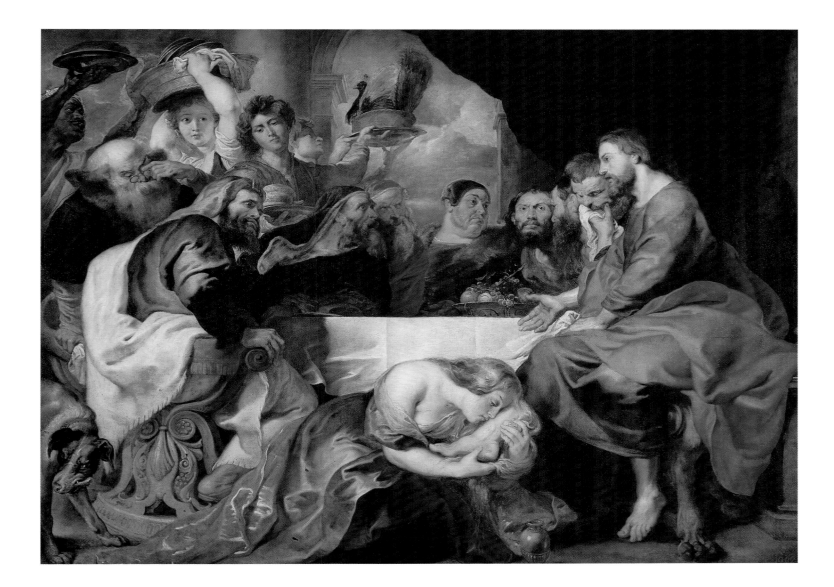

Feast in the House of Simon the Pharisee.
The Hermitage, St. Petersburg.

inferiority was noted by Schmidt; the movements of their hands are not sufficiently defined, as is the case with the youth who is taking the dish with the peacock with an awkwardly twisted hand. But the general aspect of these figures, except for the young girl with a basket on her head, coincides with the sketch.

The Negro's head (which did not appear in the Vienna sketch) is traceable to Rubens' study called *Head of a Negro* (Musées Royaux des Beaux-Arts de Belgique, Brussels). Rubens used the same model for another *Head of a Negro* study, now kept in the Hyde collection, Glens Falls, New York (see Goris & Held 1947, No. 30, p. 17). It would be possible to establish the authorship of the Hermitage Negro's head only after the final attribution of the Brussels study. Its previous attribution to Rubens was rejected by Bode ("Kritik und Chronologie der Gemälde von P. P. Rubens", *Zeitschrift für bildende Kunst*, 1905, p. 200), who ascribed it to Van Dyck, which was not, however, generally accepted. In 1968 Müller-Hofstede again referred to the Brussels study as a work by Rubens (J. Müller-Hofstede, "Zur Kopfstudie im Werk von Rubens", *Wallraf-Richartz- Jahrburch*, 1968, p. 247). His opinion seems to be the most correct one. Held included the Brussels piece into his catalogue of Rubens' oil sketches (Held 1980, Cat. No. 441, pp. 607-609).

Hymans (1883) and later Haberditzl (1908) pointed out a connection between the present picture and the composition on the same subject in the Jesuit Abbey (now the Town Hall) in Bergues St. Winnocq near-Dunkirk, France (oil on canvas, 240 x 240 cm, considerably enlarged on all sides at a later date, the original background painted out). The two pictures are quite similar in composition (but inverted), in the general appearance and even in the poses of some characters (Magdalene, the spectacled old man, the beardless man in a cap in the centre and the young man with a dish), and finally, in the architectural setting with an arch and drapings. Their complete similarity becomes clear when comparing the Hermitage painting with the copies of the Jesuit Abbey piece which are kept in the New York Antiquariat (Müller-Hofstede 1962), the Gemäldegalerie, Kassel, West Germany (reproduced either by Theodor van Thulden or by Pieter van Mol) and the Church of St. Martin, Idstein, West Germany (reproduced by Michael Angelo Immenraet). They seem to represent two approaches to the same composition: a static Romanesque pattern (Town Hall, Bergues St. Winnocq) and a dramatic Baroque treatment (Hermitage, St. Petersburg).

The composition in Bergues St. Winnocq was formerly ascribed to Otto Vaenius, Rubens' teacher (J. B. Des-

camps, *Voyage pittoresque de Flandre et de Brabant*, Paris, 1769, p. 325). In 1962 Müller-Hofstede defined it as an early work by Rubens himself, produced before the artist went to Italy, i.e. *ca.* 1594-1595. Whether his attribution is correct can be adjudged only as part of the whole problem of Rubens' immature work during his pupilage.

The Hermitage canvas seems to be painted after the fashion of Veronese's pictures showing sumptuous feasts and devoted to the same or similar subjects from the Gospels (such as *Feast in the House of Simon the Pharisee*, Galleria Sabaunda, Turin; *Feast at Cana in Galilee*, Louvre, Paris; *Feast in Levi's House*, Galleria dell'Accademia, Venice). Veronese's concept was enriched with the motif of turbulent encounters which Rubens had elaborated in a number of hunt and battle scenes dating between 1615 and 1620 (see No. 17). The dynamic design of the Hermitage picture — an open oval with its centre displaced to the right — based on movement that emerged outside the bounds of the frame, is a manifestation of the new characteristic trends of the artist's work in the 1620s. At the same time, the decorative diversity of local colours in patches is still connected with his predilections of the preceding period.

Several faces in the Hermitage painting are reminiscent of those that occurred both in the artist's earlier and later works. The picture must have been produced during a transitional period, not later than 1620, when Van Dyck was active in Rubens' workshop.

Provenance: In 1681 the picture was in the collection of le Duc de Richelieu in Paris (Roger de Piles 1681), then in the collection of le Comte de Morville, whose heirs sold it for 15,000 livres to R. Walpole in 1732 (Mariette 1854). Purchased for the Hermitage from the Walpole collection in Houghton Hall, England, in 1779.

Preliminary works: 1) Rubens, *Feast in the House of Simon the Pharisee*, sketch, Gemäldegalerie, Akademie der Bildenden Künste, Vienna, inv. No. 648; oil on wood, 31.5 x 41.5 cm. 2) Van Dyck, *Head of an Apostle*, study, Gemäldegalerie, Berlin-Dahlem, inv. No. 798 F; oil on wood, 61 x 49 cm. 3) Van Dyck, *Head of an Apostle*, study, Staatsgalerie, Augsburg, No. 1248; oil on paper mounted on wood, 57 x 41 cm.

Prints: 1) By Michael Natalis (1611-1668) (V.-S. 1873, No. 150); inscribed: *Acceptat Dominus Pharissaeae*; the Bibliothèque Nationale in Paris has a copy of the print with Rubens' corrections and additions on both sides (see Mariette 1854). 2) By Willem Panneels (1600-after 1632) (V.-S. 1873, No. 151), with alterations: the Negro and the young girl with a basket are not included. 3) By Pietro Monaco (active in Venice between 1735 and 1775) (V.-S. 1873, No. 153); signed *Pietro Monaco del. scol. e forma in Venezia*. 4) By François Ragot (1658-1716), twice (V.-S. 1873, Nos. 155-156). 5) By Richards Earlom (1742/43-1822) (V.-S. 1873, No. 154); in 1777 for the Walpole Set of 1788. 6-9) By anonymous masters, four times.

Feast in the House of Simon the Pharisee, detail.
The Hermitage, St. Petersburg.

16. *THE CARTERS*

Ca. 1620.
Oil on canvas. 86 x 126.5 cm.
Transferred from wood by A. Mitrokhin in 1823.
Originally painted on a composite board. Traces of cementation: vertical, about 15 cm off the right edge, top to bottom; about 14 cm off the upper edge, from the added piece on the right over the whole width; about 8 cm off the left edge from the upper added piece to the bottom; at the bottom, between the added side pieces, 7 cm off the lower edge; in the middle, horizontally throughout the canvas, including the added pieces (evidently the side additions consisted of two parts each). Microscopic examination shows that what is painted on all the added pieces is undoubtedly authentic.
The Hermitage, St. Petersburg. Inv. No. 480

There is no doubt that the picture was executed by Rubens himself. The distinctive stylistic features of the picture (its composition with the horizon high, pervaded with contrasting motifs and dynamic forms, the dramatic tension underlined by the staffage, and the heavily impasted deep local colours) give grounds for including the picture in the group of the artist's early landscapes of about 1620. The carriage derives from Rubens' drawing *Farmyard with a Farmer and a Carriage (ca.* 1615-1617, formerly in the collection of the Duke of Devonshire, Chatsworth, England; black and red chalk, touch-ed with white, yellow and green paint, 25.5 x 41.5 cm). Glück (1945) was of the opinion that Rubens had used for the present painting his drawing *A Dry Willow (ca.* 1620, British Museum, London; black chalk, 39.2 x 26.4 cm), with certain modifications (Held 1959, I, p. 146).

Provenance: Until recently the picture was thought to have come from the Everard Jabach collection, which was sold in 1696. The inventory of the Jabach collection, however, did not list anything resembling the present picture (Grossmann 1951; also Vicomte de Grouchy, *Everard Jabach, collectionneur Parisien...*, 1894, pp 33-76). According to Grossmann's hypothesis (1951), in the seventeenth century the picture was in the collection of Cardinal Masarini in Paris, in the inventory of which made in 1661 a picture is listed under No. 1286, described as follows: *Un paysage faict par Rubens, au milieu duquel est un chariot qui tombe, avec quelques figures; haut de deux piedz huict poelces, large de trois piedz unze poulces; prisé la somme de six cents livres* ("Landscape produced by Rubens, with a falling carriage in the middle, with several figures; 2 feet 8 inches high, 3 feet 11 inches wide [87 x 127.5 cm] if the so-called *pied du roi*, the Parisian foot, was used assessed at 600 livres" — see Cosnac 1884). It is not ruled out, however, that this note refers to a version other than the present painting. It is certain (*Aedes Walpolianae* 1752) that the Hermitage picture was in the Cadogan collection sold in London on 14 February 1726. It is quite plausible that it was precisely this picture that had been sold for 1,000 florins in the sale of the Potter collection in the Hague in 1723 (Hoet & Terwesten 1752-1770, I). But Descamps cannot have seen it round 1753 in the Lassay collection in Paris (J. B. Descamps, *La vie des peintres flamands, allemands et hollandais*, vol. I, Paris, 1753, p. 316) and it cannot have figured in the sale of le Comte de Guiche at 5,050 florins (Somov 1902) because even before 1735 it was in the Walpole collection in England (according to the hand-written catalogue of Houghton Hall in the Cholmondely collection), as part of which it was purchased for the Hermitage in 1779.

Versions: Gregory Martin (1968) maintains that soon after the present Hermitage picture Rubens produced its version (non-extant), after which Lucas van Uden (1595-1672) made an etching called *Carters Pushing a Carriage Across a Ford*.

Prints: 1) By Schelte a Bolswert (*ca.* 1586-1659) (V.-S. 1873, No. 233), the composition identical with the picture. 2-4) By anonymous engravers, with only the names of the publishers specified: a) by Cornelis Galle I and Cornelis de Bout; b) by Gillis Hendrix; c) by Fischer, with different staffage — two she-bears tearing the boys who jeered at Elisha (II Kings, 2: 23-24). 5) By John Brown, 1776, under the title *Charette embourbée* for the Walpole *Set* of 1788. 6) By S. W. Reynolds.

◀ Schelte A Bolswert. *The Carters*.
Engraving after Rubens.

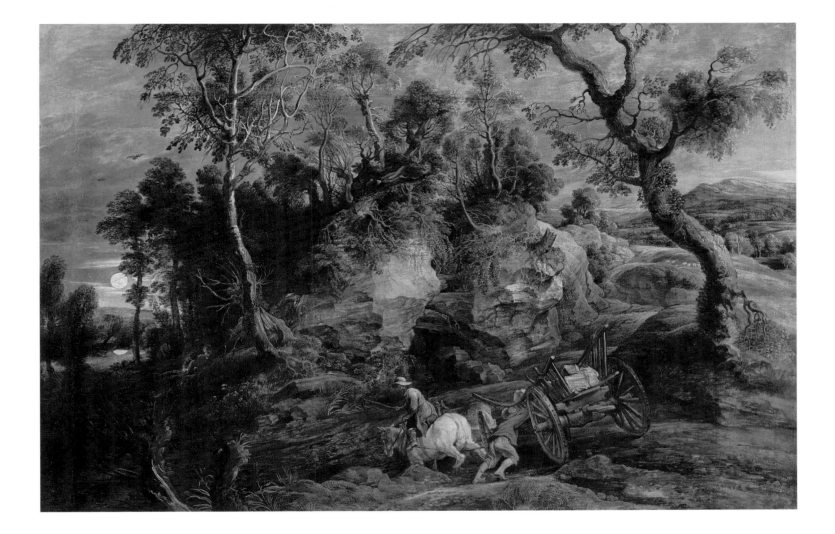

◀ Rubens. *A Dry Willow*.
Drawing. British Museum, London.

The Carters.
The Hermitage, St. Petersburg.

The Carters.
The Hermitage, St. Petersburg.

17. *LION HUNT*

Ca. 1621.
Oil on oakwood. 43 x 64 cm.
The Hermitage, St. Petersburg. Inv. No. 515.

In the period between 1615 and 1621 Rubens repeatedly turned to the subject of hunts, working at this concurrently with war and battle themes. A prominent place among these was occupied by *Lion Hunt* compositions (for further detail see Rosand 1969). Rubens' approach was undoubtedly influenced by Leonardo da Vinci's cartoon *The Battle of Anghiari*; Rubens' sketch (Louvre, Paris) of this non-extant masterpiece by Leonardo is the main source of what is known to us about it (see Held 1959, I. pp. 157-159, No. 161). The present piece is an authentic oil sketch for the *Lion Hunt* housed in the Alte Pinakothek in Munich. Until recently the Munich picture had been identified with that painted for Duke Maximilian of Bavaria which Rubens mentioned in his letter to Carleton on April 28, 1618 (*CDR* 1887-1909, II). However, in 1950 Burckhardt wrote that the Duke Maximilian painting had once been kept at the castle of Schleissheim, where Sandrart saw it (*J. von Sandrarts Academie der Bau-, Bild- und Malerey-Künste von 1675...*, hrsg. von A. R. Peltzer, Munich, 1925, p. 159), later taken away by Napoleon and transferred to Bordeaux, where it perished in the fire of 1870.
In 1969 Rosand showed convincingly that the Munich

Rubens, *Lion Hunt*.
Alte Pinakothek, Munich.

picture ought to be identified as that executed for Lord John Digby, the British Envoy of Brussels, as intimated by Rubens in his letter to William Trumbull dated 13 September 1621: "I have nearly completed a large piece, painted all by myself and, in my opinion, one of my best works representing a lion hunt, with

figures as large as in life" (*CDR* 1887-1909, II). Consequently, this Hermitage sketch also dates from *ca*. 1621.
The Munich *Lion Hunt* belongs to the second, more mature stage of Rubens' work at the theme of hunts and battles. After 1618 the artist progressed from closed compositions with a group of figures dominating to more dynamic scenes in which figures were part of the setting.
Rosand mentions a sheet of sketches for the *Lion Hunt* composition from the British Museum (Hind 1923, No. 1) as the earliest stage in Rubens' work on the Munich picture. He admits, though, that in those sketches Rubens mainly varied the motifs of the Duke Maximilian painting (completed before 1618). The latter is known by its replica executed for Carleton (now in the Spencer-Churchill collection, Northwick Park, England). In fact the initial sketch for the Munich composition was a drawing from the collection of Count Seilern in London.
Held (1959) and Rosand (1969) appropriately determined the place of the present sketch in the evolution of the concept of the Munich picture as an intermediate link between a drawing in the Count Seilern collection in London and a sketch in the Cholmondely collection in Houghton Hall, England. But this is not all. The Hermitage oil sketch occupies a special place in the evolution of the artist's general approach to violent scenes, which has so far been mostly overlooked by art scholars.
The barely discernible drawn sketch in the Count Seilern collection, with indications of almost every detail, outlines just that compositional line which was subsequently realized in the painting. The sketch in the Cholmondely collection is the next step in the evolution of the composition from the sketch — it has in fact all the elements of the final version in almost the same proportions as in the picture.
Thus the present oil sketch seems to reflect Rubens' attempt, after the first test of the pen, so to speak, in the Seilern collection drawing, to try and find a more dynamic solution. The general character of the composition is retained in the Hermitage oil sketch, but the entire central part is presented in a different fashion. The action was made more involved and extended spatially.
The rider on the white horse does not slip sideways, but is thrown back, for the lion attacks him from the right instead of left. Haberditzl (1912) draws attention to the fact that Rubens made use of the antique group *Lion Attacking a Horse* (Palazzo dei Conservatori, Rome), which had once also attracted Michelangelo.

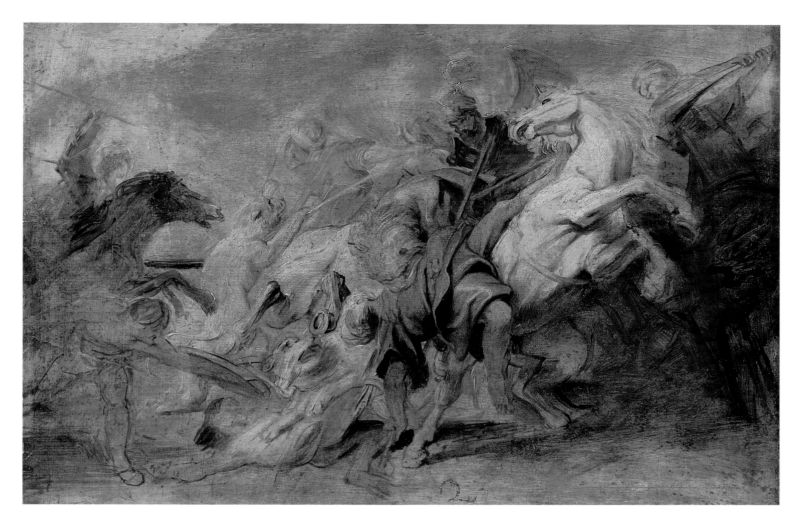

Lion Hunt.
The Hermitage, St. Petersburg.

Owing to this, the rider raising his sword to the lion loses prominence, receding, literally, into the background. A new role is played also by the horseman riding away — turning left, he is defending himself from a lioness introduced in the composition. The prostrate posture of the warrior on the ground, who is enfeebled by the struggle with the other lion, is very close to that of Saul in the Berlin *Conversion of Saul* (1616-1618).

What is retained from the Seilern drawing is the figure of a riding horseman cut off by the edge of the picture. The right-hand rider's hands with a lance (the figure appears in all the versions and even twice in the Seilern drawing) emphasize the diagonal movement dominating the composition and extending, as it were, beyond the frame.

The Hermitage version is the most dynamic of all hunts by Rubens. But this approach must have been seen by Rubens as violating the balance of design and concentration of action indispensable in a large decorative picture and he returned to the design outlined in the Seilern drawing.

In 1958 Aust erroneously considered the Hermitage sketch to be the first version of the composition and the Seilern drawing, an intermediate link between the Hermitage and Cholmondely pieces. That is why his assertion that dynamism and concentration invariably decreased in the course of Rubens' work on a composition cannot be wholly applied to the Munich picture.

Provenance: Purchased for the Hermitage from the Crozat collection in Paris in 1772.

Versions: 1) *Lion Hunt*, drawing (with *Diana's Bath* on the reverse), the Count Seilern collection, London; red and black chalk, 21.1 x 50.9 cm. 2) *Lion Hunt*, sketch (*The Wedding of Marie de' Medici* on the reverse), the Cholmondely collection, Houghton Hall, England; oil on wood, 50 x 44 cm.

Final Version: The picture *Lion Hunt*, Alte Pinakothek, Munich, No. 602/734; oil on canvas, 246 x 374 cm; engraved by Schelte a Bolswert, in the same direction.

Following page:
Lion Hunt, detail.
The Hermitage, St. Petersburg.

83

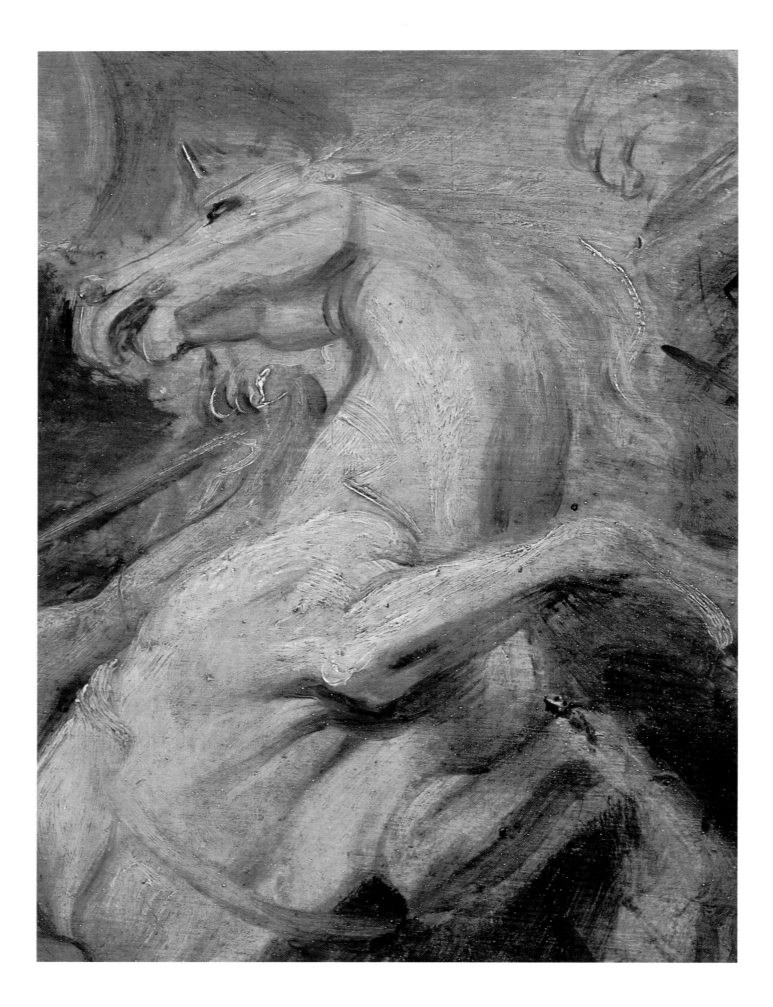

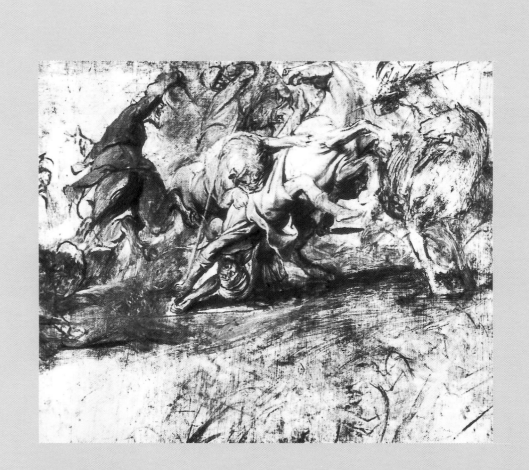

Rubens. *Lion Hunt*.
Sketch. Cholmondely collection, Houghton Hall, England.

Rubens. *Lion Hunt*.
Drawing. A. Seilern collection, London.

18. PORTRAIT OF CHARLES DE LONGUEVAL

1621.
Oil on oakwood, 62 x 50 cm.
The half-length portrait in the medallion is in colour, the figured border is in grisaille. On the oval of the portrait are two inscriptions, evidently impressed ones. The one on the right carries the name and date: *Rubens fecit et pinxit A° 1621* — in block letters; infra-red examination and particularly macrography show that the inscription was made when the paint was still soft (the signature was discovered in the course of the preparation of *The Hermitage Catalogue* of 1958). On the left there is an inscription consisting of ten lines forming a couplet in Flemish: *Dit cost / mij door't / quaet vonnis / sor <gh?> en noot veel nachten / wacken en / ongerust / heyt / groot / [VL]* (this cost me, because of the wicked verdict, worry and vexations, many nights of waking and great aggravation; VL is the monogram of the engraver Lucas Vorsterman — see below). The latter inscription was by a different hand, probably made with a sharp tool, in a barely legible cursory handwriting over a surface with a slightly different lay-in, probably because of *pentimenti*. The inscription was deciphered by Held in 1966 (in *The Hermitage Catalogue* of 1958 it was referred to as "an illegible, half-effaced inscription in Flemish"). The left upper corner, presumably enlarged, protrudes by 1.5 cm by comparison with the lower end.
The Hermitage, St. Petersburg. Inv. No. 508.

Charles Bonaventure de Longueval, Comte de Bucquoy (1561-1621), is a representative of Belgium's topmost aristocracy, the Governor of the Province of Hainaut, commander of artillery in the Spanish army, and Ferdinand II's military leader who won several battles in 1620. He was killed during the siege of the Ersekujvar (Neuhäusel) Fortress in Hungary on 10 July 1621 (Muuls 1966, p. 291).

This is a sketch for an engraving issued to commemorate the eminent soldier of the Thirty Years' War whose glories were the pride of his countrymen. The sitter is shown with a commander's sash across his armour, a marshal's baton in his hand and the Order of the Golden Fleece round his neck. In the lower part of the border on the altar some space is left for a commemorative inscription

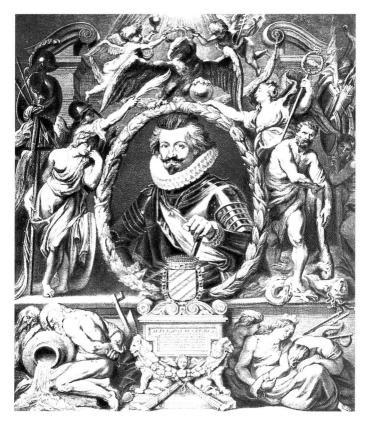

Lucas Vosterman. *Portrait of Charles de Longueval.*
Engraving after Rubens.

and an escutcheon for a family crest over the altar. The border is of allegoric character; it is a symbolic expression of the idea of peace and unification as the main objective of military victories. The emphasis on this idea was particularly characteristic of Rubens at the time when the twelve-year truce ended in 1621 and hostilities against Holland were resumed and were at first favourable for Spain.

Two lowered and crossed torches are shown resting against the altar. They symbolize mourning. On the left and right of the altar shackled male and female figures appear, symbolizing the captured rivers (as there is an urn with pouring water between them) and towns (as one of them is wearing a crown of towers). On either side of the oval portrait there is a garland of laurel and oak leaves, which symbolizes outstanding military and civilian services. Within the right-hand garland Heracles personifying Strength is shown with a club in his hand, trampling the figure of Discord, with snakes instead of hair, and the seven-headed hydra of Envy (or Enmity). Next to him stands Victory with a trophy; behind him is the winged figure of Accord with a badge representing a handshake; Accord gives the orb to the imperial eagle. The genii of the church and religion with a cross and a cup are crowning him with laurels. Within the left-hand garland Security (according to Rooses 1886-1892, IV) or Victory (according to Hymans 1893) laments the death of her protector and behind her, winged Victory (war-goddess Bellona according to Rooses) hands the palm to the eagle.

The allegory of these characters is part of the symbolic system current in Europe in the epoch of the High Renaissance. It was vividly expounded in such widely used, frequently translated and published books with illustrations as Andrea Alciati's *Emblemata* (1st ed., 1531), Vincenzo Cartari's *Imagini degli Dei degli Antichi* (1st ed., 1556), Pierio Valeriano's *Hierogliyphica* (1st ed.,

1575) or Cesare Ripa's *Iconologia* (1st ed., 1593). This portrait of Longueval in an allegorical setting should be considered in conjunction with the numerous title-pages designed by Rubens for the Plantin Press between 1611 and 1638, in which the gist of the book found expression in much the same symbolic and ornamental forms.

Before the discovery of the signature and date the present portrait was dated on the grounds of the moment of Longueval's death and of the reference to the order received by Rubens made in a letter by Rev. Canon Robert Schilders to Peiresc of 19 August 1621: "Monsieur Rubens received an order to produce an emblematic drawing to be engraved with the portrait of the deceased and a eulogy of him..." (*CDR* 1887-1909, II).

Provenance: It has not been possible to establish who ordered the portrait. Possibly it was commissioned by Longueval's son — Charles Albert de Longueval (d. 1663). Purchased for the Hermitage from the Cobenzl collection in Brussels in 1768.

Prints: By Lucas Vorsterman (1595-1675) (V.-S. 1873, p. 170, No. 257), with Longueval's arms and an inscription: *Carolus de Longueval / Eques Velleris aurei / comes de Bucquoy, Caesarei Exercitus Archistrategus / Tormentorum Bellicorum / In Belgio praefectus, comit. Hannoniae gubernator*, etc. (Charles de Longueval, Knight of the Golden Fleece, Comte de Bucquoy, Commander of the Emperor's Army, Artillery Commander in Belgium, Governor of the Province of Hainaut, etc.). Also inscribed below: *P. P. Rubens invent. — Cum privilegiis. — Lucas Vorsterman sculp. et exud.*

Preliminary Drawing: Half-length portrait of Longueval, British Museum, London, No. 5227-3; pen and sepia, 24 x 19.2 cm; signed with Lucas Vorsterman's monogram: [*VL.*] *feci* [t]; inscribed: *Escell. D. Carolus de Longueval Comes de Bucquoy et Grats. Caes. Majtis Prefectus Generalis* (His Excellency Charles de Longueval, Comte de Bucquoy et Gratsen, Imperial Commander-in-Chief). The drawing was done no earlier than 1620 when Longueval became the owner of Gratsen in Moravia (Muuls 1966, p. 288).

Hymans (1893) defined it as "an original drawing by Vorsterman"; Rooses (1886-1892, III) wrote that "it was used as a model by Rubens"; Hind (1923) and Held (1969, 1980) considered it drawn after a work by Rubens.

In 1893 Hymans pointed out that there was a very rare appendix ("annexe des plus rares") to Vorsterman's engraving: an elegy consisting of twelve lines arranged in three columns (the text was not cited), with a dedication by Vorsterman to the model's son: *Illustrissimo et generosissimo Domino D. Alberto de Longueval, et. hanc fortissimi heu! quondam parentis ad vivum expressam effigiem dedicabat Lucas Vorsterman sculptor* (To the most illustrious and generous Domino D. Alberto de Longueval the engraver Lucas Vorsterman dedicates this life portrait of his parent, the greatest — alas! — of those who ever lived). It is not quite clear what kind of "annexe" is meant. Perhaps what is meant is a special impression of a number of copies with this appendix.

The engraved portrait of Longueval is one of Vorsterman's few undated works after Rubens, which were all done after pictures painted before 1620 and must date from the same period, for some of them are mentioned in Rubens' letter of 23 January 1620 to P. van Veen. The engraving after Longueval's portrait was for a long time regarded as dating from a much later period than the

drawing on account of Rubens' having written on 2 September 1627 to Dupuy in Paris of his wish to send him a copy of the engraving (*CDR* 1887-1909, II). But by 1627 Vorsterman had been in England for a few years; besides, a mention in Rubens' letter is no proof of the engraving appearing that same year. In 1898 Rooses assigned it to 1621 — the last year of Rubens' collaboration with Vorsterman (*CDR* 1887-1909, II, p. 204). In all likelihood, Vorsterman did not work on the engraving later than April 1622.

Lucas Vosterman (?). *Charles de Longueval.* Drawing. British Museum, London.

Portrait of Charles de Longueval, detail. ▶ The Hermitage, St. Petersburg.

88

19. *PERSEUS AND ANDROMEDA*

Early 1620.
Oil on canvas. 99.5 x 139 cm.
Transferred from wood by N. Sidorov in 1864.
The Hermitage, St. Petersburg. Inv. No. 461.

The subject is derived from Ovid's *Metamorphoses* (IV. 668-764). In 1943 Evers named the following books as possible immediate sources: *Fabulae* and *De Astronomia* by Hyginus (1st century B.C.), *Bibliotheca* by Apollodorus (2nd century B.C.) and Jean-Baptiste Houwaert's book *Pegasides plein (Pegasus' Stadium),*

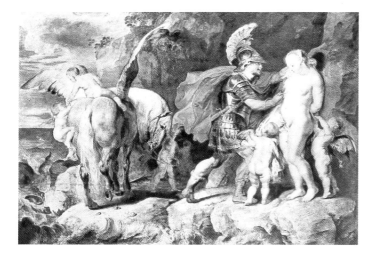

Rubens, *Perseus and Andromeda.*
Gemäldegalerie, Berlin-Dahlem.

which was published in Leiden twice, in 1583 and 1611. Apparently more authoritative, however, is the opinion of Alpatov (1969) who maintained that Rubens could have been inspired by Philostratus' story about an imaginary painting on this theme (Philostratus, *Picture*, I, 29). Philostratus' tale, though, served only as an inspiration for Rubens who created his own version of the ancient subject of the rescue of Andromeda.

In Rubens' composition two motifs are brought together — the apotheosis of Perseus (winged Victory crowns him with a laurel of the wreath) and the love of Perseus and Andromeda. Perseus is approaching Andromeda and slipping off his heavy metal shield, which is caught as if by arrangement by one of cupids bustling around. Another cupid embraces the hero's helmet with both arms and is flying away with it. Here Rubens used an allegorical motif popular in the fine arts of the sixteenth and seventeenth centuries to convey the idea of love's omnipotence — the cupids take away the armour that Perseus no longer needs. The main source of this motif is Renaissance compositions depicting Mars and Venus in which the ferocious and mighty god of war appears disarmed and parts of his martial accoutrements are either lying nearby or in the hands of mischievous *putti*. (On the representations of Mars and Venus see: E. H. Gombrich, "Botticelli's Mythologies. A study in the Neoplatonic Symbolism of His Circle", *Journal of the Warburg and Courtauld Institutes*, vol. 8, 1945, pp. 46-49). There is no doubt that the picture was painted by Rubens.

In Jacobus Harrewijn's engraving of 1684, after J. Van Croes' drawing depicting the garden front of Rubens' house in Antwerp, among other pictures shown hanging over the entrance leading to the staircase there is a composition close to the present Hermitage painting. However, in the manuscripts of J. F. Mols, an eighteenth-century scholar and collector from Antwerp, the following was said about the murals on the façade of Rubens' house: "These pictures were for the most part on the walls facing the yard and garden, between the first and second floors. They lasted for a long time and would have endured longer if they had not been neglected. They represented various mythological subjects placed within compartments corresponding to the widths of the windows. One of them remained there particularly long. That was Andromeda, painted in colour. She stood, stark naked, on the right. Perseus, who has defeated the monster, is approaching Andromeda to release her from the rock, with several cupids assisting him. On the left Pegasus was held by several

Jacobus Harrewijn, *Rubens' house in Antwerp.*
The garden façade. Engraving.

other cupids playfully climbing on his back. On the sky and near the edge of the picture the monster could be seen floating in its own blood. I can testify that at the time the house was sold the picture on the wall,

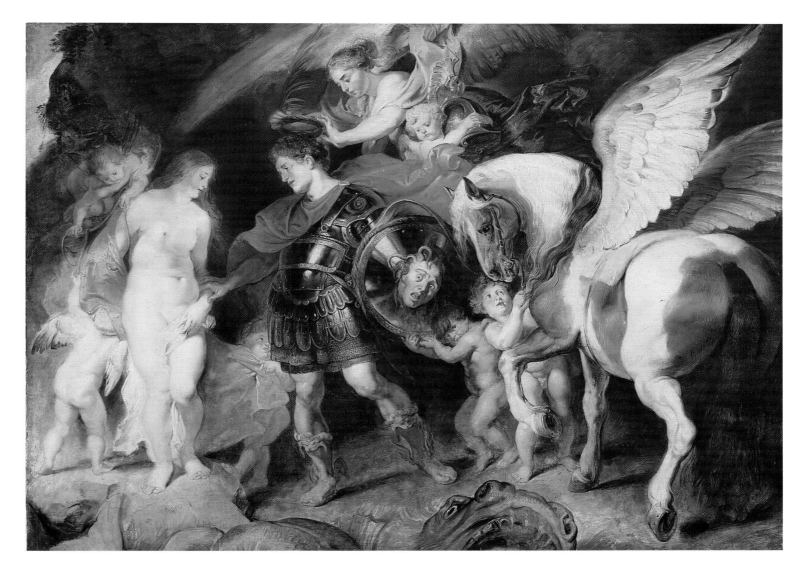

which I had seen time and again, was different from what Harrewijn showed in his engraving" (Bibliothèque Royale, Brussels, MS. 5724, F, 9 ᵛᵒ — cited from Rooses 1886-1892, IV). Mols' description suits the composition of the Berlin version much better than that of the Hermitage picture. Dating evidently from the same period as the Hermitage painting (Oldenbourg 1921, pl. 225, p. 463), the Berlin canvas has the same motif slightly modified. A date in the earlier 1620s is clearly indicated by the picture's distinctive features of style, such as its dynamic composition similar to that of the *Feast in the House of Simon the Pharisee* (see No. 15); its soft transition in texture from the thick impasto in light spots to the subtlest transparent touches in the shades, which combine to create a depth and radiance of the painted surface; also notable is its warm and resonant light colour based on a meticulous elaboration of highlights. The free and broad handling even prompted Labensky in his *Livret* (1838) to designate the piece as a sketch.

Perseus and Andromeda.
The Hermitage, St. Petersburg.

Provenance: In the seventeenth century the picture was evidently in Belgium (see above about Harrewijn's engraving); probably sold for 630 florins in the Shönborn sale in Amsterdam on 16 April 1738: "No. 8. *Perseus Rescuing Andromeda* by P. P. Rubens, gentle and limpid handling, painted in his heyday, 3 feet high, 4 feet 9 inches wide" [exposed area of 97.5 x 132.5 cm, according to the Amsterdam foot consisting of eleven inches, as the sale catalogue specifies] — see Hoet & Terwesten 1752-1770, III). It is not impossible, however, that this refers to the Berlin version. Purchased for the Hermitage from the Brühl collection in Dresden.

Preliminary works: Drawing of Pegasus, Albertina, Vienna (Michel 1900), though possibly a replica.

Version: Gemäldegalerie, Berlin-Dahlem; oil on canvas, 99x137cm.

Prints: By P. F. Tardieu (1711-1771) for the album *Recueil d'estampes gravées d'après les tableaux de la Galerie et du Cabinet de S. E. Mr. Le Comte de Brühl… à Dresde*, part 1, Dresden, 1754, pl. 27.

Following page:
Perseus and Andromeda.
The Hermitage, St. Petersburg.

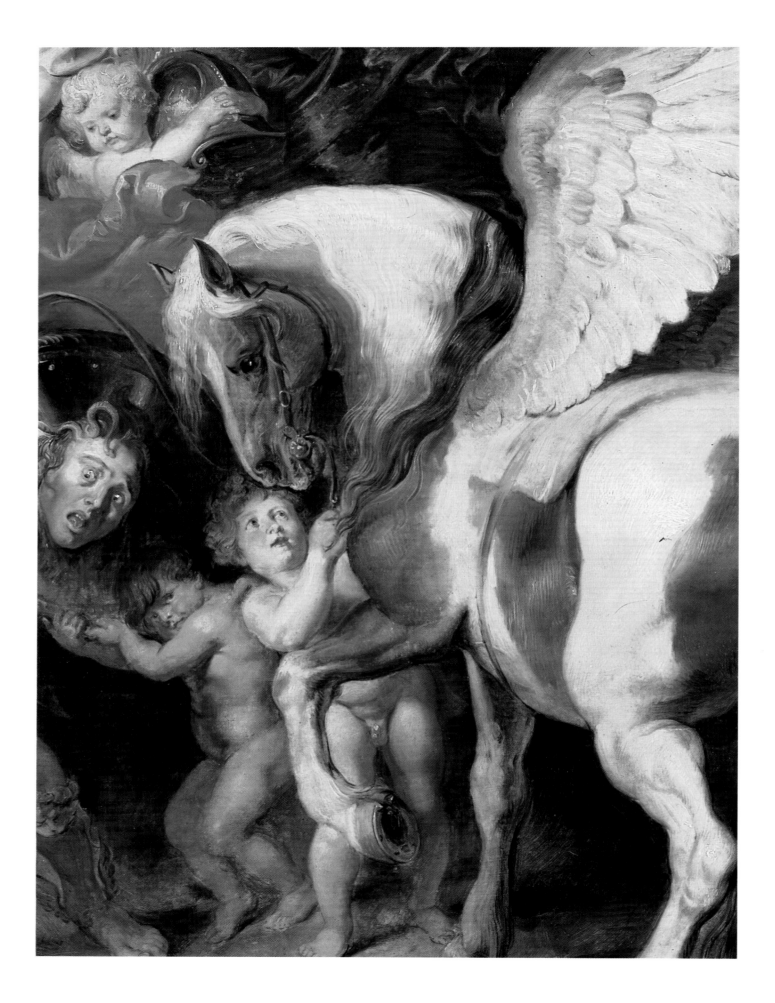

20-24. OIL SKETCHES FOR THE LIFE OF MARIE DE' MEDICI CYCLE

In 1622 Rubens received a commission from the Dowager Queen of France, Marie de' Medici, widow of Henry IV and mother of Louis XIII, for a series of paintings to decorate her new Luxembourg Palace in Paris (built in 1615-1620 by the architect Salomon de Brosse).

In January-February 1622 Rubens travelled to Paris and on 26 February a contract was signed between the artist and Marie de' Medici for the adornment of two galleries in her Palace with paintings representing The Life of Marie de' Medici *and* The Life of Henry IV *(the original copy of the contract is in the Lugt Fund in Paris — see Thullier & Foucart, 1967, pp. 95-96; also* Bulletin Rubens *1882-1910, V, 4; the contract concerning financial settlements is in the J. Pierpont Morgan Library in New York).*

The series for the second gallery was never executed. As for the twenty-four paintings for the first gallery, Rubens and his workshop were busy executing them until 1625. The first nine canvases (it is not known which) were brought by Rubens to Paris in May 1623. The others were delivered in February 1625. They had been installed in the Palace by 8-11 May 1625, when the nuptials of Princess Henrietta Maria with the future King Charles I of England were celebrated.

The programme of the cycle was prepared by the Queen and her advisers: Richelieu, then Bishop of Luçon, and the Royal Treasurer Claude Maugis, the Abbé of Saint-Ambroise. It was not long before the programme was finalized. The contract of 26 February mentioned a list of the first nineteen subjects, the other five were to be handed over afterwards. But discussion on them presumably went on even after Rubens' departure from Paris. It was not until 22 April 1622 that Rubens received the list of the first nineteen subjects in a letter from his Parisian friend Nicolas-Claude Fabri de Peiresc (1580-1637), a scholar and collector, who had also participated in the preparation of the programme. In Peiresc's letter of 26 August 1622 the other five subjects (for the right wall) were intimated to Rubens.

Nevertheless the cycle was not confined to these two known lists (see No. 20). Certain subjects were added, others excluded, and their sequence was changed, as we learn from Peiresc's letters to Rubens. Sometimes Rubens was sent special "memoirs" (see, for example, Peiresc's letter to Rubens of 15 July 1622),

which have not survived. Once even a finished picture was turned down: the Queen Flees France, *whose subject had been specified in the letter of 26 August 1622, was brought by Rubens in 1625, and had to be replaced by the* Blessings of the Regency *(Rubens' letter to Peiresc of 13 May 1625).*

Considerable freedom in the implementation of the programme was evidently given to Rubens himself. It is probable that he suggested the subjects of The Destiny of Marie de' Medici *and* The Triumph of Truth. *It is known that Rubens also sent his "memoirs", which have not survived (see, for example, Rubens' letter of 26 May 1622). In any event, any changes in the sequence of the episodes (see Nos. 23-24) and their interpretation depended to a great extent on Rubens himself. Maugis wrote to Peiresc on 1 August 1622: "...Her Majesty has given me the subjects, which should not bind Monsieur Rubens; they are but subjects, while figures can be arranged in the pictures within his own discretion" (CDR 1887-1909, III).*

In its final form the cycle comprised the following subjects: 1. Portrait of Marie de' Medici; 2-3. Portraits of Her Parents: Francesco I, Grand Duke of Tuscany, and Duchess Johanna of Austria; 4. The Destiny of Marie de' Medici; 5. The Birth of Marie de' Medici; 6. The Education of Marie; 7. The Presentation of the Portrait to Henry IV; 8. The Marriage by Proxy; 9. Marie Arrives in Marseilles; 10. The Meeting at Lyons; 11. The Birth of Louis XIII; 12. Marie Becomes Regent; 13. The Coronation of Marie de' Medici; 14. The Apotheosis of Henry IV; 15. Marie's Government (Council of the Gods); 16. Departure for Pont-de-Cé' (The Capture of Juliers); 17. An Exchange of Princesses (Spanish Marriages); 18. The Blessings of the Regency (Protector of the Arts); 19. The Majority of Louis XIII; 20. The Queen Flees France (Flight from Blois); 21. An Offer of Negotiation (Reconciliation at Angoulême); 22. Marie Consents to Peace (Peace Treaty Concluded); 23. The Reconciliation of Louis and Marie (Reunion of the Queen and Her Son); 24. The Triumph of Truth.

The paintings hung in the Luxembourg Palace until the end of the eighteenth century. In 1799, when the Palace was given to the Senate and a state staircase was built in place of the Medici Gallery by the architect Chalgrin, the pictures were moved first into the other gallery of the Palace and then, in 1802, into the Louvre, where they have been ever since, exhibited in the Grande Galerie until the end of the nineteenth

century and in a special hall since 1900, in a random arrangement until 1953. They are now arranged in the order close to their original disposition in the Luxembourg Palace. Apart from the five oil sketches in the Hermitage and sixteen in the Bayerische Staatsgemaldesammlungen, Munich, few other preliminary works for The Life of Marie de' Medici cycle are known (see No. 20). Hardly any drawings have survived (see Nos. 21, 23, 24).

Haverkamp-Begemann (1953) grouped the preliminary works into two categories: initial oil sketches, to which class the Hermitage pieces belong, and more elaborate versions incorporating the client's comments and instructions. Certain clarifying comments, however, are required in this matter.

The contract of 26 February 1622 stipulated that Rubens should submit to the Queen, along with the first batch of finished pictures, drawn designs (desseings) for all the pictures not yet executed, for both galleries. But it is known from Peiresc's letter of 15 September 1622 that Abbot Maugis, claiming it was the Queen's will, demanded that Rubens should immediately send him preliminary drawings for the pictures being executed or at least for those Rubens had conceived. But Peiresc convinced the Abbot that until Rubens' visit to Paris he should be content with nothing more than detailed descriptions of those pictures (CDR 1887-1909, III).

The first nine pictures that Rubens brought to Paris in May 1623 had evidently not been shown the client before they were finished. These were probably some of the pictures whose subjects were on the list of the first fifteen and in any event those whose dimensions had been communicated to Rubens as early as 7-8 April 1622. The sizes of the three larger paintings were not indicated to him until 14 October, and they could not have been painted by May 1623. The first consignment of nine may have included among others Portrait of the Queen, whose size must have been referred to in Peiresc's letter of 31 March 1622 ("...The Abbe de Saint-Ambrose promised me... one of the sizes you have been requesting... Mr. Brosse has promised to send all the sizes, which is as easy for him to do as to send one of them" — CDR 1887-1909, III).

The Hermitage sketches in grisaille (see Nos. 20-22) are indeed initial sketches, or bozetti, presumably for three of the first nine pictures. The more elaborate oil sketches in colour for some of the pictures delivered later, in 1625, are also original versions which were later elaborated by the artist, most probably before being shown to the customer (see Nos. 23-24). As for the modelli in the Munich collection, which are very close to their respective final versions, these include some for pictures from the first batch of nine, which had not been discussed with the patroness in advance. It can be suggested therefore that there was a third category of preliminary works: versions worked by the painter not after showing his sketches to the client, but while he was elaborating the idea or was preparing a model to be enlarged by his workshop (thus among the Munich sketches there is a sketch of the composition The Flight from France, whose finished version was excluded from the cycle). In his letter of 15 September 1622 Peiresc informed Rubens that Maugis was insisting on the Queen's alleged wish to have a complete set of the drawings and designs of the decorations for the Palace and its gardens. He adds, however that Maugis' claim that Marie de' Medici wanted them was perhaps a mere excuse for obtaining the set for his own collection. It is hard to tell whether drawings or oil sketches were meant. It is beyond doubt that drawings were indeed meant, because the letter mentions "a special book" in which they were to be bound. As for desseings, the word probably also meant oil sketches (CDR 1887-1909, III).

Maugis achieved his purpose and obtained Rubens' sketches. A letter by Peiresc (of 17 January 1630) to the Royal Librarian Pierre Dupuy, a correspondent of Rubens', contains evidence that dessins primitifs for the Queen Mother's Gallery were in the possession of the Abbe de Saint-Ambrose (CDR 1887-1909, V. p. 266), in whose place they were also seen by A. Félibien, as mentioned in his book (A. Félibien, Entretiens sur les ouvrages des plus excellents peintres anciens et modernes, vol. II, 1706, p. 269), first published in 1685. The collection is probably the source of the surviving preliminary works for the cycle.

The main source of information on Rubens' work on the Life of Marie de' Medici cycle, apart from the agreements signed on 26 February 1622 and a few letters to the artist from several persons, is the painter's correspondence with Peiresc, who was the main intermediary between the artist based in Antwerp and the Queen's court in Paris (CDR 1887-1909, II, III). No letters written by Rubens to Peiresc in that period have survived.

From Peiresc's letters it is not always possible to find out what exactly the customer wished and what Rubens' original ideas were. For this reason the few descriptions of the gallery made by contemporaries

or their immediate descendants and based on eye-witnesses' evidence are of particular value.

The earliest evidence of this kind is found in the twenty-four Latin distichs summarizing each painting's content written in 1626 by Mathieu de Morgues (1582-1670), who wrote pamphlets and was Marie de' Medici's confessor and her supporter in disputes with Richelieu (the verses were published in Bulletin de la Société d'histoire de Paris as late as 1881). Of considerable interest, chiefly because we know Rubens' opinion about it, is another poem in Latin, Porticus Medicaea, by Claude Barthélémy Morisot (1592-1661), a scholar and barrister at Dijon's Parliament; its first edition appeared in 1626. In his letter to Pierre Dupuy of 29 October 1626 Rubens pinpointed several places in the poem where the real meaning of some of the pictures had escaped the poet (an example of Rubens' corrections can be seen in No. 21). Rubens' corrections were intimated to Morisot by Dupuy. In Morisot's letter of 5 January 1628 the writer thanked Rubens for the corrections; later that year, on 11 February, Morisot sent Rubens a copy of the second edition revised in accordance with Rubens' comments. Evidently, it still contained some inaccuracies, as Rubens wrote in his letter to Dupuy dated 20 January 1628 that Morisot was not sufficiently versed in all the peculiarities of the subjects, which were not so easy to construe per conguetura (by conjecture), without the artist's own explanations.

He promised to help Morisot at his earliest convenience, adding: "But at the moment my written account of the subjects is not here, while my memory may fail me." In his letter to Dupuy of 25 February Rubens again said he had not yet found his notes on the subjects, but hoped to find something (CDR 1887-1909, III). As to the literature written at a later date, it can be concluded that the most authoritative work was the detailed description of the Gallery made, in the seventh of his Talks, by Andre Félibien (1619-1695), who was Secretary of the Academy, Royal Historiographer and a writer on art. Contemporary or nearly contemporary materials (probably verbal evidence) were used also by F.-B. Moreau de Mautour (F.B. Moreau de Mautour, Description de la galerie du Palais du Luxembourg, Paris, 1704) and by the painters Jean-Marc and Jean-Baptiste Nattier when they worked on the drawings and texts for their album of engravings after the Medici cycle (La Galerie du Palais du Luxembourg peinte par Rubens, dessinée par les Mrs. Nattier, Paris, 1710). Of particular interest is a manuscript housed in the Bibliothèque Nationale in Paris (Fonds Baluze, No 323; see: J. Thuillier, "La Galerie de Médicis de Rubens et sa genèse: un document inédit", Revue de l'art, vol. IV, 1969, pp. 52-62) which contains a description of the first fifteen subjects in the cycle, written in 1622, i.e. when the first paintings were being produced and the rest of the programme was perhaps under discussion.

PRIVATE APARTMENTS OF THE QUEEN

CABINET DORÉ

ANTECHAMBERS

CEREMONIAL BEDCHAMBER OF THE QUEEN

THE QUEEN'S ORATORY

GALERIE HENRI IV

MEDICI GALLERY

GARDEN

COURT OF HONOR

ENTRANCE PORTICO

TERRACE

TERRACE

RUE DE VAUGIRARD

Plan of the Gallery in the Luxembourg Palace, Paris.

20. *MARIE DE' MEDICI IN THE GUISE OF PALLAS*

1622.
Oil (grisaille) on oakwood. 22.5 x 15 cm. Both the ground and the coat of oil are so thin that the texture of the wood is visible. The Hermitage, St. Petersburg. Inv. No. 511.

This is the first oil sketch of the allegorical portrait of the Queen, which hung over the fireplace before the entrance doors in the front end wall of the Gallery.

It is not clear when the portrait was included in the programme. It did not appear on the lists sent to Rubens by Peiresc on 22 April and 26 August 1622, nor is it mentioned in any other records available (*CDR* 1887-1909, III).

It was included in the programme of the cycle not later than August 1622 — the accepted dating of the manuscript in the Fonds Baluze (see: Thuillier 1969) which contains the first know description of this subject. The portrait is mentioned in the manuscript as No. 1 — a depiction of "une reine triomphante".

The picture was referred to as a portrait of the Queen in the guise of Pallas in all seventeenth- and eighteenth-century sources except for Moreau de Mautour who identified the goddess as Bellona.

But what matters most is that *Palladis habitu* was the title which Morisot used and which elicited no objections from Rubens. The title — and hence the subject-matter of the painting opening the cycle (Rubens numbered the pictures in the Gallery from the front end wall — see P. Dupuy's letter of 20 January 1628) — can hardly be regarded as a trifle that Rubens would not bother to note at once. Morisot stressed that "...circa bombardae, tubae, litue et belli velut in alta pace neglecta jacent"

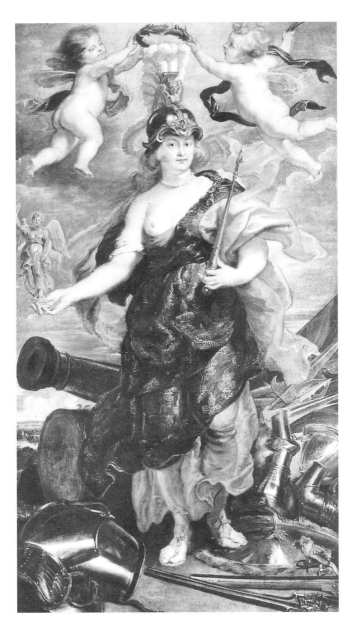

Rubens, *Portrait de Marie de Médicis*. Louvre, Paris.

("canons, trumpets, bugles and other attributes of war are scattered round as in times of secure peace" — *CDR* 1887-1909, II, III).

Marie de' Medici is represented here as Pallas (Minerva), goddess of wisdom, also a goddess of war who overrides feuds; it was Pallas Athene that was shown with a statue of Victory (Nike) in her hand, as exemplified by Phidias' Parthenon virgin goddess Athene.

This interpretation is in accord with the general design of the cycle. The portrait of the Queen "prevailing over wars" (Mathieu de Morgues' expression) hanging over the entrance confronted the image of Bellona with a trophy on the opposite wall (see No. 24). The Queen's portrait was both at the beginning and at the end of the cycle. In 1936 Simson aptly likened this to the role of the Prologue in dramatic performances of those days.

In the manuscript from the Fonds Baluze it is pointed out that the cupids' butterfly wings signify immortality, and a detail is mentioned which is absent from the final painting and merely outlined in the sketch: two figures symbolizing Glory (The contours of one figure blowing a trumpet are just discernible in the upper left-hand corner of the sketch).

The present oil sketch differs from the picture in the Louvre (where the Queen is portrayed standing with a sceptre in her hand) and from another sketch, now in the Stiftung Kunsthaus Heylshof, Worms (the queen is shown standing and trampling the trophies of war; the cupids crowning her representation are absent) which represents the next stage in the development of the concept featured in the Hermitage sketch.

Provenance: Purchased for the Hermitage from the Crozat collection in Paris in 1772.

96

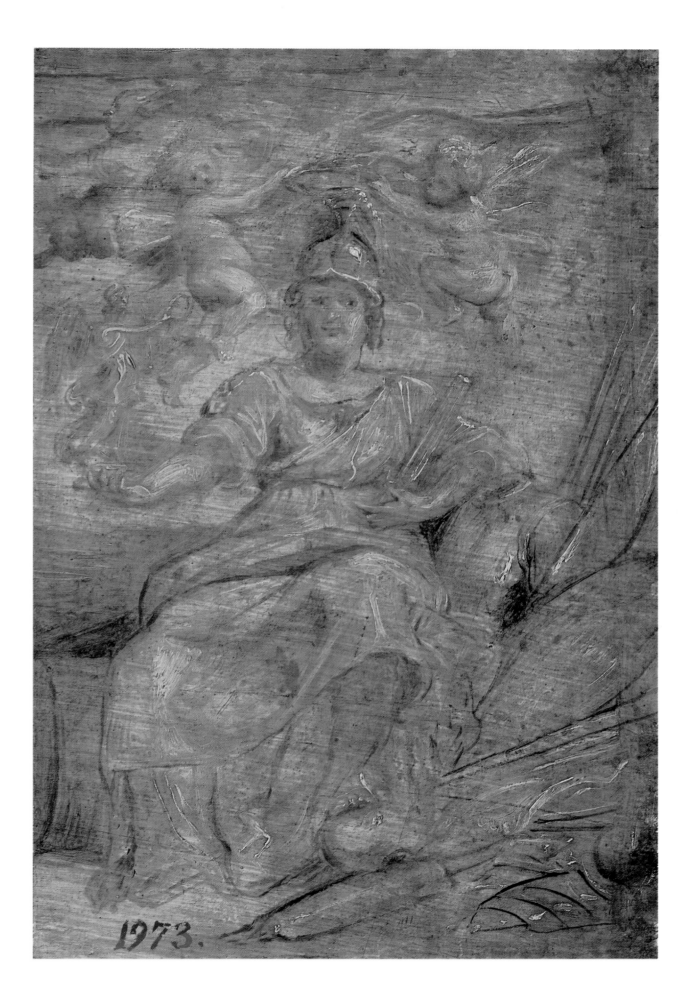

1973.

21. *THE MEETING AT LYONS*

1622.
Oil (grisaille touched with colour) on canvas. 33.5 x 24.2 cm.
Transferred from wood by A. Sidorov in 1893.
The Hermitage, St. Petersburg. Inv. No. 505.

This is an oil sketch of the tenth picture of the cycle, an allegorical representation of Marie's first meeting with Henry IV in Lyons on 9 November 1600.

This subject is the sixth in the list of fifteen sent to Rubens by Peiresc in his letter of 22 April 1622 (*CDR* 1887-1909, III) and the tenth in the Fonds Baluze manuscript.

The King and the Queen are represented as Jupiter and Juno being united by Hymen. The goddess of Lyons wearing a crown of towers and with a crested shield in her hand, rides in a chariot drawn by a team of lions symbolizing the city of Lyons. In his letter to Dupuy of 29 October 1626 Rubens rebuked Morisot for confusing in the fourth and ninth compositions (*The Birth of Marie de' Medici* and *The Meeting at Lyons)* the goddesses of the cities, Florence and Lyons, with the mother-goddess Cybele, whose attributes were also a crown of towers and lions.

Simson (1936) observes that Rubens, in representing the King and Queen as Olympian gods, followed an old tradition of court art. In France compositions of

this kind became greatly favoured in the sixteenth century. According to Nattier (see the above introduction to this series of oil sketches), Rubens employed the "device chosen by the Queen in 1608", in which Juno was supported by a peacock and an elephant, *viro partuque beata* (blessed with marriage and progeny). The motif of the cupids riding the lions is, according to Simson, connected with an emblematic representation of the saying *Etiam ferocissimos domari* (I tame even the most ferocious ones) derived from Alciati's *Emblemata* of 1531.

In the Fonds Baluze manuscript the chariot drawn by lions is interpreted as representing "everything that was done to welcome the King and the Queen when they entered Lyons", i.e. the state decorations for the official reception of the royal couple.

No other preliminary versions of the present composition are known.

The sketch is slightly different from the final version: in the Louvre painting the lions are ridden and steered by two cupids, each with a torch; there is no flying genius under Jupiter's feet; three cupids are seen behind Jupiter and next to Juno there is a chariot drawn by two peacocks. Juno's head is crowned with a diadem; the city of Lyons is shown in the far background of the picture and at the top there is a rainbow and a six-point star.

The diagonal rhythm — upwards, from left to right — is part of the general undulating compositional movement evident in all the paintings on the left-hand wall of the Gallery.

Provenance: Purchased for the Hermitage from the Crozat collection in Paris in 1772.

Final Version: *The Entry into Lyons*, Louvre, Paris; oil on canvas, 394 x 295 cm (prior to 1802 in the Luxembourg Palace, Paris).

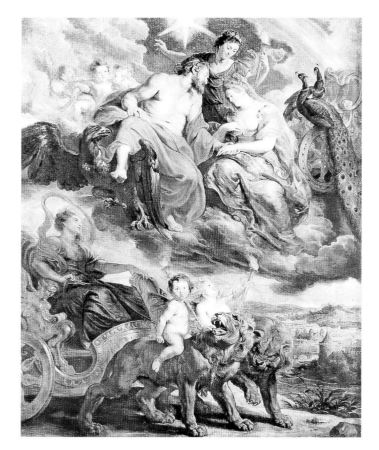

The Meeting at Lyons.
The Hermitage, St. Petersburg.

Rubens, *The Entry into Lyons*.
Louvre, Paris.

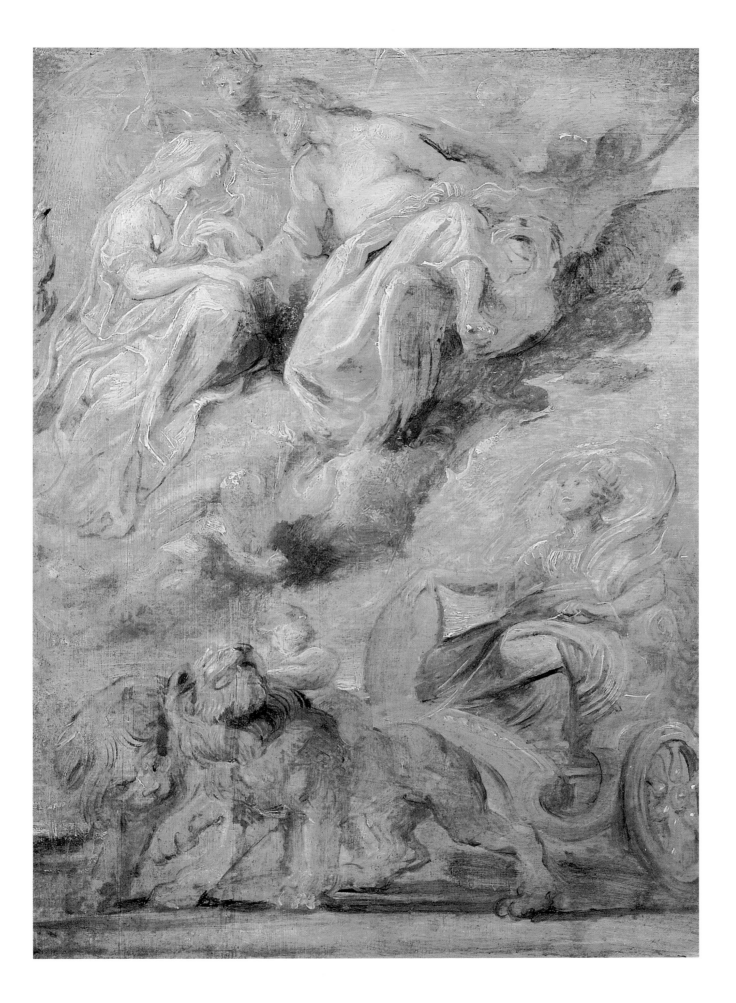

22. *THE BIRTH OF LOUIS XIII*

1622.
Oil (grisaille touched with colour) on oakwood. 33.6 x 24 cm.
The ground and the coat of paint are so thin that the pattern of
the wood is visible.
The Hermitage, St. Petersburg. Inv. No. 506.

This is a sketch for the eleventh composition of the
Medici cycle. It is an allegorical representation of the
nativity of Louis XIII at Fontainebleau on 27 September 1601, an event which was credited to Marie de'
Medici as one of her services to the French state.

The subject, *Nascita del Dauphino*, is the seventh in
the list of fifteen themes sent to Rubens by Peiresc in
his letter of 22 April 1622 (*CDR* 1887-1909, III) and
the eleventh in the Fonds Baluze manuscript.

The figure of Health with its attribute — a serpent
coiling round his arm — receives the newborn baby
from Justice, who, according to Grossmann (1906)
symbolizes legitimate primogeniture. On the left the
Queen is flanked by Fecundity with a cornucopia in
which Marie's five future babies can be seen. The
Queen is supported, according to Morisot and Grossmann (1906), by the great mother-goddess Cybele,
mistaken for Fortune by Félibien (see the introduction
to this series of oil sketches) and Rooses (1886-1892,

III) after him. In the sky Apollo's chariot can be seen,
which indicates that the event took place in the morning. In the manuscript from the Fonds Baluze (Bibliothèque Nationale, Paris) there is in addition a mention
of five stars preceding the chariot.

No other preliminary works for the present composition are known.

The difference from the final version is slight: only the
figure of Health is represented in a different fashion
in the Louvre painting. Justice is shown there with
her attribute, a balance. The precious vessels in the
foreground do not appear in the Louvre picture, their
place taken by an Oriental rug. The dog is different.
Over Apollo Pegasus is visible in the sky.

Grossmann (1906) thought the composition to be a
free reinterpretation of the canonical scenes of *The
Virgin Enthroned with the Apostles* or of *The Holy
Family*. Simson (1936) regarded as a more likely prototype the apotheoses of Roman emperors, where the
central character was always surrounded by gods.
Haberditzl (1912) suggested classical prototypes for
all the figures in the composition.

Thuillier & Foucart (1967) pointed out a resemblance
to Apollo's chariot with the same motif in Primaticcio's
cartoon for the murals in the Ulysses Gallery in Fontainebleau.

The diagonal movement of the unfurled drapery
emphasized by the flying chariot is part of the general
undulating movement from left to right, which is characteristic of all the left-hand wall pictures.

Provenance: Purchased for the Hermitage from the Crozat collection in Paris in 1772.

Final Version: *The Birth of the Dauphin*, Louvre, Paris, oil on canvas, 394 x 295 cm (until 1802 in the Luxembourg Palace, Paris).

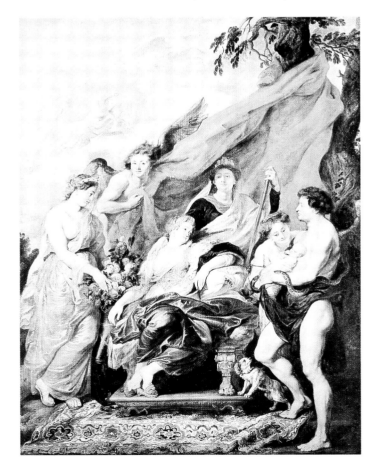

Rubens, *The Birth of the Dauphin*.
Louvre, Paris.

The Birth of Louis XIII.
The Hermitage, St. Petersburg.

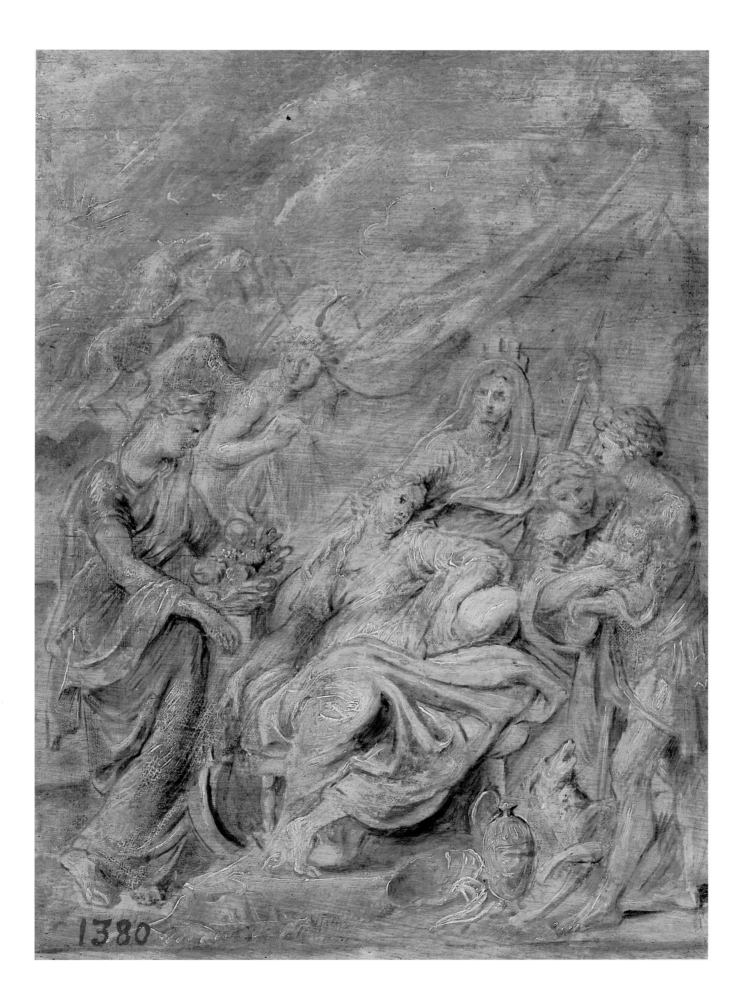

1380

23. *THE CORONATION OF MARIE DE' MEDICI*

1622.
Oil on oakwood. 49 x 63 cm.
The Hermitage, St. Petersburg. Inv. No. 516.

This is a sketch for the original version of the thirteenth picture of the cycle, which represents the coronation of Marie de' Medici in the St. Denis Church in Paris on 13 May 1610. Particular importance was attached to the coronation as it set the final seal of approval, as it were, on Marie's claim to the French throne. The subject, *L'Incoronamento*, is the eighth in the list of fifteen sent to Rubens by Peiresc in his letter of 22 April 1622 and the thirteenth in the Fonds Baluze manuscript.

The crown is bestowed on Marie by Cardinal de Joyeuse. She is accompanied by the Dauphin, the

Leonard Gaultier. *The Coronation of Marie de' Médici.*
Engraving.

future King Louis XIII. The ceremony is attended by Cardinals de Gondy and de Surdis, as well as by four bishops. A page is seen behind the Queen, and a little way off on the right is Princess Henrietta Maria, later Queen of England. A procession of courtiers appears on the right: Henry IV's natural sons take the lead — le Duc de Vendôme with a sceptre and the Archduke de Ventadour with an orb of justice (in this respect Rubens departed from authenticity, for the orb and the sceptre were held by the Queen at the moment of the coronation). They are followed by Queen Margaret Valois, Henry IV's first wife, and other exalted ladies (no historical persons can be recognized). Far in the left background Henry IV is shown in the pew. On his right is a platform with foreign ambassadors and over

him a stand with a band of musicians. A platform with spectators is shown in the far right background.

The Hermitage oil sketch preceded its counterpart in the Alte Pinakothek in Munich. Not only is it smaller in size and less elaborate, but it has a different format, not so elongated, and what is more, the Hermitage painting is in the opposite direction to that of the final version in the Louvre and the Munich sketch.

The first idea of the composition may have been suggested to Rubens by contemporary engravings of Marie de' Medici's coronation, which were arranged to the left. Rubens' employment of the engraved scenes of the coronation was mentioned by Simson (1936) and Evers (1942) with reference to the Munich sketch and the final version of the painting (see the *Supplement* to L. Gaultier, *Pourtraict du Sacre et Couronnement de Marie de Médicis,* 1610; also the *Supplement* to A. Rossaccio, *Esequie d'Arigo Quarto Christianissimo Re de Francia e di Navarra, celebrata in Firenze da Giulio Giraldi,* Florence, 1610). The Hermitage sketch is closer than any subsequent version to the engravings, especially Gaultier's. Not only is it executed in the same direction as both engravings, but it has obviously the same figure of Princess Henrietta Maria, whose posture and position in the composition almost repeat Gaultier's engraving.

The horizontal rhythm of the composition discovered in the Hermitage sketch, with the emphasis on the group of cardinals, was further developed and elaborated afterwards, when the place of this composition was finalized in the general pattern of the left-wall decorations, which were united by a "flowing" undulating compositional movement. The Munich sketch differs considerably from the Hermitage piece and virtually coincides with the final version. Rubens attached great importance to *The Coronation* and did his best to have it displayed in as much sunlight as possible: he intended to have an extra window in the opposite wall or to have the balcony door there glazed, but later the artist abandoned the troublesome plan (see letters by Maugis and Peiresc dated 4, 11, 17-18 November and 1 December 1622 – *CDR* 1887-1909, III).

Provenance: Appeared in the sale of the F. I. Dufferin collection in Amsterdam on 22 August 1770, where it was purchased by the antique dealer Van der Schley (see Rooses 1886-1892, III). Purchased for the Hermitage before 1774.

Preliminary works: A drawing of Marie de Medici's head in left profile, Albertina, Vienna, No. 384/440; black and red chalks, heightened with white, 30.8 x 21.5 cm. It is probably related not to the Hermitage pieces (Haverkamp-Begemann 1953, p. 66), but to item No. 19 of the cycle, *The Reconciliation*, where the Queen is shown not with her head lowered to her left shoulder, as in the Hermitage piece, but in strict profile, as in the drawings.

Version: Sketch, Alte Pinakothek, Munich; oil on wood, 39.4 x 72.7 cm (until 1802 in the Luxembourg Palace, Paris).

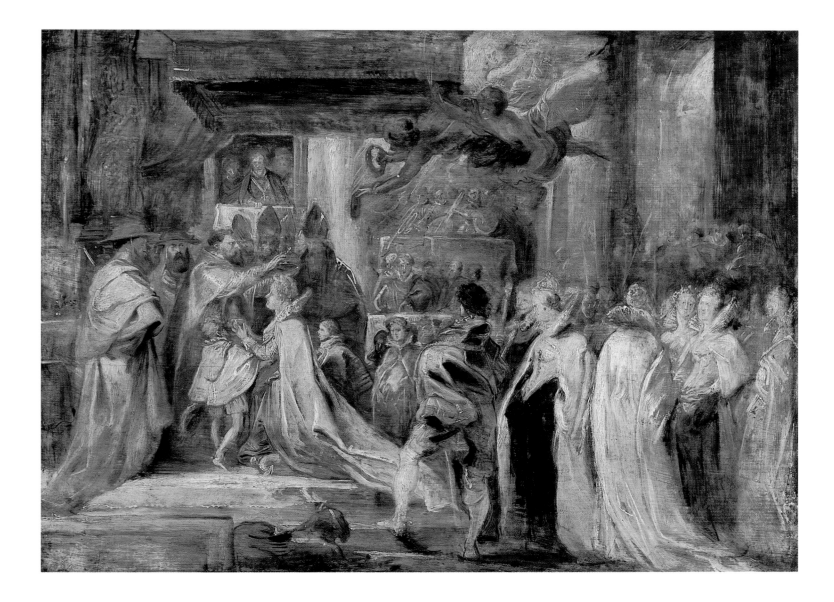

The Coronation of Marie de' Medici.
The Hermitage, St. Petersburg.

Page suivante :
The Coronation of Marie de' Medici, detail.
The Hermitage, St. Petersburg.

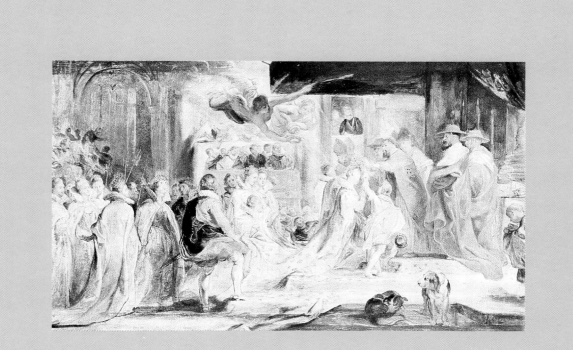

Rubens. *The Coronation of the Queen.*
Sketch. Alte Pinakothek, Munich.

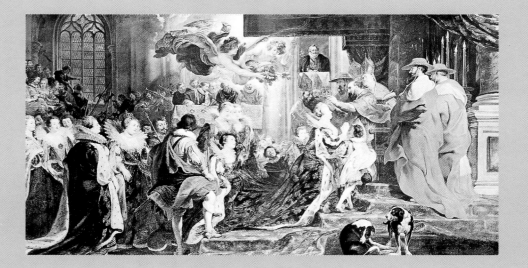

Rubens. *The Coronation of Marie de' Médici.*
Louvre, Paris.

24. *THE APOTHEOSIS OF HENRY IV*

1622.
Oil on oakwood, 48 x 65 cm.
The Hermitage, St. Petersburg. Inv. No. 514.

This is a sketch for the original version of the four-teenth picture of the cycle. It is an allegorical repre-sentation of Marie de' Medici taking over the reins of government on the day of Henry IV's assassination by Ravaillac (14 May 1610).

This subject, *La morte del marito e la Regenza,* is the ninth in the list of fifteen sent by Peiresc in his letter to Rubens of 22 April 1622 (*CDR* 1887-1909, III) and the fourteenth in the Fonds Baluze manuscript.

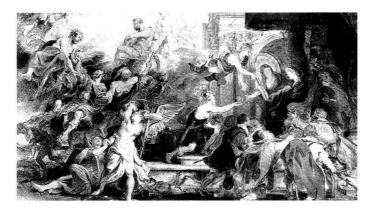

Rubens. *The Death of Henri IV
and the Proclamation of the Regency.*
Sketch. Alte Pinakothek, Munich.

Henry IV supported by Saturn (by Time, according to Félibien and Nattier) ascends to the throne of Jupiter, as in apotheoses of Roman emperors (see No. 29). Winged Victory is shown at his feet wringing her hands in despair, while the war goddess Bellona (according to Morisot) or Glory (according to Moreau de Mau-tour), with a trophy in her hand, tears her hair (the Fonds Baluze manuscript speaks of two Victories). In the left background there is a warrior (?) pointing to the King. Kneeling France accompanied by a female figure wearing the *mauerkrone* of Paris (according to Somov 1902) and three representatives of the French nobility stretch their hands towards the Queen attired in mourning, with Minerva on her right and Prudence (Constance, according to Morisot) on her left, a serpent wound round her arm; there is one more figure (per-haps an image for the decoration of the throne). A genius with a helm in his hands (according to Félibien and Nattier, the personification of Regency) is flowing down from the heavens. In the lower right-hand corner the frightened War and Feud are shown (see the intro-ductory note to the present series of oil sketches).

In 1958 Aust suggested that the merger of the two compositional lines in the Hermitage sketch was an expression of the idea of continuity of power in the hands of Marie de' Medici. In 1965 Warnke attached particular importance in the cycle as a whole to the figure of France personifying the nation (M. Warnke, *Kommentare zu Rubens,* Berlin, 1965).

The present oil sketch is a predecessor of the sketch in the Alte Pinakothek, Munich: the Hermitage paint-ing is of smaller size and less elaborate, its format is less elongated and its compositional arrangement is different.

The sketch represents a compact group of people very slightly shifted from the foreground into the depth on the left. The two diagonals of its compositional move-ment, intersecting in the centre, give the impression of a sturdy, pyramid-like structure. The female figure shown turning round behind France links the "celes-tial" and the "earthly" parts of the composition into an integral scene laid, as it were, on the steps of the Queen's throne. The allegorical figures in the lower right-hand corner aptly conclude the composition.

Some writers observe affinity of the figures of Henry IV and the descending genius, as well as of the group round Marie and France, with Primaticcio's cartoons for the Ulysses Gallery in Fontainebleau (see F. Hamil-ton Hazlehurst, "Additional Sources for the Medici Cycle", *Bulletin des Musées Royaux des Beaux-Arts de Belgique,* 1967, p. 128); the group of the Queen and representatives of the nobility has a similar dispo-sition of figures to Caravaggio's painting *Madonna with a Rosary* (see Robert W. Berger, "Rubens and Caravag-gio. A Source for a Painting from the Medici Cycle",

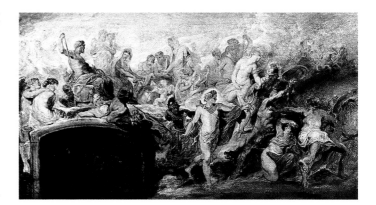

Rubens. *The Council of the Gods.*
Sketch. Alte Pinakothek, Munich.

The Art Bulletin, December 1972, pp. 473- 477).
The vagueness of the background behind the throne (cursorily indicated are a column capital, an arch above it and a canopy) and of the figures surrounding

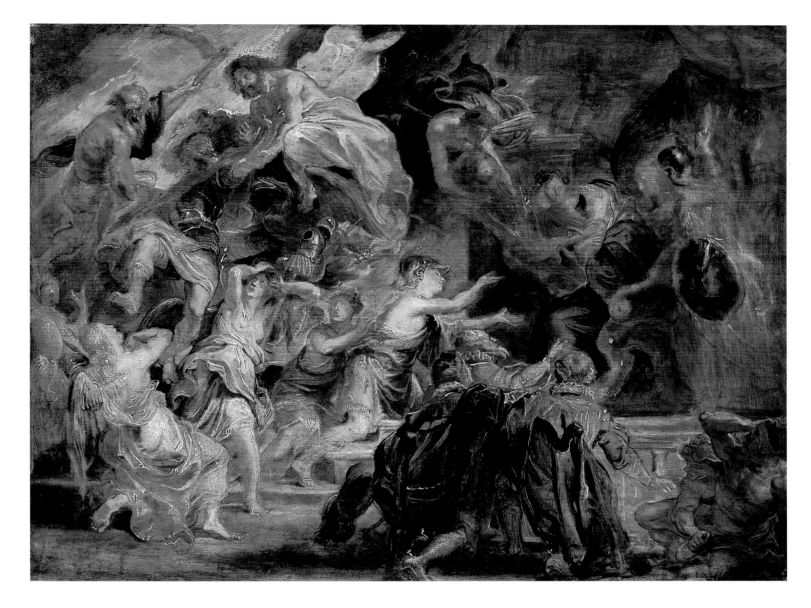

The Apotheosis of Henri IV.
The Hermitage, St. Petersburg.

the Queen give the impression of crudeness. No attention at all is paid to the small door that existed in the right part of the end wall and led to service premises; its casing encroaches on the composition — in the Louvre painting one can distinctly see in its place an addition under the steps of the throne, which was added after the transfer of the paintings from the Luxembourg Palace, when it was occupied by the Senate.

It is known from Peiresc's letter of 22 April and 26 May 1622 that Rubens *de principio* set aside the three largest piers for the three most important pictures of the Medici cycle — *The Coronation of Marie de' Medici. The Apotheosis of Henry IV* and *The Council of the Gods.* It was not, however, until 26 August 1622, when the programme for the opposite wall was finalized, that it became possible to achieve a compositional unity for these three paintings crowning the entire series. Moreover, the three titles had not been

placed in this succession in the original list, so arranging them in this order entailed a certain rearrangement of the display on the right-hand wall (see Peiresc's letter of 6 May 1622 — *CDR* 1887-1909, III).

The Hermitage sketch for *The Apotheosis of Henry IV* must have been executed before the rearrangement was effected. This hypothesis is corroborated by its composition. When working on it, Rubens already saw the picture as a climax in relation to several pictures to be placed before it, but he did not yet know what picture would come after it, what kind of transition *The Apotheosis* was to provide. Apparently, the place of *The Council of the Gods* had not yet been determined; perhaps it had not even been conceived. In any case, in the Munich oil sketch for *The Council of the*

107

Gods, which is the only known preliminary work for that composition, use was made of the posture of one of the two allegorical figures in the right-hand corner of the present oil sketch, which, however, proved superfluous as the artist further worked out the composition.

In the Hermitage sketch the King is wearing plain, unadorned steel armour. In the Munich sketch it is parcel-gilt and sumptuosuly decorated, evidently in accordance with what Peiresc wrote to Rubens on 3-4 November 1622: "I think Your Worship may safely depict the King in gilt armour; if you represent him in this way, *all'antiqua*, it will not cause any objection, for the King, in his lifetime, liked to see himself in portraits clad in classical robes, richly decorated." In the same letter and also in that of 17-18 November it was also discussed whether the Queen's mourning cloak might appear to some as an article of Spanish rather than classical costume (*CDR* 1887-1909, III). Evidently, in November 1622 Rubens was still working out the design of the final version of the decoration for the end wall, which was to become the central link connecting the two rows of pictures not only as regards their composition, but also their decorative effect. It was then that the artist produced the Munich oil sketch, in which both halves of the composition were expanded in order to emphasise its connection with the other pictures.

In the right-hand part of the new version Rubens placed the throne at a higher point under a canopy supported by two twisted columns, which are replicas of those in the original version — this Hermitage sketch; the same columns are retained in the final version (Louvre, Paris), where the central figure of Bellona with a trophy in her hand became essentially pivotal for the entire ensemble of the Gallery.

Provenance: Appeared in the F. I. Dufferin sale in Amsterdam on 22 August 1770; purchased by the antique dealer Van der Schley (Rooses 1886-1892, III). Purchased for the Hermitage before 1774.

Preliminary works: Pen sketches of different figures on a fragment of a sheet (previously ascribed to Van Dyck, see Lugt 1925) — formerly in the Kunsthalle, Bremen, No. 658 V°; present whereabouts unknown; 17.5 x 17.1 cm; on the reverse, an early version of the twenty-first picture of the cycle — *The Reconciliation of Louis and Marie* (or *The Treaty of Angoulême*).

Version: sketch, Alte Pinakothek Munich; oil on wood, 53.7 x 91.7 cm.

Final Version: *The Apotheosis of Henry IV*, Louvre, Paris; oil on canvas, 395 x 727 cm (until 1802 in the Luxembourg Palace, Paris).

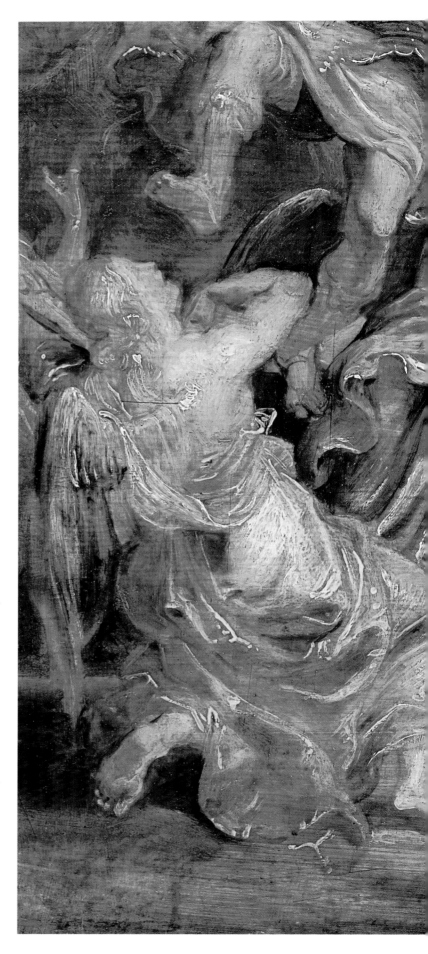

The Apotheosis of Henri IV, detail.
The Hermitage, St. Petersburg.

25. PORTRAIT OF A LADY-IN-WAITING TO THE INFANTA ISABELLA (PORTRAIT OF RUBENS' DAUGHTER CLARA SERENA?)

1623-1625.
Shoulder-length portrait.
Oil on oakwood. 64 x 48 cm.
The thin coat of paint, which has grown still more transparent with age, shows the bluish tone of the white ground laid with a thick brush in broad diagonal bands.
The Hermitage, St. Petersburg. Inv. No. 478.

The traditional title of the portrait is based on an inscription, in an unknown hand, presumably dating from the seventeenth century, on the artist's preliminary drawing housed in the Albertina, Vienna: *Sael doeghter van de Infante tot Brussel (Infanta's Waiting-maid in Brussels)*. Held (1959) tentatively identified this drawing as a portrait of Rubens' eldest daughter Clara Serena (1611-1623) pointing to the similarity between its model and two representations traditionally held to be of the artist's daughter (the first is in the Metropolitan Museum of Art, New York, formerly the Ch. U. Bay collection, New York — see Lidtke 1984, pp. 231-233, as "a copy after Rubens, possibly 17th century"; the second is in the Musée Diocesain, Liège).

The inscription on the Albertina drawing cannot disprove this since, on the one hand, it was made by an anonymous hand at an unknown date and therefore does not constitute documented evidence; while, on the other hand, Rubens' daughter may have been bestowed the honour even as a child (Held 1959). Indirectly this is proved by the fact that the same face was repeatedly portrayed by Rubens (and his workshop).

Clara Serena was born on 21 March 1611 (P. Genard, *Peter Paul Rubens*. Antwerp, 1877, p. 414); she died, twelve and a half years of age, in October 1623 (see Rubens' letter to Peiresc of 25 October 1623 and Peiresc's letter of 11-12 February 1624 — *CDR* 1887-1909, III). The model in the Vienna drawing is therefore still a child, a thin sickly girl with narrow shoulders and a large head. The drawing was done from life, probably during the girl's last illness before her death. It cannot be ruled out that the artist produced also a painted study, close to the Vienna drawing but not surviving (Held 1959).

The Hermitage piece appears to be a somewhat idealized posthumous portrait. In it Clara Serena looks older, the proportions of her figure are more presentable and the oval of her face more regular. But she

has the same sad and dreamy expression on her face and the same weak flicker of a smile, the same posture, nearly the same dress and the same distinctive details as in the drawing: the chain on her breast, the earring, the way her hair is done, with a stray wisp of hair on her temple. The somewhat archaic composition with the shoulder-length portrait in a close framing, which is uncharacteristic of Rubens' later work, may be due to the dependence of the posthumous portrait on the last sketch done from life. These unusual circumstances evidently resulted in the intimate lyrical quality of this portrait, which is unique in the master's œuvre.

The deep psychological insight, superb execution and characteristic handling (see the material characteristics above) seen in this portrait leave no room for doubting Rubens' authorship.

If one admits that the portraits in St. Petersburg, Vienna, New York and Liege really represent Clara Serena, then the *ante quem* date, at least for the drawing in the Albertina, Vienna, which is the source of all the painted versions, is 1623, i.e. the year of the girl's death. The Hermitage painting may have been produced somewhat later, between 1623 and 1625. This is evidenced by its stylistic features, such as its warm, crisp colouring and light, limpid brushwork.

Portrait of a Lady-in-Waiting to the Infanta Isabella.
The Hermitage, St. Petersburg.

Provenance: In the posthumous inventory of the property of Jan Brant, Rubens' father-in-law, the following was written in 1639: "Twee stuckens schilderije respective, op panneel, olieverve, in lijste, d'een van Jan Brant, des afflijvigens soontken was, ende d'ander van Clara Serena Rubens, dochterken was des voors. Hr Rubens" ("Two pictures, oil on panel, framed, one of Jan Brant, the deceased man's little son, and the other of Clara Serena Rubens, young daughter of the above-mentioned Mr. Rubens" — see Denucé 1932, p. 54). The entry may have referred either to the present Hermitage portrait or its variant.
Purchased for the Hermitage from the Crozat collection in Paris in 1772.

Preliminary works: A drawing by Rubens in the Albertina, Vienna, No. 8259; black chalk and sanguine over ink, heightened with white, 35 x 28.2 cm; inscribed — at the top, in an unknown hand: *Sael doeghter van de Infante tot Brussel*; at the bottom in a different hand, seen in a large group of drawings in the Albertina: *P. P. Rubens* (it has been suggested that this inscription was made when a posthumous inventory of Rubens' property was taken or when his drawings were being prepared for the sale of 1657).

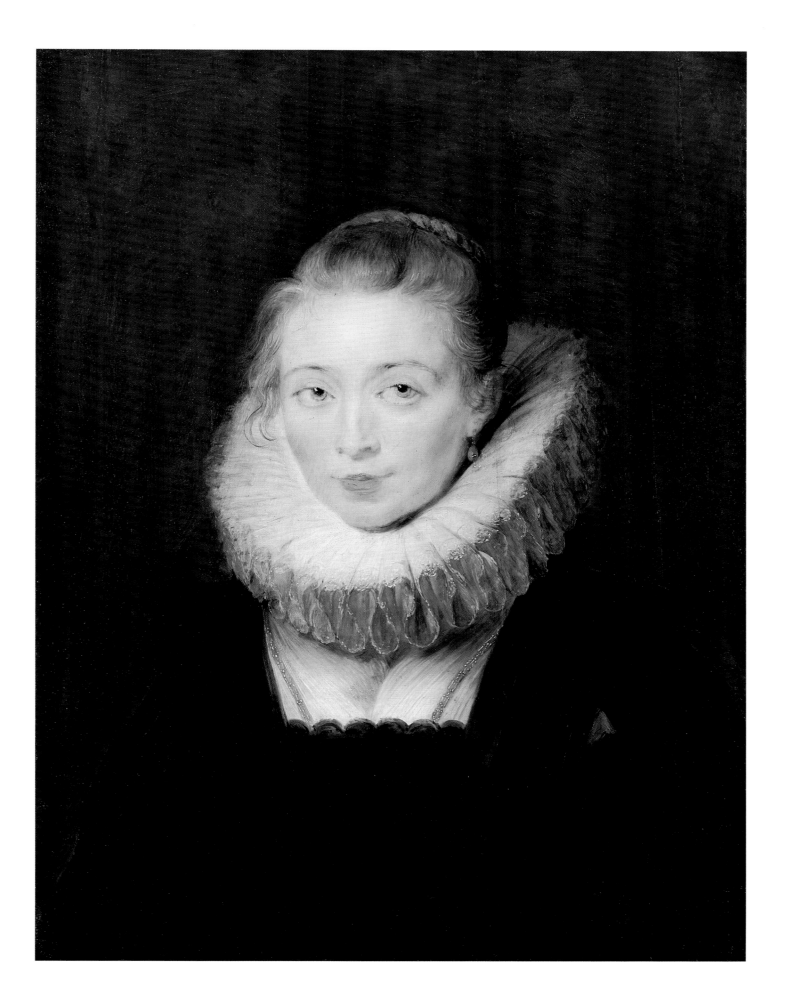

Rubens, *Lady-in-Waiting
to the Infanta Isabella at Brussels*.
Drawing. Albertina, Vienna.

Rubens, *Head of a Child*.
Sketch. Liechtensteinische
Staatliche Kunstsammlung, Vaduz.

Rubens, *Portrait of Isabella Brant*.
Drawing.
British Museum, London.

Workshop of Rubens,
Portrait of Clara Serena. Drawing.
Metropolitan Museum of Art, New York.

26. *THE VISION OF ST. ILDEFONSO*

1630-1631.
Oil on canvas. 52 x 83 cm.
Transferred from wood before entry to the Hermitage.
Enlarged by about 9 cm on the left before the transfer onto canvas.
Judging by the texture of the ground revealed by radiography, the structure of the wood in the attached piece differed considerably from that of the original board. In places the paint from the attached piece overruns to the main part (on the Archduke's mantle and on the robes of St. Albert). The semi-circular streaks of white on the curtain are all that radiography shows on the appendage.
In 1765 Lalive de Jully (see Castan 1885) made the following remark: "I am inclined to believe that this sketch has sustained some damage and has been mended in many places."
Regretfully, the measurements he gives seem to be approximate (1 foot by 2 feet, i.e. 30 x 60 cm) and cannot serve as ground for drawing a conclusion as to the date when the picture was enlarged.
The Hermitage, St. Petersburg. Inv. No. 520.

The present painting is a sketch for the triptych of *St. Ildefonso* (Kunsthistorisches Museum, Vienna) which was commissioned to Rubens by the Infanta Isabella for the altar of the Fraternity of St. Ildefonso in the Royal Church of St. Jacob at the Caudenberg, Brussels (for further detail see Rooses 1905, pp. 535-537; M. de Maeyer, *Albrecht en Isabella en de Schilderkunst.* Brussels, 1955, pp. 126-127). The altar was erected to commemorate Archduke Albert (d. 1621),

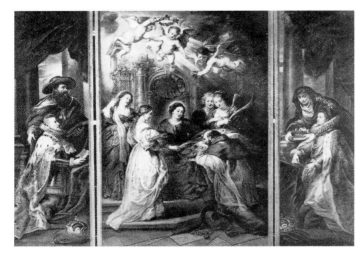

Rubens, *The Vision of St. Ildefonso.*
Triptych. Kunsthistorisches Museum, Vienna.

who had founded the Brotherhood in Lisbon in 1588 (at the time of his governorship in Portugal). In 1603 the seat of the fraternity was moved to the Netherlands.
Legend has it that St. Ildefonso (606-667, Archbishop of Toledo from 657) had a vision of the Virgin when he arrived at his church, accompanied by the dean and some lay brothers on the eve of the Assumption festival; the Virgin was surrounded by attendant female saints and angels. The lay brothers scurried away, in

fright, and the Virgin bestowed on Ildefonso a sumptuous vestment in reward for his zealous defence of the Immaculate Conception dogma (for more details see Réau 1955-1959, III, pp. 676-678; Künstle 1926, p. 329; J. Coulson, *The Saints. A Concise Biographical Dictionary.* London, 1955, p. 232).
According to Rooses (1886-1892, II), the Virgin is surrounded by St. Rosalia, St. Agnes, St. Catherine and St. Barbara. In 1940 Knipping (B. Knipping, *De Iconographie van de Contra-Reformatie in de Nederlanden,* vol. I, Hilversum, 1940, pp. 203-204) observed that the identification was hypothetical since no attributes of the saints appeared in the painting. The right and left sections carry representations of the donators kneeling in prayer: the Infanta Isabella with St. Elizabeth of Hungary (not St. Clara, as assumed by Rooses in 1886-1892, II) and Archduke Albert with St. Albert of Liege in a cardinal's vestments.
The present oil sketch is an independent version of the altarpiece housed in the Vienna museum. The differences between the two are mainly stylistic and only to a certain extent iconographic.
The figures of the scurrying lay brothers do not appear in the Vienna altarpiece, but there are angels, which were evidently abandoned in the sketch (see the material characteristics). St. Albert is shown in the Vienna painting wearing a black hat and a violet mantle as a sign of mourning because the altar was commissioned by the widow to commemorate her late husband (Künstle 1926, p. 44). Instead of two gold crowns on the book in her hand, St. Elizabeth in the Vienna picture has three diadems: of laurels, of roses and of gold (Künstle 1926, p. 44). The Infanta holds a rosary.
The main difference of the sketch from the altarpiece lies in that the latter is a real triptych, i.e. a folding object consisting of a central panel and two hinged wings, each in a frame of its own. The sketch shows the triptych unfolded, seen as a single composition not divided into the central panel and shutters. Rubens had already resorted to this device in his previous work.
By the turn of the seventeenth century polyptych altars had already dropped out of fashion in Europe and only in the Netherlands this old tradition was still cultivated (for further particulars see C. Eisler, "Rubens' Uses of the Northern Past...", *Bulletin des Musées Royaux des Beaux-Arts de Belgique,* 1967, pp. 43-78). Rubens produced a considerable number of triptychs for altars and tombs, especially in the years immediately following his return from Italy. In one of his early masterpieces, the *Raisin of the Cross* triptych (1610-1611, Antwerp Cathedral), the artist

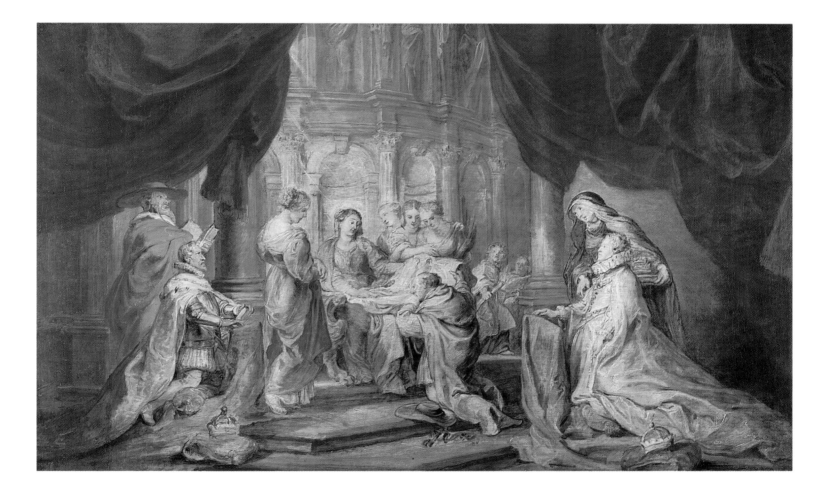

The Vision of St. Ildefonso.
The Hermitage, St. Petersburg.

had attempted to overcome the lack of unity in composite works of this kind by incorporating the pictures on the wings into the general design of the central panel, even though the side parts remained separated from the central piece by the framing.

The Hermitage sketch, which was produced in 1630-1631 (the altar was consecrated in 1632 — see Rooses 1905), reflects Rubens' novel tastes characteristic of his last period. Closely following the text of the legend of St. Ildefonso's vision, the artist strove to capture the spatial relationships, the effects of light and air and the riot of colours in such a way as to recreate the scene as if he had actually seen it.

Rubens placed the Virgin and the donators in the same ecclesiastical setting. The donators and their saints are separated from the scene of the miracle that is being worked before their eyes only by the columns; the composition is based on a viewpoint in the foreground from which everything is consistently projected, in a slightly oblique perspective into the depth of an inner room (this was even more pronounced before the enlargement, which affected the composition). The figures of the donators are placed nearer to the viewer and are shaded by drapery from the celestial light blazing in the depth of the church; the figures of the Virgin and the saints are somewhat blurred by the radiance. The diagonal contours of the three steps on which the Virgin's throne rests emphasize the direction into the depth, where the lay brothers are running.

The central group is quite asymmetrical — the desolate figure of Rosalia on the left is opposed by three embracing holy maidens on the Virgin's right. The group of figures is subdued by the architectural setting in which spatial considerations are predominant: the diagonal with the elevation where the Virgin is seated is juxtaposed with a wall forming a semicircle. While working on the composition the artist further enriched the sculptural decoration of the wall by adding the caryatides, the cornice and the niches with statues.

The dynamic effect of the picture is enhanced by its succinct, sketchy style: the handling is light and free, except for the parts that are lighter in colour or are in greater relief, which are impasted and do not show the yellowish-grey ground otherwise visible all over the surface and in places breaking the monotony with some patches of local colours.

Provenance: In the eighteenth century in the collection of the Archbishop of Cologne, Clemens August von Bayern, who was the son of the Governor-General of the Netherlands, Elector Maximilian of Bavaria. Appeared in the sale of that collection in Bonn, which opened on 14 May 1764. Afterwards owned by the French dealer Boileau *père*, in whose possession it was seen by the French collector Lalive de Jully, who wrote to Comte de Cobenzl in Brussels in May 1765: "This sketch is two feet long and one foot high. It is most probably a sketch by Rubens, the original version of the fine painting in Condenberg. Both figures seen on the wings, the Archduke and the Infants, appear in the sketch too. But the picture is so beautiful that I found the sketch rather inferior and was unimpressed by it at a sale in Paris this winter, where it was referred to as acquired at the Bonn sale of the Bavarian Elector's pictures from his collection in Cologne. I am inclined to believe that this oil sketch, although an original Rubens, has sustained some damage and been repaired in many places. Boileau got it at the sale in Paris; its price was even under 400 livres. His wife tells me that he wants thirty louisdors for it, which is the equivalent of 725 livres" (Castan 1885). Somov's assertion (Cat. 1902) that the painting was bought for the Hermitage at the auction of Boileau-père's collection on 4-9 March 1782 is erroneous, as is Vlieghe's conjecture (1973) that it was bought by Carl de Cobenzl and entered the Hermitage in 1768 (It is not recorded in the manuscript catalogue of the Cobenzl collection).

Preliminary works: Three drawings by Rubens for the heads of the women in the present sketch – Albertina, Vienna: 1) the Virgin's head, inv. No. 457; black chalk and sanguine, 19.3 x 16.7 cm; 2) a woman's head in right profile, for Rosalia's head, inv. No. 455; black chalk and sanguine, 24.5 x 16 cm; 3) a young woman's head in left profile, a study for Agnes' head, inv. No. 456; black chalk, sanguine, pen and ink, touched with white, 25.3 x 16.6 cm. Vlieghe (1973) believes that the Hermitage piece was preceded by a drawing housed in the Rijksmuseum in Amsterdam (the Fodor collection) — *Infanta Isabella with St. Elizabeth of Hungary*, inv. No. 123; brown ink and pen, with wash over the original drawing in black chalk, 20 x 7.8 cm. A drawing of the left wing of the triptych, *Archduke Albert with St. Albert of Liege* is in the Philadelphia Museum of Art (inv. No. 28-42-4013; brown ink and pen, with wash over the original sketch in black chalk, 20.3 x 97 cm — see J. S. Held, "Some Rubens Drawings — Unknown or Neglected", *Master Drawings*, vol. XII, No. 3, 1974, pp. 254-256, fig. 30).

Final Version: Altarpiece of St. Ildefonso, 1630-1632, Kunsthistorisches Museum, Vienna; oil on wood, central piece 350 x 236 cm, wings 352 x 109 cm each (the central panel engraved by I. Witdoeck in 1638); the side panels bear *The Holy Family under an Apple Tree* (at present detached from the altar and combined to form a single composition).

The Vision of St. Ildefonso, detail.
The Hermitage, St. Petersburg.

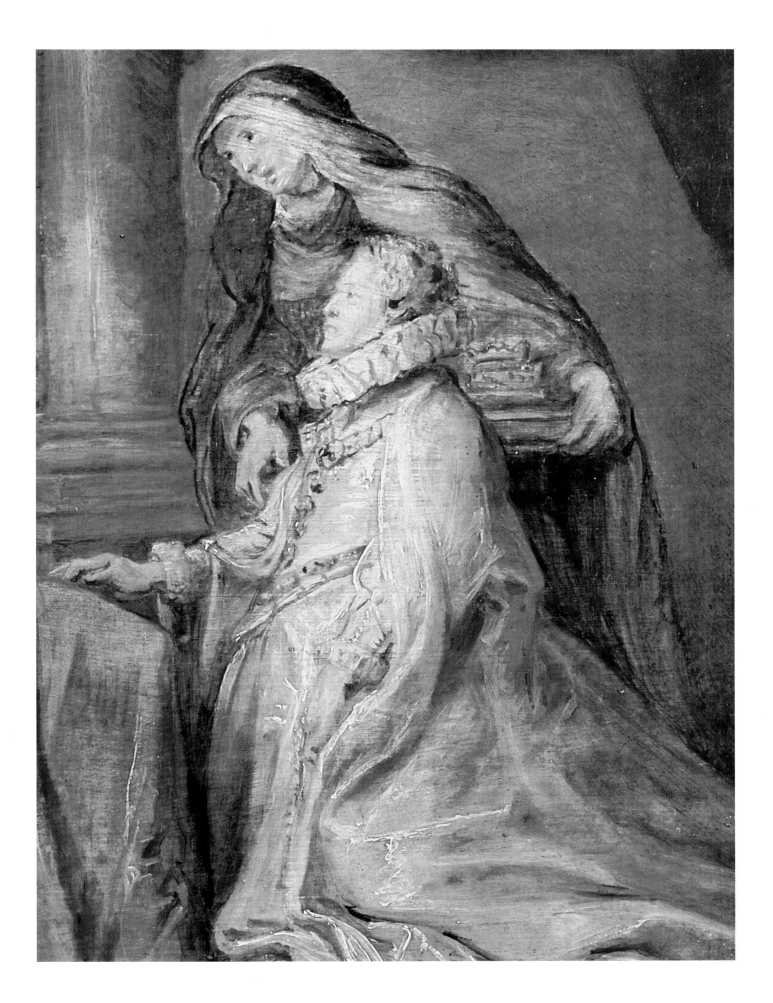

27. *THE LAST SUPPER*

1631-1632.
Oil on oakwood. 45.8 x 41 cm.
Cradled. The paint layer is extremely uneven. The middle part (the upper parts of the figures) is painted more thoroughly. In places the light-coloured ground was left uncovered revealing a drawing in black chalk or with a brush in brown paint. The same colour prevails throughout. Only the clothes of some characters are touched with pale colours; the more noticeable are the rose-red clothes of Christ and the yellow ochre cloak of Judas.
The Pushkin Museum of Fine Arts, Moscow. Inv. No. 653.

Christ is shown blessing the bread and wine for the Eucharist (St. Matthew 26: 26-28; St. Mark 14: 22-25), but the Apostles' agitation and the ominous figure of Judas in the foreground evoke the preceding episode of the Gospels, Christ predicting Judas' betrayal (St. Matthew 26: 21-25; St. Mark 14: 18-21). The present painting is a preliminary sketch for the large picture commissioned by Catharina Lescuyer in 1630-1631 in memory of her father Pauwels Lescuyer for the altar of the Holy Sacrament Chapel in the St. Rombout Church in Mechlin, where it was placed in 1632. Taken to Paris during the Napoleonic Wars, the picture was later transported to Italy and is now in the Pinacotheca di Brera, Milan. The Musée des Beaux-Arts in Dijon has two small pictures forming a *predella* for the Brera panel: *Christ's Entry into Jerusalem* and *Christ Washing the Feet of the Apostles*.

The Moscow sketch on the whole coincides with the Brera panel. The nearly square format of the sketch became more vertical in the final version; the figures are more slender.

The large, highly finished altarpiece does not rank among Rubens' masterpieces as it is largely a product of his assistants, who diligently and competently executed his design. The Moscow sketch, on the contrary, enables the viewer to observe the course of the artist's creative thinking as it is reflected in numerous modifications of the original concept. Most of the changes concern details, such as the characters' hands, folds of their clothes, etc. In the lower part of the picture (the legs and feet), they are particularly numerous. Some of the modifications were not incorporated in the final version, but they were included in the artist's small-scale grisaille executed as a model for engraving. Each of the three (the altarpiece panel, the present sketch and the grisaille model for engraving) is to some extent different from the others.

In the altarpiece of 1631-1632 the master returned to the traditional type of symmetrical composition, with Christ in the centre facing the viewer, and the meaning of the scene is self-evident. The design is reminiscent of the painting in Antwerp Cathedral by Otto van Veen,

Rubens' teacher. At the same time, comparison with Otto van Veen's picture shows how full of vitality and dramatism Rubens' art is and how vigorous and strong, both physically and spiritually, his characters are. In the Moscow sketch these features of Rubens' art are particularly salient.

The Apostles' agitation is evidently connected not only with the Holy Sacrament, but also with the prediction of Judas' betrayal they have just heard. In Rubens' composition the two main episodes of the Lord's Last Supper are combined (J. Müller-Hofstede, "Rubens' Grisaille für den Abendmahlstich des Boetius à Bolswert", *Pantheon*, 1970). Instead of the traditional solemnity required in a representation of the Eucharist, the dominant note here is struck by the strain of human emotions. The theme of spiritual salvation and triumph of good resounds together with the motif of confrontation between good and evil. In this context the contraposition of the two figures in the foreground is very significant: Judas, dejected, looking away from Christ, is countered by the young man whose back is turned to the viewer. As a faithful pupil, he is engrossed in what Christ is saying.

The sketch is datable at *ca.* 1631, when Rubens was commissioned the altarpiece (Rooses 1886-1892, II; Puyvelde 1939; Held 1980), although attempts have been made to assign it to an earlier date, *ca.* 1620 (Oldenbourg 1921; S. Rosenthal, "Zwei unbekannte Rubens-Skizzen", *Der Kunstwanderer*, vol. X, 1928-1929).

The Last Supper.
The Pushkin Museum of Fine Arts, Moscow.

Provenance: Purchased for the Hermitage from the Cobenzl collection in Brussels in 1768. Transferred from the Hermitage to the Pushkin Museum of Fine Arts in Moscow in 1924. Appeared in the sale at Lepke's in Berlin on 4-5 June 1929, but was not sold and returned to Moscow.

Final Version: *The Last Supper*, 1631-1632; Brera, Milan, inv. No. 679; oil on wood, 304 x 206 cm. In addition to the present Moscow sketch, the artist used a study from life, *Head of an Apostle*, oil on canvas, 45 x 32 cm, private collection, London; Müller-Hofstede 1968, p. 245, pl. 176. There is also a grisaille version by Rubens of the Milan altarpiece (*The Last Supper*, *ca.* 1632; oil on wood, 61.8 x 48.5 cm) in the collection of Dr. Peter Mertens in Estoril, Portugal. The grisaille, which incorporates some details from the present sketch not included in the final version, was produced as a model for engraving by Boëtius à Bolswert (*ca.* 1580-1633) (V.-S. 1873, p. 37, No. 220). For further information on the grisaille see Müller-Hofstede 1970; Held 1980, pp. 468-469, cat. No. 341, pl. 335. For other engravings after the Milan altarpiece see V.-S. 1873, p. 37, Nos. 221-226.

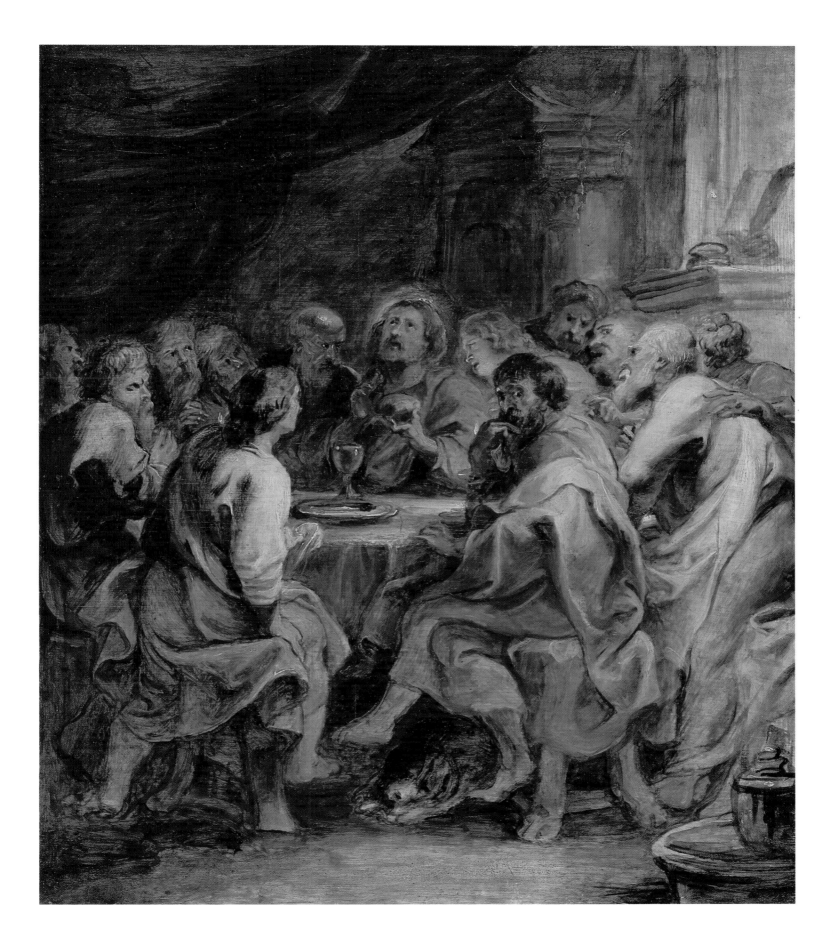

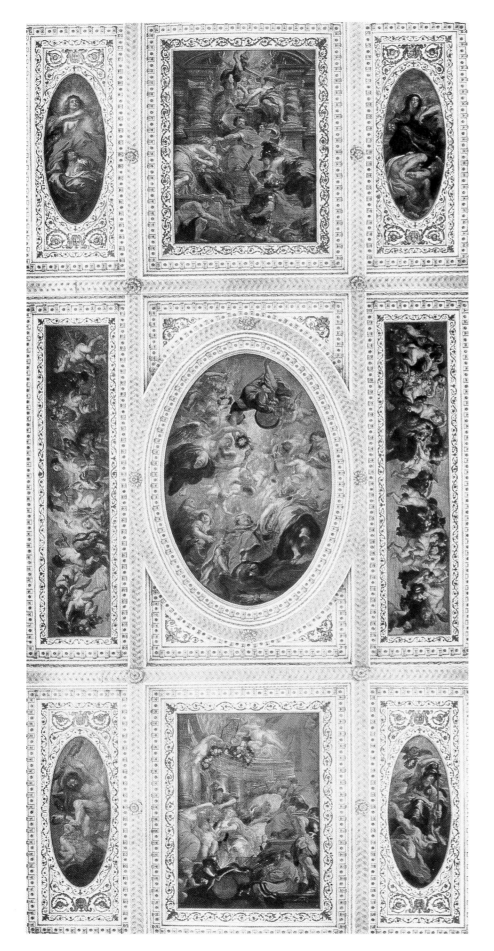

Rubens (with pupils).
Ceiling Painting of the Whitehall
Banqueting House, London.
(before the reconstruction in 1974).

28-29. SKETCHES FOR THE CEILING PAINTINGS IN THE ROYAL BANQUETING HOUSE IN WHITEHALL, LONDON

The Banqueting House in London designed by the architect Inigo Jones was built in 1619-1622. Constructed in the so-called Palladian classical style, which was then new in England, the building was intended for court ceremonies, festivities and theatrical performances.

It appears that as early as 1621 commissioning the ceiling decorations from Rubens was under consideration. In connection with this proposed commission Rubens wrote to William Trumbull, the English agent in Brussels, in his letter of 13 September 1621, describing his own monumental decorative style as follows: "Regarding the hall in the New Palace I confess that I am by natural instinct better fitted to execute very large works than small curiosities. Everyone according to his gifts; my talent is such that no undertaking, however vast in size or varied in subject, has ever surpassed my courage" (CDR 1887-1909, III; Masters of Art on Art, vol. III, Moscow, 1971, p. 194).

At that time, however, the whole subject was confined to talks, although Per Palme observed in 1956 that Rubens must have begun working at the Banqueting House project as early as the 1620s and it was then that the scene for the central oval, The Ascension of Psyche to Olympus (its sketch is in the Liechtensteinische Staatliche Kunstsammlungen, Vaduz) was conceived. Actually the commission was received from Charles I (1600-1649), the son of James I Stuart, in the winter of 1629-1630, when the artist was on a diplomatic mission in London, negotiating a peace treaty between Spain and Britain. The programme of the ceiling decoration consisted in glorifying the activities of James I for unifying the country and bringing it peace and prosperity (for further details see Per Palme 1956).

After returning to Antwerp in August 1630 Rubens set to work on the plafond and completed it in early 1634. All the canvases were ready for shipment on 11 August 1634 (according to Balthasar Gerbier's letters to Charles I and Tobias Matthew – CDR 1887-1909, III). They were not shipped, however, until July-December 1635 and were installed without Rubens' participation.

This is the only decorative cycle by Rubens that has remained intact in its original position (the Banqueting House is now occupied by the Royal United Service Museum). The plafond was restored in 1951. In 1974 the paintings by Rubens were arranged according to the plan offered by Held (for more detail concerning

the arrangement of the canvases after the restoration and Rubens' original idea of their disposition see Held 1970, 1982).

The hall for which the paintings were executed is two-tiered, with Ionic columns in the lower part and Corinthian order above, the ceiling resting on the entablature. The painted decoration consists of nine separate compositions in carved gilded framings and shows affinity with the style of Venetian ceilings, like those by Titian and Veronese, which Rubens had already used in 1620 in the decoration of the Jesuit Church in Antwerp. Comparison with ceilings painted by Rubens' Italian contemporaries, such as Lanfranco, Sacchi and particularly Cortona (the ceiling in Palazzo Barberini, begun in 1633), in whose highly illusionist works the entire ceiling seemed open to the sky, may make the plafond of the Banqueting House appear somewhat archaic. The artist, however, offered a new interpretation of the old motif: the medallions are treated not as independent pictures but as lights opening into some ideal "third tier" of the very hall where the viewer is (Evers 1942, p. 260). In the centre of the cycle is a large oval with the picture The Apotheosis of James I (see No. 29). It is adjoined by two rectangular pieces placed along the longitudinal axis of the hall: The Union of the Two Crowns (see No. 28) and The Wise Government of James I (a sketch for which is in the Akademie der bildende Künste, Vienna) in the depth (another sketch, for its left part, is in the Paul Mellon collection, Yale Center for British Art, New Haven, USA; a sketch for the right side of the composition is in the Musées des Beaux-Arts in Brussels). The central oval is flanked by two long frieze-like panels representing triumphal processions of cupids, while the rectangles are flanked by smaller ovals with allegories of the King's virtues prevailing over vice (oil sketches for these are in the Koninklijik Museum voor Schone Kunsten, Antwerp; the Count Seilern collection, London; the collection of Frau Dr. Anni BodmerAbegg, Zurich; the Museum Boymans-van Beuningen, Rotterdam). The original sketch of the entire plafond is in the Brand collection, Glynde Place, Sussex, England (see No. 29). Among the presently known works for ceiling paintings in the Banqueting House, which are now in the Hermitage, are two sketches made by Rubens himself (No. 13) and two copies from the modelli, probably lost, that were final versions of the compositions The Peaceful Reign of James I (inv. No. 2579) and The Union of Great Britain (inv. No. 2576). A woodcut (on three blocks) of the entire ceiling was made by Simon Gribelin (1661-1733) in 1720 (V.-S. 1873, No. 60).

121

28. THE UNION OF THE TWO CROWNS

Ca. 1630.
Oil on oakwood. 64 x 49 cm.
The Hermitage, St. Petersburg. Inv. No. 513.

This is an oil sketch for the decoration of the ceiling panel nearest to the entrance in the Banqueting House in Whitehall.

The original titles, *James I Appoints Charles King of Scotland* (Somov 1902) or *James I Hands Over the Sovereignty of Scotland to Prince Charles* (*The Hermitage Catalogue* 1958), should be changed to *The Union of the Two Crowns*. In 1970 Held called the composition *The Union of the Kingdoms*, and later (Held 1980) changed it for *King James I Designates the Prince Charles as Heir to the United Kingdoms of England and Scotland*.

This theme was one of the leading ones in the pro-

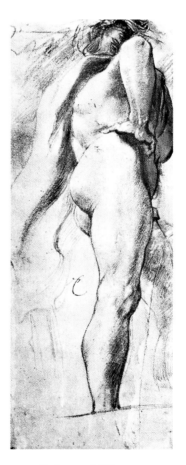

Rubens. *James I Enthroned.*
Sketch. City Art Gallery, Birmingham.

gramme of the ceiling decoration (the idea of peace promotion was dealt with in the other rectangular piece). In 1603, after the death of Queen Elizabeth, who left no offspring, she was succeeded on the throne by James VI of Scotland, the son of Mary

Stuart, who inherited the English crown as James I, which meant a peaceful termination of the age-long feuds between the two neighbouring kingdoms. The resultant union of England and Scotland was regarded as James I's personal desert.

James I is shown with all his royal regalia seated on the throne, the back of which is decorated with a carved sphinx (the King was nicknamed "the northern sphinx" by his contemporaries — see Burchard 1950, pp. 25-26); with a touch of his sceptre he endows infant Charles with power over the entire isle. Scotland and England, aided by Britannia (personified as Minerva to symbolize wise government), are bestowing a double crown on Charles' head. Over him two cupids are carrying an emblem of the United Kingdom (or of Wales — see Smith 1830-1842, II, pp. 232-233, No. 814), while a third is setting fire to the weapons, which are no longer needed. The scene is laid in a rotunda under rib vaulting which seems to belong to the hall where the beholder is.

Compositionally the painting is fully analogous with the ceiling painting *Esther Before Ahasuerus* produced by Rubens for the Jesuit Church in Antwerp, which, in its turn, was based on Veronese's plafond of the same subject in the San Sebastiano Church in Venice — even the guard's figure at the foot of the throne reappears in the Antwerp plafond and in *The Union of the Crowns*; in the latter, however, as pointed out by Burchard in 1950 and Burchard & d'Hulst in 1963, the guard was reworked after Rubens' drawing *A Warrior* (Louvre, Paris) sketched from Correggio's plafond in the Cathedral of Parma.

Rubens. *A Warrior.*
Drawing. Louvre, Paris.

It is probable that originally Rubens intended to present the occasion as occurring without the King's participation or that he wanted to divide the scene into two episodes. This stage in the evolution of the

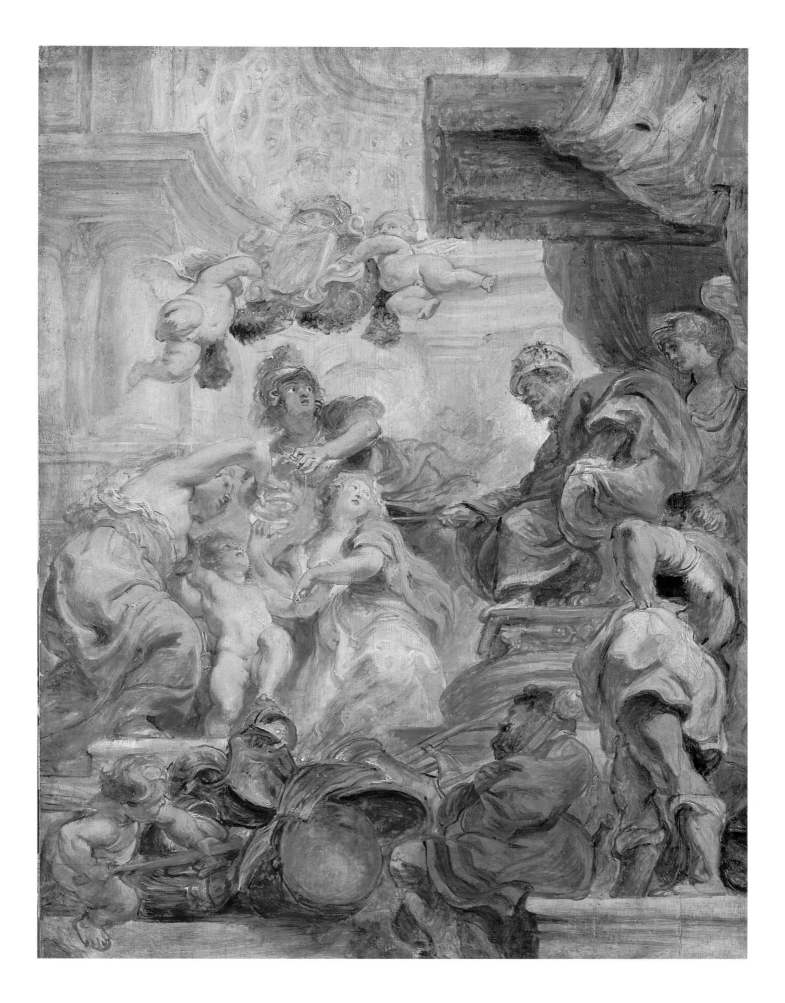

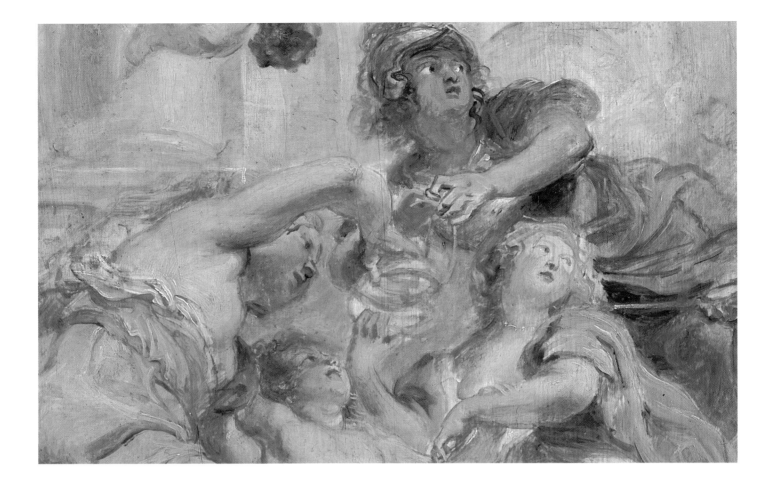

subject is reflected in the preliminary sketch in the Museum Boymans-van Beuningen (Rotterdam), in which the composition is confined to the group around Prince Charles, forming a closed oval; only Britannia's head is in right profile. Instead of the cupids with the state emblem there are genii with a laurel crown; one of them also faces right.

As Rubens proceeded to make the composition more complex, or to combine the two episodes in one scene, he produced two more sketches. The first one is also confined to the group surrounding Prince Charles, but it is designed in a pyramid-like shape and is very close to the Hermitage piece. Presumably this sketch was the next step in the preliminary work leading to the Hermitage *modello*.

The second sketch, in the City Art Gallery of Birmingham (the R. H. Davis collection), is preparatory for the right side of the more advanced composition and must have also preceded the *modello,* since it has only the figures of the King and the guard and contains no details seen in the *modello.*

The Union of the Two Crowns, detail.
The Hermitage, St. Petersburg.

Provenance: Purchased for the Hermitage from the Crozat collection in Paris in 1772.

Preliminary works: 1) Rubens' sketch *England and Scotland Crown Prince Charles*, Museum Boymans-van Beuningen, Rotterdam; oil on wood, 64 x 49 cm. 2) Rubens' sketch *England and Scotland Crowning Prince Charles*, Minneapolis Institute of Arts, USA; oil on canvas, 84.1 x 70.7 cm. 3) *Rubens' sketch James I Enthroned*, City Art Gallery (the R. H. Davis collection), Birmingham; oil on wood, 65.5 x 48.3 cm. 4) Rubens' drawing *A Warrior*, Louvre, Paris, No. 20255; sanguine, touched with red and white oil, 38.2 x 14.1 cm. The drawing was sketched by Rubens from Correggio's plafond in the Cathedral of Parma, where the figure is greatly damaged at present; originally done in Italy, but reworked *ca.* 1630. A non-extant counter-proof of the drawing must have been employed in the present composition (Burchard & d'Hulst 1963, No. 165; Lugt 1949, No. 1106). 5) Rubens' sketch *Mercury and a Yoman*, Museum of Fine Arts, Boston; oil on wood, 63.5 x 52.5 cm (see Held 1980, cat. No. 139, pp. 208-209, pl. 145).

Final Version: *The Union of the Two Crowns*, one of the nine paintings decorating the ceiling of the Banqueting House in Whitehall, London.

124

Rubens. *England and Scotland Crown Prince Charles*. Sketch. Museum Boymans-van-Beuningen, Rotterdam.

Rubens. *England and Scotland Crowning Prince Charles*. Sketch. Minneapolis Institute of Arts, USA.

29. *THE APOTHEOSIS OF JAMES I*

Ca. 1630.
Oil on canvas. 89.7 x 55.3 cm.
The Hermitage, St. Petersburg. Inv. No. 507.

This painting is a sketch for the central medallion of the plafond in the Banqueting House.

James I with a sceptre in his hand is seated on the globe carried by an eagle with a thunderbolt in its claws. On his right Justice is shown, with a balance and a sword, while on his left are Religion before an altar and Faith with a book. Winged Victory with a caduceus and Minerva with a sword and shield are

Rubens. *The Apotheosis of James I.*
Sketch for the ceiling painting in the Whitehall
Banqueting House, London. Mrs. H Brand collection, England.

bestowing a laurel wreath on the King; the flitting cupids are carrying the crown and orb, as the palm and the olive branch and trumpeting glory. The scene, which appears to open through a light in the ceiling, is on the whole fashioned after classical apotheoses of Alexander the Great or Roman emperors.

Except for its rectangular form, the present Hermitage sketch differs but little from the final version, where Justice has a bifurcated thunderbolt instead of a zigzag sword and Minerva is armed only with a sword. The figures in the sketch are arranged more sparsely and are more foreshortened, especially James. The difference from the original composition sketch (collection of Mrs. H. Brand, Glynde Place, England), where there are six angels instead of ten, is more considerable.

The present sketch is evidently the *modello* which Van der Doort described in the catalogue of the Gallery of Charles I (see Millar 1960), because the medium and dimensions given in the catalogue coincide with those of the Hermitage sketch.

Provenance: In 1639 the sketch was in the Gallery of Charles I (Millar 1960). Later it was in the collection of the artist Godfrey Kneller (1646-1723), who, according to Horace Walpole, thoroughly studied it, as evidenced by his sketch for the picture showing King William in his drawing-room (*Aedes Walpolianae* 1752). Between 1722 and 1732 it was already in the Walpole collection (see the handwritten catalogue of Houghton Hall in the Cholmondely collection). Purchased for the Hermitage from the Walpole collection in Houghton Hall, England, in 1779.

Preliminary works: 1) Rubens' original sketch of the composition (for seven out of the nine pictures: the central oval and the side panels and ovals), Mrs. H. Brand collection, Glynde Place, Sussex, England; oil on wood, 95 x 63 cm. The central oval was engraved by L. Vorsterman Jr. According to Millar's hypothesis (1956), the composition sketch was painted in Antwerp, before Rubens left for England. But Held (1970) proved convincingly that the sketch had been produced in England when Rubens received the commission. 2) Rubens' sketch for the figures of Faith and Victory (close to the sketch in the Brand collection, Glynde Place, England), Louvre, Paris, No. 2126; oil on wood, 41 x 49 cm.

Final Version: *The Apotheosis of James I*, one of the nine paintings decorating the ceiling of the Banqueting House, Whitehall, London.

Rubens (with pupils). *The Apotheosis of James I.*
Ceiling painting in the Whitehall Banqueting House, London.

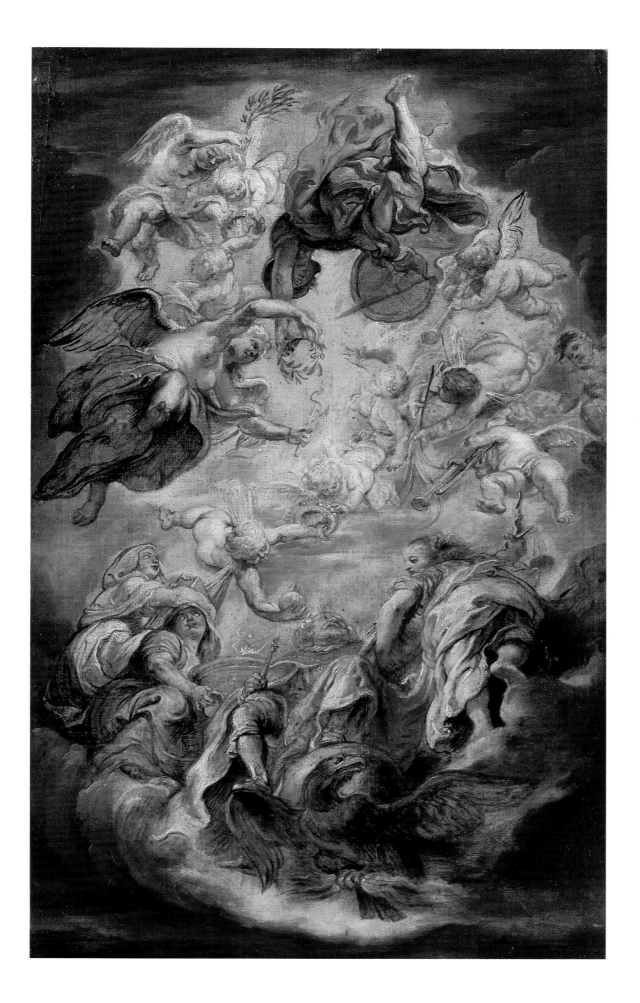

30. *LANDSCAPE WITH A RAINBOW*

1632-1635.
Oil on canvas. 86 x 130 cm.
Transferred from wood by A. Sidorov in 1869.
The Hermitage, St. Petersburg. Inv. No. 482.

The pastoral idyll in the foreground was probably intended to be a rustic parallel of the fashionable idylls in *The Garden of Love* (1632-1635, Prado, Madrid; the Rothschild collection, Waddesdon Manor, Aylesbury, England) and in the *Landscape with a Party in the Steen Park* (1635-1640, Kunsthistorisches Museum, Vienna). Unlike the present Hermitage picture, *The Garden of Love* is dominated by the group of

Rubens. *The Garden of Love*.
Prado, Madrid.

figures, not the landscape. But there is an undoubted analogy between the two couples of lovers in the Hermitage painting and the couples on the left in *The Garden of Love*.

Rubens' hand has never been questioned — although in 1965 Puyvelde quite groundlessly described the present picture as a replica of a painting in the Louvre, whereas the quality of that painting is in fact inferior (see below).

In 1931 Kieser pointed out some possible prototypes of this composition in Titian's work: thus the architectural motifs in the background are found in an engraving by an unknown master (presumably a seventeenth-century Dutchman) after a drawing by Titian or his followers (Kieser 1931, p. 281, pl. 1); and the foreground composition is similar to that of a Titian landscape, known from the Lefebvre engraving of 1642 (according to Kieser, Rubens could see either the original Lefebvre engraving or one of its copies). This similarity, however, concerns only the arrangement of the seated figures in the centre and coulisse-like place-

ment of trees on one side. While in the background Titian's motifs are quite obvious and likely to have been intentionally introduced by Rubens (Glück 1945), the foreground composition rather reflects a general influence of "Titian's scenes in the landscape", which was characteristic of Rubens' work in the 1630s (*The Holy Family with Saints in the Landscape*, Prado, Madrid).

Rubens considerably modified the motifs derived from the Venetians: he broke free, as it were, from the close setting characteristic of the Renaissance painting — the mountains in the background of the picture seem to have been moved apart, the horizon is veiled in haze and the middle ground is bathed, in sunshine.

The artist's striving for harmony and balance is evident even in the content (a pastoral motif and a rainbow in the sky), which plainly distinguishes the present piece from the tense dynamism of the "heroic landscapes" of the 1620s (see No. 16)

Tinged also with some Italian reminiscences, it differs from the so-called Flemish landscapes of the second half of the 1630s. Therefore the present piece should be assigned to a date between 1632 and 1635.

Provenance: In the seventeenth century in the collection of Duc de Richelieu (Roger de Piles 1677; Burchard 1927; Glück 1945). Afterwards the painting was given as a present to Comte de Brühl by the Elector of Bavaria, son of Emperor Charles VII (Somov 1902). Purchased for the Hermitage from the Brühl collection in Dresden in 1769.

Preliminary works: The drawing *Shepherd with a Flute and a Seated Couple* (*Feasting Mercenaries* on the reverse), the Lugt collection, Paris; black chalk, pen and ink, 27 x 35.7 cm; inscribed in Rubens' hand: *met een groot slegt landschap* (with a large flat landscape) — see *Dessins flamands du dix-septième siècle. Collection Frits Lugt. Institut Néerlandais. Exposition...*, Gand, 1972, p. 121, No. 85.

Versions: Rubens' studio, *Landscape with a Rainbow*, Louvre, Paris (temporarily in the Musée de Valenciennes), from the collection of Louis XIII; oil on canvas, 122 x 172 cm. Kieser (1931) noted "lesser orderliness" in the Louvre painting in comparison with the present Hermitage picture, which made him think that it belonged to an earlier stage in the evolution of the concept. But in 1945 Glück correctly described the Louvre painting as a later replica of its Hermitage counterpart.

Prints: By Schelte a Bolswert (1581-1659) (V.-S. 1873, No. 10), with some alterations (e.g. the rainbow is on the right).

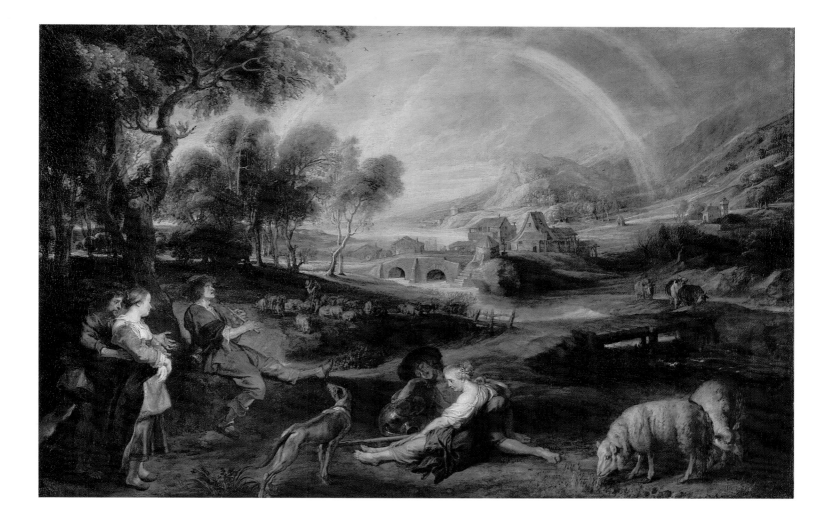

Landscape with a Rainbow.
The Hermitage, St. Petersburg.

Theodor van Thulden. Plan of Antwerp. 1635.
3. Felicitations on the Arrival of the Infante Ferdinand
in Antwerp.
6. Statues of the Emperors of the Hapsburg House.
8. The Arch of Ferdinand.
10. The Temple of Janus.
14. Mercury Leaving Antwerp.

16. The Arch of Hercules,
Etching in C. Gevartius
Pompa Introitus Honori Serenissimi Principis
Ferdinandi Austriaci..., Antwerp, 1642.

31-37. SKETCHES OF STATE DECORATIONS FOR THE TRIUMPHAL RECEPTION IN ANTWERP OF THE NEW SPANISH GOVERNOR OF THE SOUTHERN NETHERLANDS CARDINAL INFANTE FERDINAND ON 17 APRIL 1635

The custom of the ceremonial entry (Joyeuse entrée) of new Governors existed in the Netherlands from the Middle Ages. In the seventeenth century when the Netherlands became part of the Hapsburg Empire, splendid civic welcomes still remained festive occasions which reflected something of the public sentiment. At the same time the pageantry of these occasions reflected the atmosphere of the court with its obsequious and bombastic praise of all that the ruler did.

In the course of time certain conventions had evolved for decorating the city on such occasions, a particular routine and itinerary were adopted for the procession's passage through the city and certain subjects and motifs of decoration had become traditional.

These traditions were followed by Rubens too, when, in November 1634, he received a commission from Antwerp's magistrates to design a pageant of welcome for the incoming successor to the Archduchess Isabella as Governor — Cardinal Infante Ferdinand, brother of King Philip IV of Spain.

Rubens' decoration of Antwerp for Ferdinand's triumphal entry has, until very recently, been regarded in literature as an ordinary tribute to the ruler, distantly related to historical events in their real significance, which was characteristic of "secular apotheoses" in the age of absolutism. It has not been disputed that any reminders of the city's needs included in the programme of the pageant were anything but humble petitions from faithful subjects. Some scholars even believe that on account of the shape Rubens gave to the city's appeal to the ruler, its urgency was "somewhat veiled" (Rooses 1886-1892, III), and the public sentiment was "smothered" by the splendour and grandeur of Rubens' art (Evers 1942). Artistically, the difference of the decorations for the reception of 1635 from those on previous occasions has often been reduced to the general stylistic dissimilarities between the Baroque and the art of the Renaissance and Mannerism (Roeder-Baumbach & Evers 1943).

This viewpoint is unacceptable. What has been appreciated until recent times is the fact that the programme of the Antwerp reception in 1635 and its artistic aspect were unique in principle (Varchavskaya 1967).

131

Ferdinand arrived in Brussels on 4 November 1634 after defeating the Swedish army at Nördlingen in Germany (the fact that he had been created Cardinal and Archbishop of Toledo did not prevent him from taking part in the hostilities in the capacity of Commander-in-Chief of the Spanish troops). On 13 November 1634 the magistrates of Antwerp asked Ferdinand to make his triumphal entry into Antwerp. Ferdinand was to have arrived in Antwerp in the middle of January, but his visit was postponed twice — first until 3 February and then until 17 April 1635. The postponements were partly due to the extremely cold weather; the main cause, however, was the necessity to check the advance of the troops of the Franco-Dutch coalition, which had made an incursion on the Southern Netherlands. Ferdinand's actions were successful again. And although the victories scored by the Cardinal Infante were merely fortuitous and made no decisive impact on the outcome of the Thirty Years' War, the Southern Netherlands was not unaffected by them.

After the separation of the Dutch Republic as a result of the sixteenth-century revolution, when the Dutch Navy's blockade of Antwerp cut off the Southern Netherlands from the sea, their only link with the world at large, which provided them with at least some chance of retaining their national economy independent, was a southward route to the Mediterranean, across Germany

Rubens. *The Triumphal Arch of the Mint* (front). Sketch. Koninklijk Museum voor Schone Kunsten, Antwerp.

and the Alps. But even this was in jeopardy in the 1630s: the Spaniards suffered defeat after defeat and the trade route across Europe became increasingly perilous. Therefore, when Ferdinand's victory in Germany seemed to have set back the Swedes, the new Governor was seen by his Netherlandish subjects as a real saviour of their country. After such a splendid beginning, great expectations were made of him. For this reason the decoration of the festive city's arches and porticoes was to become a rostrum, as it were, from which the people of Antwerp sought to make the Governor aware of their disastrous plight, "...to demonstrate the present level of impoverishment in the country and the city in order that His Majesty may be impelled to help them," as the resolution adopted

by the Great Council on 7 December put it (Rooses 1886-1892, III, p. 293; Martin 1972, p. 27).

As soon as he entered the city, Ferdinand was to see that his new subjects set great hopes on him (No. 31). The next highlight on his route was Philip's Arch representing the "happy marriages" that linked the Netherlands with Spain, which reminded the new Governor of the significant role the Netherlands had played in the history of the Hapsburg dynasty. The figures of the emperors belonging to the dynasty portrayed in the portico in la Place du Meir (No. 32) seemed to call upon Ferdinand to uphold the glory of his predecessors. The Apotheosis of the Infanta Isabella (No. 33), the subject of the next portico, was to stress the importance of his new office and to urge Ferdinand to follow his predecessor's precepts. The Arch of Ferdinand (No. 34), devoted to the battle of Nördlingen, made it plain which of Ferdinand's deeds entitled him to the status of a hero. The Temple of Janus (No. 35) outlined the magnitude of the task of his future activities. Antwerpia (the Maiden of Antwerp) from the portico Mercury Leaving Antwerp *(No. 36) called upon the Governor to take effective steps for the benefit of the country. The Arch of the Mint carried a picture of the silver mines in Peru, which symbolized potential prosperity. The Arch of Hercules (No. 37) was devoted to the glory in store for him if Ferdinand was to become the saviour of the Netherlands.*

In the sixteenth century the decorations for civic receptions usually consisted of sham architectural structures, fashioned, in three dimensions, out of wood and canvas, like theatrical properties, and adorned with elements of sculpted or painted decor; alternatively, richly adorned platforms were erected and "live pictures" were performed on them. Rubens was the first to substitute paintings for stage sets and performances of this kind. The huge triumphal arches spanning the streets along which the Governor and his train passed or the porticoes in the squares or at crossroads, were flat wooden frames covered with canvas, on which pictures were painted. Decorations in relief were confined to carved wooden entablatures, beams and columns with their pedestals, bases and capitals.

132

Various vases, chandeliers and figures surmounting the architectural structures were cut from planks of wood and painted, as were also some figures and ornaments flanking the main painted decorations on the façades (see the texts of orders for the making of wooden components — Martin 1972, pp. 228-255). There were few statues actually hewn from stone (see below).

A significant role in this may have been played by the resolution of the Great Council, which said: "On account of the general impoverishment of the community it would be desirable to lessen the expenditure generally incurred in the past by such receptions and to compensate this deficit by the beauty and inventiveness of design and general layout" (Rooses 1905, p. 559; Martin 1972, p. 27).

These temporary structures with their fanciful, dynamic contours and illusory painted decorations blended organically with the cityscape, their effect being all the more convincing because the illusory paintings reproduced different levels of reality, as it were. Where direct appeals were to be voiced to the Governor on his way through the city, all boundaries separating the picture from reality seemed to vanish, for the spectators — the guest of honour and the citizens of Antwerp cheering him — found themselves part of the scene taking place in the illusory space of the painting, since the emotional focal point of what was happening was designed to be outside the confines of the canvas, in the viewer's mind (see No. 35 and particularly No. 36). At the same time the scenes in which Ferdinand himself was the main character and which depicted what he had accomplished or was to accomplish were presented either as framed pictures hanging on walls or as tapestries draping the archways, thus distancing them from the past or future (see Nos. 31, 34, 37). Only the statues of the new Governor's ancestors, emperors of the House of Hapsburg, were carved from stone, conveying in this way the idea of the immutability of monuments to heroes abiding in eternity (see No. 32).

The programme for the decoration of the city was worked out by Rubens in co-operation with two

Rubens. *The Triumphal Arch of the Mint* (back). Sketch. Koninklijk Museum voor Schone Kunsten, Antwerp.

eminent public figures of Antwerp, both known for their humanist pursuits: Nicolaes Rockox, the former mayor, a scholarly patron and collector, and Caspar Gevaerts, Secretary to the Magistrature, a man of letters and an authority on classical writers.

Rubens was paid 5,000 florins for designing the nine main structures, for painting two large pictures and for painting the finishing touches to the other paintings executed on a large scale after his painted sketches by several Antwerp artists (see Nos. 31-37).

None of these temporary structures has survived. The pictures that decorated them were presented to the Governor in accordance with the resolution of the Antwerp Council of 29 April 1636 and most of them were lost in the fire of Brussels Palace in 1731. For further information on the preparation of the pageant and its conduct on 17 April 1635, see Rooses 1886-1892, III, pp. 292-336; Martin 1972.

The appearance of the festive town during the pageant was recorded in etchings by Rubens' pupil Theodor van Thulden, whose prints illustrated a book devoted to that occasion. The book, the Latin text of which was written by C. Gevaerts, was published in 1642, after Rubens' death (see Gevartius 1642).

Gevaerts' scholarly commentary, which contains his interpretations of the symbolic meaning of the decorations and is accompanied by detailed references to classical authors, helps one to understand the allegories, some of which are extremely involved. The names of the decorative structures referred to in this catalogue are given as they are in Gevaerts' book. Few of Rubens' own works for the pageant have survived. There are his sketches for three pictures that decorated some of the structures (Nos. 31, 37) and for eight statues for the Emperors' Portico, five of which are in the Hermitage (see No. 32). In addition to these several sketches of the structures themselves are extant. Two of them (for the front and back of the Mint Arch) are in the Koninklijk Museum voor Schone Kunsten in Antwerp, and six in Russian museums: one in the Pushkin Museum of Fine Arts in Moscow (No. 33) and five in the Hermitage Museum in St. Petersburg (Nos. 31, 34-37).

31. *FELICITATIONS ON THE ARRIVAL OF THE INFANTE FERDINAND IN ANTWERP ADVENTUS SEREN. PRINC. GRATULATIO*

1634-1635.
Oil on oakwood, 73 x 78 cm.
The thin layer of grisaille, touched with colour only in the opening of the arch, does not conceal the drawing (or rather, the outline) in black chalk over a light-coloured ground: a vertical central line, a vertical for the pilaster on the extreme right, some intersecting vertical and horizontal lines marking the position of various elements of the structure, such as the pedestals, the griffin, the Telamon atlas, the cantilevers above it, and the cornices. The top of the portico is cut short by the edge of the panel (no traces indicate it was sawn off afterwards); the left part of the sketch was left unfinished.
The Hermitage, St. Petersburg. Inv. No. 498.

This original sketch was for the portico erected near St. George's Church at the entrance to Antwerp through St. George's Gate or Keyserport.

The picture is centred on a tapestry being unfurled in the opening of the arch by three cupids (the same motif was previously used by the artist in his series called *The Triumph of the Eucharist* executed in 1626-1628, now in the Prado, Madrid), symbolizing the welcome accorded to the Governor. (In 1549 on the occasion of the arrival of Charles V and Philip II the same site was used for a platform on which a kneeling Antwerpia, accompanied by personifications of her virtues, greets Prince Philip).

Ferdinand, crowned by Victory and accompanied by triumphant *Mars Gradivus* (Marching Mars), Valour and Fortune, is shown on horseback trampling the corpses of the Swedes. Ferdinand stretches his hand in a gesture of peace-making (*Pacificatoris habitu,* as Gevaerts put it in 1642) towards Antwerpia who is greeting him; she is accompanied by a lion symbolizing Belgium and a figure personifying Welfare with a serpent coiled round her arm, and an angel over them, carrying the crest of Antwerp. In the tympanum of the arch the statue of *Bona Spes* (Good Hope) is placed; its significance was stressed by the fact that it was, as Gevaerts remarked, one of the few statues "skilfully carved from hard stone". In the side niches of the arch two statues are shown: *Laetitia Publica* (Public Rejoicement), as inscribed on the pedestal, with a wreath and a helm, on the left; and the genius of Antwerp with a cup and a horn of plenty on the right, the pedestal inscribed: *Genius Urbis Ant.* Over each statue the same inscription appears: *Vota publica* (Public Approval). Under the tapestry there is a ring

of dancing infants with a hare and a basket full of flowers, which signify fertility and plenty. One of the children holds a cartouche inscribed: *Felicitas Tempor* [*um*] (Happiness of the Times): the inscription on Van Thulden's etching reads: *Sperate temporum felicitas* (Much Desired Felicity Forever). The playing children, as Rubens himself explained when he used a similar motif in his title-page for F. de Marcelaer's book *Legatus (Ambassador)* in 1638, symbolize "happiness for all time" (*CDR* 1887-1909, VI, p. 200).

The central image of the portico and its decoration as a whole were intended not only to glorify Ferdinand as victor, but also to stress the importance of his military victories as a path towards achieving peace and prosperity.

This was thus the original design of the portico. But when Ferdinand's visit was postponed for a second time, the magistrates ruled on 5 February 1635, on the motion by Mayor Robert Tucher and with Rubens' consent, to have some elements added to the structure (Rooses 1886-1892, III; Martin 1972). In the augmented form the portico is shown in Van Thulden's etching. The main elements added were two side panels depicting some events of good omen on the Governor's way to the Netherlands; the side parts are at an angle to the central one. The two pictures were listed among those for which Rubens was paid 5,000 florins. One of them, *Neptune Taming the Winds,* or *Quos ego,* on a subject from Virgil's *Aeneid,* was an allegory of Ferdinand's safe passage from Barcelona to Genoa. It is in the Gemäldegalerie, Dresden (oil on canvas, 326 x 384 cm). Its sketch is in the Fogg Art Museum, Cambridge, USA (oil on wood, 49 x 64 cm). The other composition represents the Infante Ferdinand's meeting with King Ferdinand of Hungary, which led to their joint victory over the Swedes at Nördlingen in Germany (Kunsthistorisches Museum, Vienna; oil on canvas, 328 x 388 cm). Its sketch is in the S. Binghorst-Kramarsky collection in New York (oil on wood, 48 x 35 cm).

The sketch was produced before 5 February 1635, probably even before 3 December 1634, when the wooden framework for the portico was ordered, without the added elements, which were commissioned on 9 February 1635 (Martin 1972). The large-scale central panel was painted by Rubens' pupil Cornelis Schut; several other painted decorations for the portico at St. George's Church were executed by Jacob Jordaens and Jan Cossiers with assistants.

The portico was 80 ft high and 78 ft wide (22.72 x 22.25 m).

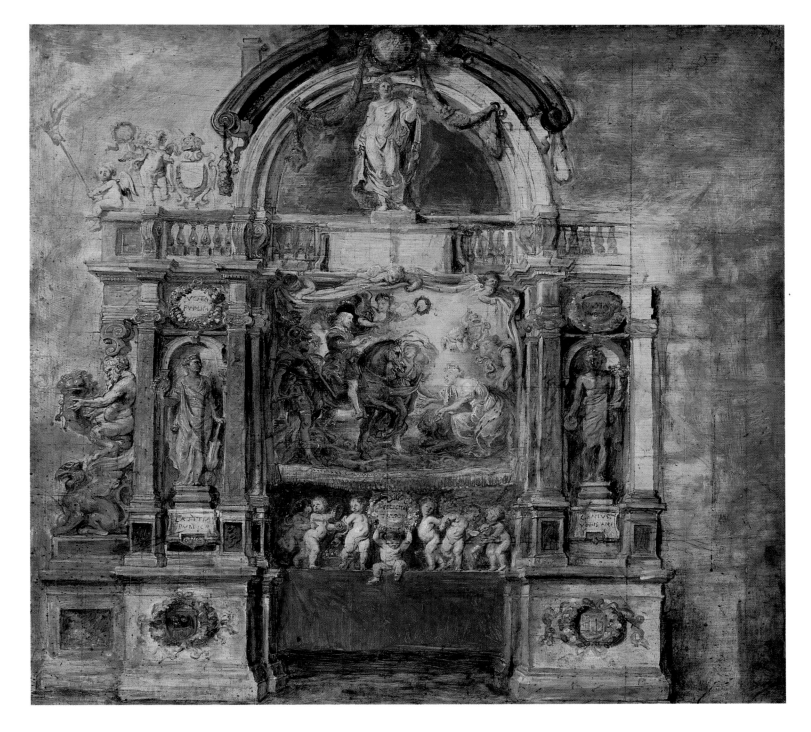

Provenance: In 1965 Puyvelde was of the opinion that these designs of the pageant of 1635 came from the collection of the Governors of the Netherlands. It is not clear what his hypothesis is based on, for Ferdinand was presented in 1637 with the pictures that had decorated the arches and porticoes, but not with sketches for them. Commissioned by the Antwerp Magistrature, they must have originally been in municipal possession, in the Town Hall. Rubens' sketch for decoration on a different occasion (*The Chariot of Calloo*, 1638) came into the Museum in Antwerp straight from the Town Hall, just as the oil sketches for the Mint Arch came from the Antwerp Mint, who had commissioned them. On 23 January 1693 it was sold in London as one of Rubens' *Six Triumphs* (Nos. 207-212) in the auction of the collection of the artist Prosper Henry Lankrink. Although the Lankrink sale catalogue published in 1945 contains a note by the editor to the

Felicitations on the Arrival of the Infante Ferdinand in Antwerp.
The Hermitage, St. Petersburg.

effect that it did not appear possible to identify the *Triumphs*, there is an entry concerning Rubens' *Six Triumphs* in the *Notebooks* of the English engraver George Vertue, appended by an inscription by Horace Walpole, the writer of the catalogue of the Robert Walpole collection. The inscription reads that the picture was then at Houghton Hall.
Between 1722 and 1735 the present piece was in the Walpole collection in Houghton Hall, England.

Prints: By Theodor van Thulden (1606-1669) – in Gevartius 1642, pls. 6,7 (with additions).

Felicitations on the Arrival
of the Infante Ferdinand in Antwerp, detail
The Hermitage, St. Petersburg.

Felicitations on the Arrival
of the Infante Ferdinand in Antwerp, detail
The Hermitage, St. Petersburg.

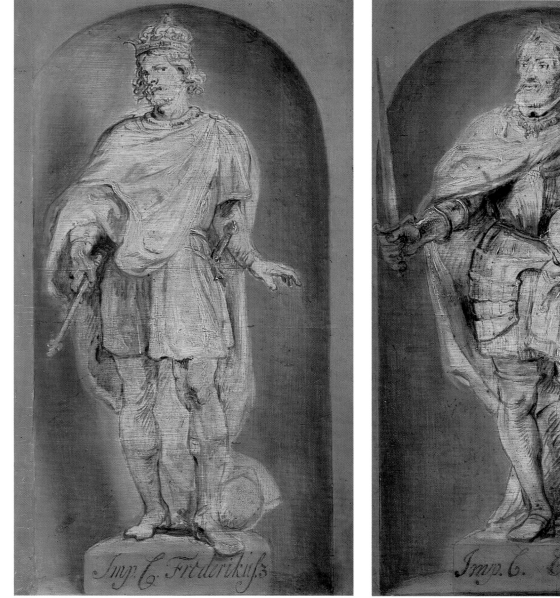

32. STATUES OF THE EMPERORS OF THE HAPSBURG HOUSE

1634.
Oil on oakwood. Five separate pieces: 38.8 x 21.3; 38.5 x 21.5; 38.5 x 20.6; 39 x 21.5; 38.5 x 21.5 cm.
All, except No. 4 (Charles V) enlarged, as follows: No. 1 (Rudolph I) by about 0.5 cm at top left tapering down almost to zero; No. 2 (Albert I) on the right, by halved joint, on the obverse side by 2 cm at top and 3 cm at bottom and on the reverse side by 3.7 cm; No. 3 (Frederick III) by 1.3 cm on the left, halved joint; No. 5 (Ferdinand II) on the left, halved joint: by 1.2 cm on the obverse and by 2.2 cm on the reverse. The niches and the pedestals outlined in pencil, with inscriptions, were added later. This is evident from all the contours of the figures, including the swords and sceptres in their hands. In the original portions the grisaille applied in thin layers to the light-coloured ground does not conceal the pattern of the wood. The added pieces are painted with body colour, greenish raw dark earth, with black specks, as seen under the microscope, laid in impasted strokes perpendicular to the fibres of the wood.
The Hermitage, St. Petersburg. Inv. No. 510.

These are oil sketches of five statues for the portico of the Hapsburg Emperors, *Porticus Caesarea Austriaca*, in the Meirplein (Place du Meir). No sketch of the entire structure survives, if it existed at all (Martin 1972). The general appearance of the portico is known from Theodor van Thulden's etching: it was a semi-oval arcade with twelve statues in the openings: of the Emperors Rudolph I, Albert I, Frederick III, Albert II, Frederick IV, Maximilian II, Rudolph II, Matias and Ferdinand II. In the bays between the arches there were herms of the great gods of Olympus painted on cut wooden panels. Burning torches and streamers were affixed at the top. The arch in the middle was surmounted by an obelisk in stained glass, illuminated from within and crowned with a representation of the sun. The obelisk was flanked by twisted columns representing the Pillars of Hercules, which, coupled with the words *Plus ultra* inscribed on the banderoles wound round them, formed Charles V's motto.

It was an established convention to include in the decoration portraits of the new ruler's illustrious predecessors, who blessed him, as it were, as he embarked upon the new office. Thus, in 1549 in the reception of Philip II there was a portico in the same square, Meirplein (Place du Meir), decorated with statues of the nine most famous Philips of the past: Philip II of Macedon, Philip the Fair, Philip the Good and others. In 1599, for the entry of the Archduke Albert and the Archduchess Isabella, portraits of the twelve Emperors of the Hapsburg dynasty were displayed in the streets leading to the monastery of St. Michael, whereas in la Place du Meir there was an arch from the merchants of Genoa: a semi-circular colonnade surmounted by an obelisk and decorated with statues of the predecessors of Albert and Isabella in the office of Governor of the Netherlands. Architecturally, the Genoan arch of 1599 and the Emperors' portico of 1635 appear to derive from the decorations used on similar occasions in France, e.g. in Lyons in 1595, when Henry IV's entry was celebrated.

Originally it was planned that the Emperors' figures for the decoration of the portico were to be painted on cut wooden boards, but later it was decided that they should be carved from stone and gilded, as described by Gevaerts. The framework ordered on 5 December 1634 was still intended for painted images, so on 10 December it became necessary to reinforce the wooden supports for the stone statues.

The Hermitage sketches were designed as models for sculptures in stone, and they fully coincide with the statues shown in Van Thulden's etching.

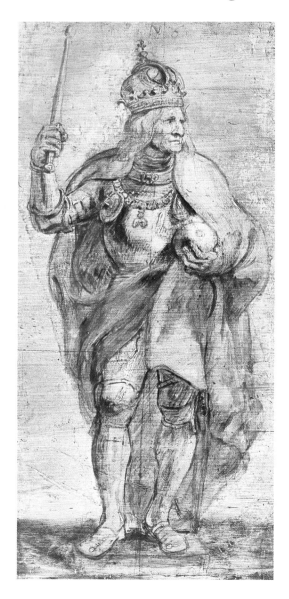

Held believes that Rubens' main sources for the Emperors' portraits were engravings by Christoffel Jegher (1596-1652/53), produced between 1631 and 1634 for a new edition of Hubert Goltzius' book *Icones Imperatorum Romanorum* (published in Antwerp in 1645; see Held 1980, pp. 231-234).

The statues were executed by the following sculptors: Huibrecht van der Eynde, Jenyn Veldenaer, Paul van der Mortel, Forcy Cardon and Sebastian de Neve.

The portico was 80 ft high and 110 ft across (22.72 x 31.24 m).

Of all the works by Rubens for this portico, besides the present five sketches (for a sixth one see below) in the Hermitage, only the following others are known: two oil sketches for the statues of Albert II and Ferdinand I (both formerly in the Suermondt Museum, Aachen — lost in World War II) and one oil sketch for the statue of Maximilian I (Ashmolean Museum, Oxford).

◄ Rubens. *Statue of Emperor Maximilian I.* Sketch. Ashmolean Museum, Oxford.

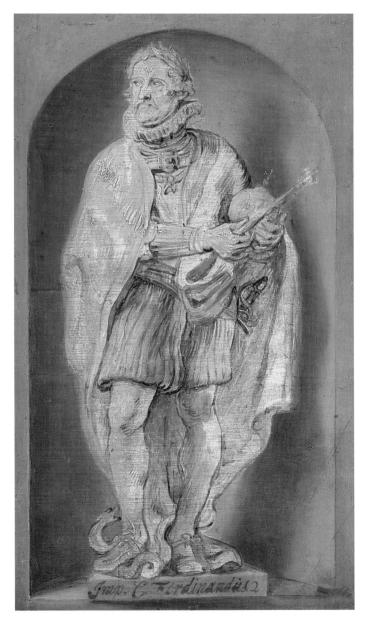

Provenance: Received by the Hermitage between 1774 and 1783, the old inventories of the Hermitage containing in the same entry a sixth statue — of Maximilian II ("according to the inscriptions appearing on each portrait"); it was never mentioned subsequently. The sketches were received as works by Rubens, their function not indicated. At the time of acquisition the present sketches already contained the added pieces with niches and inscribed pedestals, which look exactly the same as in the sketches from Aachen (No. 439: *Albert II*, oil on paper mounted on wood, 39 x 22 cm. Enlarged on the right by a strip 1.5 cm wide at the top and 0.5 cm wide at the bottom; No. 440: *Ferdinand I*, oil on oakwood, 39 x 22 cm. Enlarged by a strip 3.5 cm wide at the top). As to the sketch in the Ashmolean Museum, Oxford (oil on wood, 39 x 17.5 cm), it has neither any added pieces, nor any niches and pedestals represented. This prompts a suggestion that the St. Petersburg and the Aachen sketches have the same origin. The catalogue of the Suermondt Museum states that the sketches were brought by B. Suermondt (d. 1887), the founder of the museum, from Warsaw (*Aachen Suermondt Museum. Gemälde Katalog. Amtliche Ausgabe*, Aachen, 1932).

Prints: By Theodor van Thulden (1606-1669) – in Gevartius 1642, pls. 17, 18, 20, 22.

33. *THE APOTHEOSIS OF THE INFANTA ISABELLA*

1634.
Oil on oakwood. 69 x 70 cm.
Cradled. The layer of paint is very thin, revealing in many places a light yellowish ground and an outline in black chalk, not always coinciding with the painted image. The architecture in the right-hand part is merely indicated. There are numerous pricks of small nails used for transfer onto paper and for making a large-scale technical drawing of the structure.
The Pushkin Museum of Fine Arts, Moscow. Inv. No. 2626.

After passing the Emperors' Portico, the 1635 procession turned into the short street of Poor Clares, at the end of which one could see a structure commemorating the late Infanta Isabella Clara Eugenia (1559-1633), who preceded Ferdinand as Governor of the Southern Netherlands. The structure concealed a side entrance to the Church of St. Jacob. Thus instead of its old-fashioned Gothic forms the viewer could see a magnificent, strange and contemporary architectural fantasy. It had the shape of a two-storeyed façade with a huge picture above the portal. The picture was bordered by twisted columns (columns of this kind were believed to have decorated the temple built by Solo-

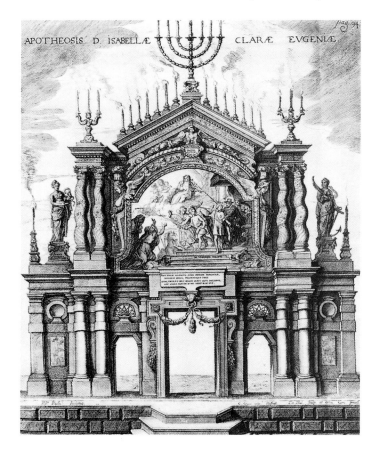

Theodor van Thulden. *Portico: The Apotheosis of the Infanta Isabella*. Etching in C. Gevartius, *Pompa Introitus Honori Serenissimi Principis Ferdinandi Austriaci...*, Antwerp, 1642.

mon). The columns supported a pediment, inscribed into which was an arch decorated with flowers and cherubs' heads. The arch was surmounted by a sort of altar, inscribed: *MATRI PATRIAE/ CAELO RECEPTAE* (to the Mother of the Fatherland received into Heaven). This is what the decoration looks like in Van Thulden's etching (Gevartius 1642).

Unlike the etching, the present sketch has no lit candles at the top of the structure, nor a podium with steps — evidently these were left to the discretion of the contractors. But the composition of the large painting over the portal was elaborated with great precision and the detailed sketch contained everything required for reproduction it on a large scale.

Gevaerts gives a detailed description of the picture's content (Gevartius 1642): the upper part shows Isabella seated on the clouds in the dress of St. Clare's Order, which she adopted after the death of her husband, the Archduke Albert of Austria, in 1621. The woman and children placed next to her symbolize Isabella's motherly love for her Netherlandish subjects. The two matrons in the lower left part are Sorrow in a mourning cloak and kneeling Belgium, with her emblem, the lion. Belgium, with raised arms, supplicates Isabella for help and the latter points to Prince Ferdinand as protector and deliverer from misfortunes. Ferdinand is being sent to Belgium by his brother, Philip IV of Spain, and they are depicted in the company of Jupiter and Minerva, "the patron goddess of the arts of war and peace". Two winged genii are taking the prince away, one of them carrying the shield with the Gorgon head symbolizing war, the other with a caduceus and a cornucopia, emblems of peace. A youth leads up a horse and warriors with lances are seen some way off.

The meaning of the scene is further clarified by the following inscription in Latin: *IN VTRVMQ [UE] EN VINCE* at Ferdinand's feet (the last two words are partly overpainted), which means "ready for either" (Virgil, *Aeneid.* II, 61), i.e. either for peace or for war; over the portal: *HIC VIR, HIC EST ETC. (Aeneid. VI. 791)* — "This man, this is he..." Gevaerts connects the latter words with Isabella's gesture.

Thus, the picture has two aspects: it glorifies the deceased ruler and voices the hopes set upon her successor. The goals of both Isabella's and Ferdinand's activities are conveyed through the two allegorical figures flanking the upper tier: of Popular Welfare on the left and of Security on the right, as shown by the respective inscriptions on the pedestals: *SALVS PVBLICA* and *SECURITAS*. Rubens had a profound respect for the Infanta Isabella whom he know well

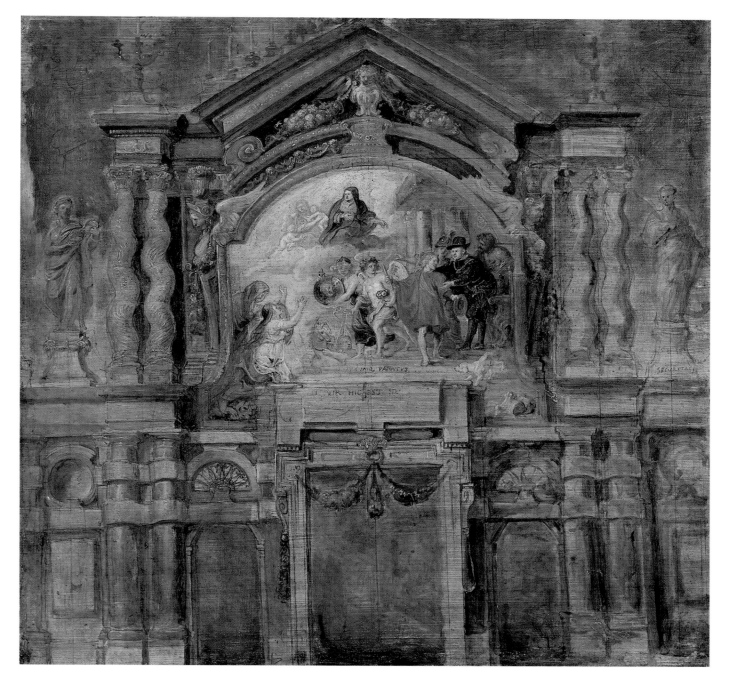

as court painter. He was also a gifted diplomat who for many years ably conducted, on behalf of the Infanta, official and secret negotiations aimed at concluding peace and ceasing the infinite and exhaustive wars with Holland. That is why Rubens was most closely concerned with the contents of this painting, a work which reflected his inmost thoughts and feelings.

The sketch was painted between 13 November (the date when Ferdinand was invited by the magistrates of Antwerp) and 3-5 December 1634, since the contract with the builder dated 11 December was signed on the basis of the working drawings which must have taken about a week to prepare. The overall measurements of the structure, the podium and the candles included, were 17.04 m in height and 13.63 m in width. The large picture was painted after Rubens' sketch by Gerard Seghers (1591-1651); its fragment with four figures has survived (Rubenshuis, Antwerp). The painted planks imitated the statues of Public Welfare and Security, as well as the carved details surrounding the main picture. These works, painted by Jan van Boeckhorst and Jan Borchgraef, have not survived.

Provenance: Purchased for the Hermitage from the Walpole collection in Houghton Hall, England (for more details see No. 31). In 1930 transferred to the Pushkin Museum of Fine Arts in Moscow.

Prints: By Theodor van Thulden (1606-1669) — in Gevartius 1642, Nos. 24, 25.

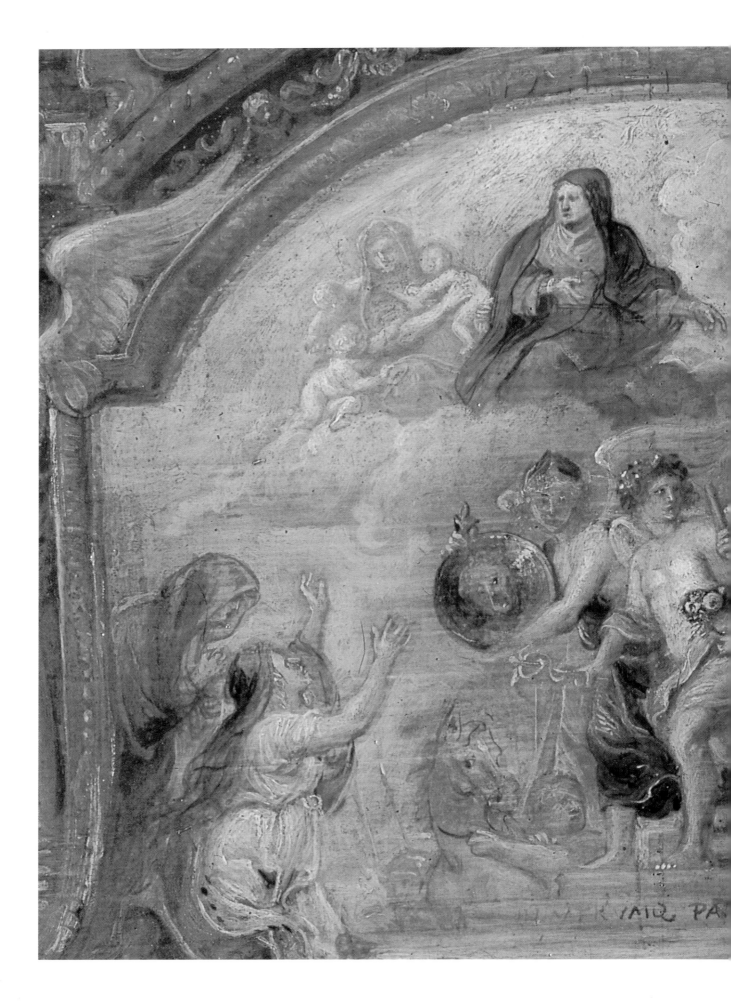

The Apotheosis of the Infanta Isabella, detail.
The Pushkin Museum of Fine Arts, Moscow.

34. *THE ARCH OF FERDINAND (back)*

1634.
Oil on canvas. 104 x 72.5 cm.
Transferred from wood by A. Sidorov in 1867.
The thin layer of grisaille touched with colour over the light-coloured ground does not conceal the underlying drawing in black chalk. On the right, a drawn cartouche of a different shape, with a draping hanging from it in a semi-circle, is visible from under the one painted over the medallion. Over the right niche there is a round cartouche fringed with draperies — it is merely outlined in chalk. On the unfinished pilaster in the extreme right of the upper floor, a herm with a woman's head is sketched in chalk. The candelabra in the hands of the Telamon Atlantes are elaborately drawn but only touched with brown paint. In the lower left cartouche over the medallion the outlines are done in chalk, the finish of the ornaments on its sides varying considerably. The figure on a winged horse in the upper central part may have been either barely indicated initially or overpainted with greyish-blue afterwards. The right-hand side of the picture is on the whole less developed.
The Hermitage, St. Petersburg. Inv. No. 502.

The sketch was done for the decoration of the reverse side of the arch at the entrance to the Lange Nieuwstraat (Longue Rue Neuve). The arch celebrated the victory over the Swedes won by the Infante Cardinal Ferdinand jointly with King Ferdinand of Hungary (the future Emperor Ferdinand III) at Nördlingen in Germany on 4-5 September 1634.

The present oil sketch in the Hermitage depicts, over the central span of the arch in a golden frame, the picture *Triumph of Ferdinand after the Battle of Nördlingen* (now in the Uffizi, Florence; oil on canvas, 435 x 528 cm).

Ferdinand, who is being crowned by Victory, rides in a chariot; another Victory, accompanied by Hope, flies over him with a palm, symbolizing peace, and a trophy. In front of the chariot a half-length portrait of the genius of Nördlingen and a *labarum* (an imperial standard) with the letter *F* are carried. Captives are shown on both sides of the chariot. In front of it a soldier with a trophy and a standard-bearer appear. The picture is crowned by the Spanish King's emblem guarded by lions, with *Auspice Philippi Magni regis* (under the auspices of King Philip the Great) inscribed over it. The picture is flanked by statues: of Honour, with a sceptre and a cornucopia, on the left, and of Valour, in a lion's skin with a cudgel and a sword, on the right. The left niche has the picture *King's Gen-*

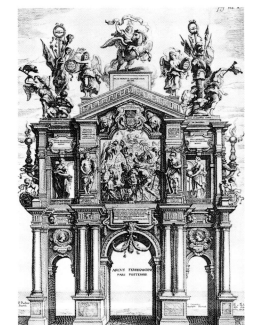

Theodor van Thulden.
The Arch of Ferdinand (back).
Etching in C. Gevartius, *Pompa Introitus Honori Serenissimi Principis Ferdinandi Austriaci...*, Antwerp, 1642.

erosity showing a figure pouring coins from a cornucopia, inscribed above: *Liberalit. regi.* The picture in the right niche is *Foresight,* with a globe and a helm, inscribed: *Provident.* (both paintings are in the Musées des Beaux-Arts, Lille; oil on canvas, 284 x 145 each). In the medallions over the side spans, the picture on the left is called *Nobility,* inscribed *Nobilit.,* and on the right *The Youth of Ferdinand,* inscribed on the medallion *Juvent* and again under the medallion — *Juventas Ferd. P.* In the left and right upper corners there are trumpeting Glories, trophies and shackled captives, as well as Victories with shields; the shield of the Victory on the right has an inscription: *Fides militum* (fidelity of the troops). In Van Thulden's etching the shield of the Victory on the left is inscribed: *Concordia exercitum* (accord in the troops). These inscriptions derive from Roman coinage (see Martin 1972). On the left cornice, beneath the group of prisoners, the following inscription appears: *Haud vires ac...* [acquirit eundo] [(his glory) cannot grow any longer], which is a paraphrase of a line from Virgil's *Aeneid* (4, 175): "Viresque acquirit eundo" ([his glory] keeps growing). The arch is surmounted by a winged horse ridden by a barely indicated figure of Lucifer Laureatis, the laurel-wreathed Morning Star, or the planet Venus, or Aurora. In Van Thulden's print Aurora has a scroll with the words *Io triumphe* (I triumph) in her hands. It is noteworthy that the decor of the arch contains hardly any attributes of war, except the trophies with captives; this motive derives from the imagery of Roman coins (Martin 1972). The sketch seems to have taken a short time to paint and must have been produced before 24 November 1634, when the wooden framework for the arch was ordered and certainly not earlier than 28 November 1634 as on that day the painted decorations for the arches of Philip and of Ferdinand were purchased (Martin 1972). The sketch is identical to the picture in Van Thulden's etching. The painted decorations for the Arch of Ferdinand were executed by Gaspar van den Hoecke and his son, Jan van den Hoecke. The arch was 72 ft in height and 40 ft in width (20.45 x 11.36 m).

Provenance: Purchased for the Hermitage from the Walpole collection in Houghton Hall, England, in 1779 (for further details see No. 31).

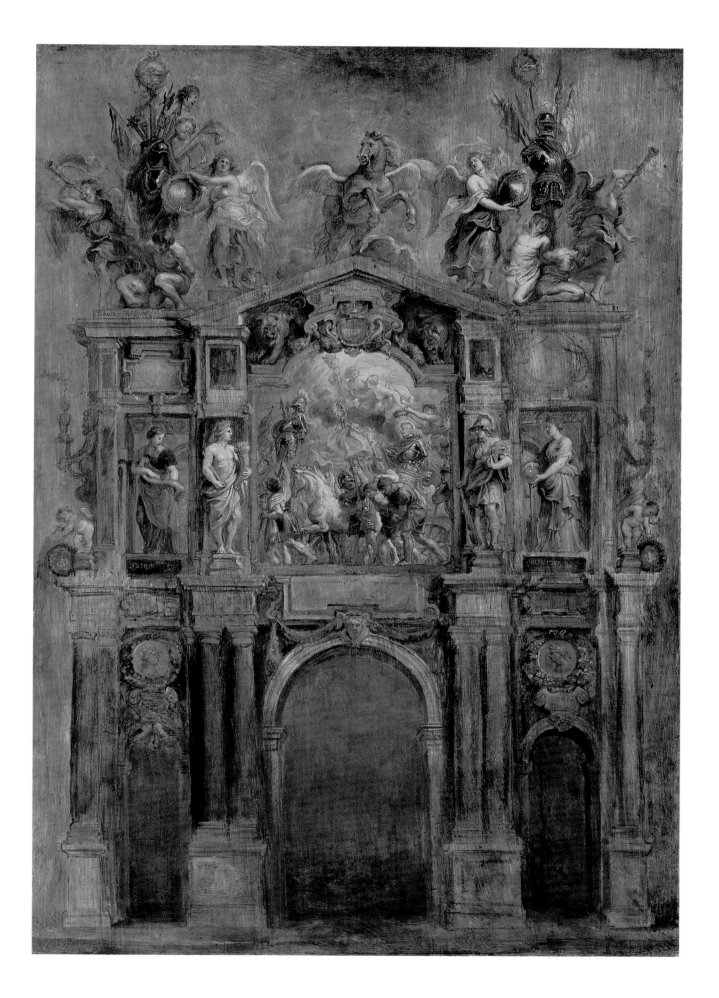

35. *THE TEMPLE OF JANUS (TEMPLUM JANI)*

1634.

Oil on oakwood. 70 x 65.5 cm.

In the upper left part, along the edge of the panel, there are three half-obliterated lines in Latin, evidently in Rubens' hand, of which only a few separate words are legible: *...Jan?. post saecularis paen[e] belli.../...virtute [?] Ferdinande Face.../...[t]erra marique part [a] Janum [c] lud.* (*...Jan?...after nearly a century-long war.../...by the valour[?] of Ferdinand with peace.../...to the lands and seas granted by Janus closed*). Grisaille touched with colours is applied in a thin layer to a light-coloured ground, but the underlying drawing does not show through the elaborate painting. The Hermitage, St. Petersburg. Inv. No. 500.

This Hermitage painting is the original sketch for the portico in the Dairy Market.

Janus is the ancient Roman god of time and beginnings, who knew both the past and the future and was therefore represented with two faces *(Janus bifrons)*. Legend has it, as recorded by Plutarch and Macrobius, that the temple of Janus was constructed by Numa Pompilius, who introduced the custom of keeping the gate closed in times of peace and open in war time. Gevaerts wrote: "Numa, the Roman Emperor, was the first... to shut the temple of Janus. Consul Titus Manlius was the second to do it after the First Punic War... Augustus was the third, owing to the peace granted to the lands and seas *(pace terram marique partam)*." Gevaerts adds that a coin issued by Emperor Nero was stamped with the inscription: *Pace terra marique parta Janum clusit* (owing to the peace granted to the lands and seas, he closed Janus — see Martin 1972). This inscription almost coincides with the one above, in which Rubens used the same words for Ferdinand and his activities in the Netherlands. The same content is found in the Latin verse appearing over the entrance to the temple in Van Thulden's etching (it must have actually been there during the pageant):

O utinam, partis terraque marique triumphis / Belligeri cludas, princeps, penetralia Jani! / Marsque ferus, septem jam paene decennia Belgas / Qui premit, Harpiaeque truces luctusque, furorque / Hinc procul in Thraces abeun scithicosque recessus / Paxque otata diu populos atque arva revisat! ("Oh, if only you, our ruler, after your triumphs on land and sea, were to shut the gaping gate of warlike Janus! May the ferocious Mars that has for almost seven centuries harassed the Belgians, go away from here into the remote depths of Thrace and Scythia, taking with him the fierce harpies, the wailing and the fury, may the long desired peace settle on the people and their fields!").

The sketch represents Discord, with snakes for hair, and the fury Tisephone overturning an urn from which blood pours; they pull the door of the temple, with a bloodthirsty harpy flying over them; at the bottom there is a barely legible inscription: *Discordia Tise [phone]*. Fury dashes out of the door, blindfolded, with a sword and a burning torch; under it *Furor* is written. But Peace, looking imploringly at the beholder, tries to shut the door; he has a caduceus in his hand, which signifies peace, but his cornucopia has dropped on the ground. Near an altar Piety is shown, behind Peace, and in the background the Infanta Isabella appears, in a nun's dress, with an inscription beneath: *Pax Pietas*.

On the left, under the portico, the horrors of war are represented: a soldier pulls by her hair a woman who tries to protect her child; Death (or Plague) looms over her with a torch and a scythe, and Hunger flies; there is an inscription underneath, which is not quite legible, probably reading: *Saevities belli* (Cruelties of war). On the right over the portico Security appears with one hand on her heart, and Tranquillity with ears of cereals and a poppy in one hand and a palm in the other — there is a slab of stone to symbolize permanence; the inscription beneath

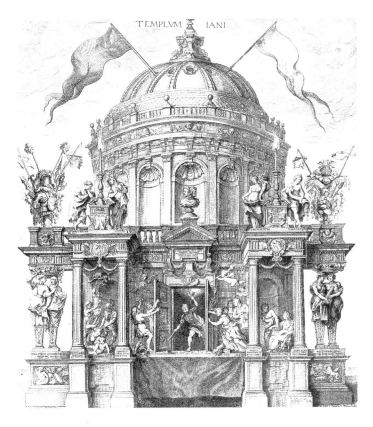

Theodor van Thulden. *The Temple of Janus.*
Etching in C. Gevartius, *Pompa Introitus Honori Serenissimi Principis Ferdinandi Austriaci...*, Antwerp, 1642.

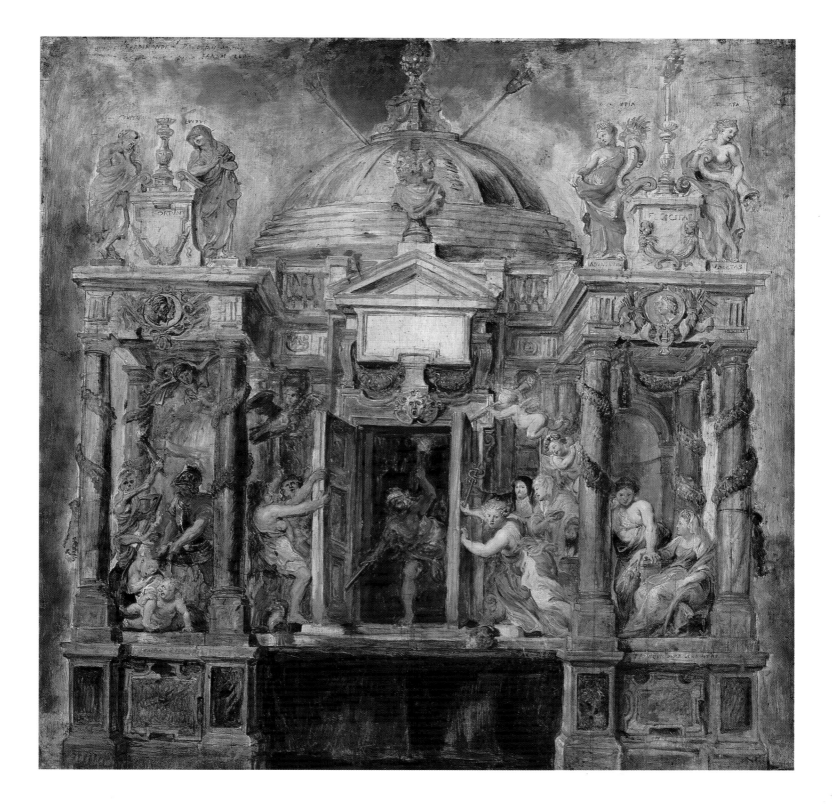

The Temple of Janus.
The Hermitage, St. Petersburg.

Following page:
The Temple of Janus, detail.
The Hermitage, St. Petersburg.

reads: *Tranquilitas Securitas*. The figure of Tranquillity is derived from the antique carved stone *Gemma Tiberiana* (Bibliothèque Nationale, Paris), which was sketched by Rubens (Stedelijk Prentenkabinet, Antwerp — see Martin 1972). Over them there is a medallion carrying a double profile of Valour and Honour, within a wreath formed by a lyre, brushes and a palette, a compass and a ruler. On the left, over the scene representing the horrors of war, there is a double profile of Pallor and Fear within a wreath of thorns, whips and chains. Over the portico Poverty and Lamentation are represented, with *Paupertas* and *Luctus* inscribed over their heads; they are bent over an extinguished candelabrum, on the pedestal of which are representations of mourning torches and an inscription — *Infortuna* (Misfortune). Over the portico on the right Abundance with spikes and a horn of plenty and Fertility pouring gifts from her cornucopia are shown. The inscriptions *Abundantia* and *Ubertas* over their heads are repeated, in a different hand, on their pedestals. A burning candelabrum is placed between them; its pedestal is decorated with two crossed horns of plenty with children's heads and an inscription, *Felicitas* (Happiness). The motif of the temple of Janus with

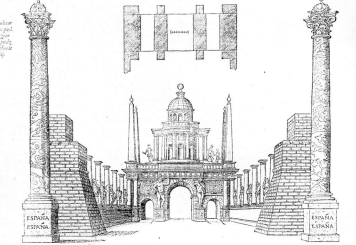

The Arch of the Spaniards in 1549.
Engraving in *La très admirable... entrée du prince Philippe...*, 1550.

its door shut had long been used in the decorations of pageants on occasions of festivities and triumphal entries — it symbolized the idea of peace bestowed by the ruler on his subjects.

Rubens addressed himself for the first time to the subject of Janus' temple in 1623, on the title-page of the third volume of Franciscus Haraeus, *Annales Ducum Brabantiae* (vol. III, Antwerp, 1623), which was devoted to the Netherlandish Revolution and the partition of the Netherlands. There the message of the temple of Janus was highly topical and had a different meaning — instead of peace granted by the ruler it conveyed apprehension and alarm: the door of the temple had been opened by Fury and Discord, and there was nobody to shut it.

In the Hermitage sketch this motif sounded in 1635 as an urgent call for resolute actions to be taken by the Governor. There is no retrospective reference, no parallel with Emperor Augustus. Ferdinand is urged to follow, before it is too late, the example of his predecessor, who aspired to peace and wanted "to shut Janus" *(Janum cludere)*. Three years later, in 1638, in his painting *The Horrors of War* (Palazzo Pitti, Florence) Rubens showed Europa bewailing the disasters facing mankind when the door of the temple of Janus is open wide.

It was decided to supplement the original design of the portico after the Governor's arrival was postponed for a second time (on 9 February some additional parts were ordered for the wooden frame of the portico — see Martin 1972). Van Thulden's etching shows these additions: the dome was placed on a tall drum, ledges were made on the sides, etc. The ledges are supported by herm caryatids representing Quarrel and Dissension, on the left, and Accord on the right. Over them are trophies consisting of various weapons and enemies' heads on lances on the left and of various fruit and agricultural implements, with billing doves, on the right. Above, on the sides of a stone pine cone, there are banners in red and white, the colours of Antwerp, in place of torches. Martin (1972) interpreted the colours as war contrasted with peace.

The Hermitage sketch appears to date from before 7 December 1634, when the framework for the original version of the portico was commissioned (Martin 1972).

The painted decorations for the portico were executed by Theodor Rombouts, Jan Cossiers, Artus Wolfaerts and Geeraard Weri. Jacob Jordaens took part in the supplementary work. The portico was 66 ft high and 53 ft wide (18.74 x 15.5 m).

Provenance: Purchased for the Hermitage from the Walpole collection in Houghton Hall, England, in 1779 (for further details see No. 31).

Prints: By Theodor van Thulden (1606-1669) – in Gevartius 1642, pls. 30, 31 (with additions).

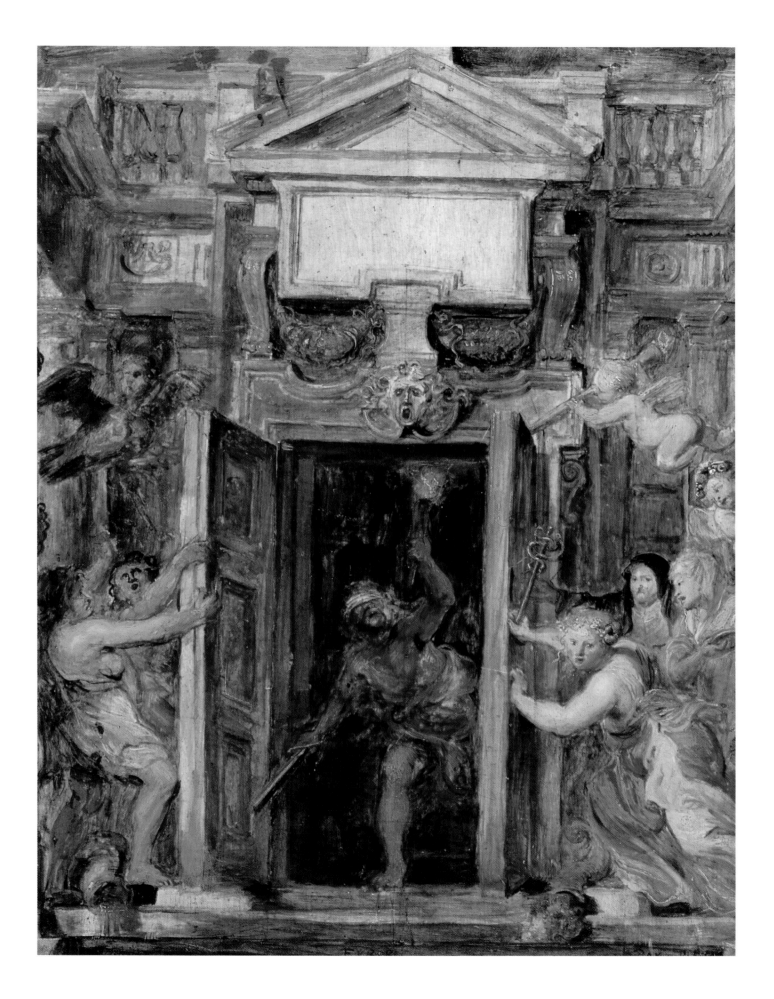

36. *MERCURY LEAVING ANTWERP (MERCURIUS ABITURIENS)*

1634.
Oil on oakwood. 76 x 79 cm.
The painting in grisaille touched with colour is fairly elaborate, yet traces of pencil show in many places: the central vertical line is visible, so are the vertical axes of the Atlantes and column bases marked out in the left part of the picture. Some indistinct contours can be seen over the right Atlas' head; the right column ends in a plume of lines. In the upper right part, over a cupid, there is a pole with a streamer and a sphere (the globe?). A swirl of curves appears over the triton's head on the left.
The Hermitage, St. Petersburg. Inv. No. 501.

This is the original sketch of the portico at St. John's Bridge, which was devoted to the subject of the Liberation of the Scheldt.

In the central bay of the portico Mercury, the Roman god of commerce and craft, with a purse and a caduceus, is poised for flying away from Antwerp, where there is nothing for him to do any longer: the sails of the idle ships are furled, a sailor is sleeping on an overturned boat next to a rusting anchor and even the god of the river, his feet shackled, is dozing on the fishing nets. The cupids are trying, to no avail, to hold Mercury. Antwerpia, wearing the city crown of towers and kneeling before Ferdinand who is riding past, appeals to him for help to alleviate the town's disastrous state. The niche on the right gives a dismal picture of the present: the starved family of a sailorman, their meal consisting of nothing but a head of cabbage; the master of the family is shown with an unwanted helm. The niche on the left represents possible prosperity in the future: Abundance pours treasures into Wealth's lap. Above these scenes there are cartouches, still unfilled in the sketch, but in Van Thulden's etching bearing the inscriptions: "Ferdinand will introduce the Golden Age" and "Ferdinand will open the Scheldt." The central arch ends in a mascaron of Ocean supporting the

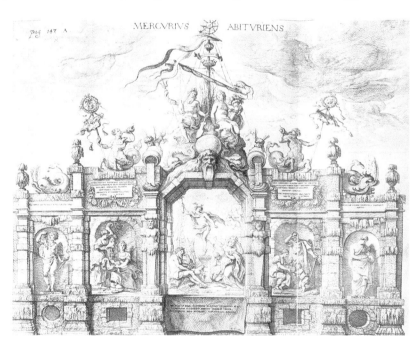

Theodor van Thulden. *Portico: Mercury Leaving Antwerp.*
Etching in C. Gevartius, *Pompa Introitus Honori Serenissimi Principis Ferdinandi Austriaci...*, Antwerp, 1642.

globe on which the rulers of the sea rest: Neptune with a trident and a helm and Amphitrite with her cornucopia and a ship rostrum. They are surrounded by their subjects: playing dolphins that symbolized the East (Baltic) Sea and the West (North) Sea, tritons with emblems of Antwerp, blowing shells, and streams of water pouring from overturned urns.

In 1594 for the reception of the Archduke Ernst and in 1599 for the entry of Albert and Isabella, the same site, which is so near the port of Antwerp that the masts of ships could be seen, was occupied by platforms on which scenes devoted to the subject of the liberation of the Scheldt were performed. In those "live pictures" the rulers were praised to the skies and the liberation was presented as already achieved, although it was in fact not effected even in 1635. In 1594 the performers depicted the God of the Scheldt in shackles surrounded by nymphs and tritons blowing shells. At the appearance of the Archduke Ernst the nymphs cast off his chains and water began to flow from the empty urn on which he was leaning. In 1599 Ocean and Thetis were on the stage with the sea and ships as the setting; they were leaning on urns from which milk and wine flowed; a band of musicians were playing and above, over the picture of Albert and Isabella, a powerful fountain spouted. In 1943 Evers (see Roeder-Baumbach & Evers 1943) described Rubens' treatment of the subject as more pessimistic than his predecessors'. It seems, however, more appropriate to say that instead of humble sycophantic allusions Rubens unambiguously pointed to the real needs of the moment. The new Governor's victories gave Antwerp a hope that peace could be achieved and with it a chance to regain control over the Scheldt's estuary. What was central to the picture was the contrast between the current devastation and future prosperity arising from mastery over the sea trading routes, over

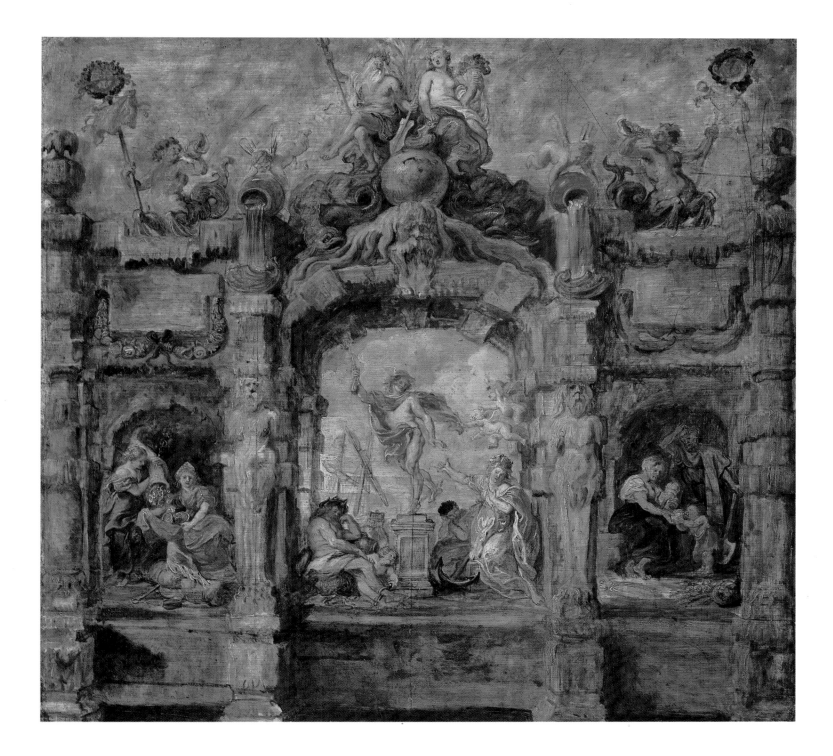

the elements of the sea, arising from "navigation which used to flourish in Antwerp", as Gevaerts put it (see Martin 1972). Antwerpia addresses Ferdinand, who is riding down the street, and this creates an illusion of unity between the reality and the painted scene. In this way Rubens evoked the spirit of the early *Joyeuses Entrées*, when the citizens negotiated their rights and privileges directly with their ruler (as early as 1515 in Bruges one of the performers of the *Wheel of Fortune* "live picture" submitted to Charles V a petition of the town).

After the second postponement of the Governor's visit it was decided to enlarge the portico. As follows from Van Thulden's etching, niches with figures were added on both sides. The figure on the left was that of Comus, the god of festivities and feasts, while on the right was Industry, the daughter of Poverty. The structure was surmounted by a ship mast with a compass at the top.

Aiming at the utmost expressiveness in the depiction and praise of the element of water, Rubens invested with a dramatic quality not only the subject and composition, but even the architectural setting, almost naturalistically rendering heavy stone masses flooded by water. This approach to architectural form has often led art scholars to the conclusion that the artist's architectural ideas were not sound, that they were amateurish and that his painted buildings looked like stage properties (see, for example, Grimm 1949). One should bear in mind, however, that it was precisely this distinctive originality of Rubens' decorative art that made an appreciable impact on builders in subsequent decades. The façade of *La Fregatte*, one of the guild-halls in Brussel's Grande Place can serve as an example: it imitated the round forms of a ship's stern (the building was constructed on the site of the ruins caused by the French bombardment of the city in 1699). In the design of the portico Rubens partly reproduced the shape of the central bay of the arch between the court and the garden of his own house in Antwerp: the corners are at right angles, the pillars have solid rustic plinths.

The Hermitage sketch appears to have been painted before 5 December 1634, when the framework for the original version of the portico was commissioned; afterwards a separate order was made for the suplements (Martin 1972).

The painted decorations for the portico were executed by Theodor van Thulden, Jean de la Barre, Jan Erasmus Quellinus, Jan and Gaspard van Balen, the sons of Hendrik van Balen. The portico was 60 ft high and 70 ft wide (17.4 x 19.88 m).

The picture that decorated the portico figured in the inventory (No. 17) of Brussels Palace taken between 1665 and 1698: "Picture 16 ft high and 14 ft wide, representing Mercury on a pedestal, with the Skaldis (Schelte) recumbent on his right and kneeling Antwerp on the other side, painted by T. van Thulden" (M. de Meyer, *Albrecht and Isabella en de Schilderkunst*, Brussels, 1955, p. 457). It is probable that the same picture is depicted in David Teniers' painting, *Gallery of the Archduke Leopold William* (Alte Pinakothek, Munich, No. 1839/927; oil on canvas, 96 x 128 cm), where it is shown on the floor on the left, partly covered by some other pictures, inscribed on the frame: *T. van Thulden* (Speth-Holterhoff 1957, pl. 60).

In the Nationalmuseum in Stockholm there is a painting by Rubens' workshop, ascribed to Theodor van Thulden. It repeats, with some modifications, the Mercury of the present Hermitage sketch: he stands on top of a heap of goods holding two caducei; there is a cupid in the sky and two others on the ground (inv. No. 597; oil on canvas, 291 x 140 cm; entered in the catalogue of 1761 as acquired from the Antwerp Stock Exchange — see *Notice descriptive des tableaux du Musée National de Stockholm...* par G. Goethe, Stockholm, 1909, p. 293).

Provenance: Purchased for the Hermitage from the Walpole collection in Houghton Hall, England, in 1779 (for more details see note on No. 31).

Prints: By Theodor van Thulden (1606-1669) – in Gevartius 1642, pls. 33-34 (with additions). The scenes in the niches were engraved separately by an anonymous master (V.-S. 1873, Nos. 7879) and are very rare.

Decorative structure at St.John's Bridge in 1594. Engraving in Descriptio publice gratulationis... principis Ernesti..., 1595.

Decorative structure at St.John's Bridge in 1599. Engraving in Pompa triumphalis... in adventi... Alberti et Isabellae..., 1602.

37. *THE ARCH OF HERCULES (front)*
HERCULES PRODICIUS (pars anterior)

1634-1635.
Oil on canvas. 150 x 73 cm.
Transferred from wood by A. Sidorov in 1871.
This sketch is in grisaille touched with colour; in many places the underlying drawing in black chalk is visible. The contours of the arch are marked on the left with a double line and on the right with a treble line. There are vertical lines indicating the axes of the two columns on the left and of one column on the right. There are also horizontal lines marking the level of the capitals and the cornice on the right, the level of the bases on the left and right, and the profile of the left cornice. In the upper left part the monogram P within a wreath is repeated in chalk. Near the left upper edge of the background there is a drawing that shows the disposition of the side pilasters and columns with their cross-sections at the level of the bases.
The Hermitage, St. Petersburg. Inv. No. 503.

This is a sketch of the obverse side of the arch which gave an effect of unity to the ensemble in Monastery Street, at the entrance to St. Michael's abode, the official residence of the Governor.

Over the bay of the arch in the Hermitage sketch one can see a painting depicting *Hercules at the Crossroads between Virtue and Vice*. The latter are represented by Venus with Bacchus and Cupid and by Minerva, who is summoning the hero to the temple of Glory. The story derives mainly from Prodicus, Sophist of Ceos (hence the title *Hercules Prodicius*, corrupt Prodiceus, i.e. *Prodicus' Hercules*), whose version was cited by Xenophon in his *Memoirs of Socrates* (II, I, 21-34); it also derives from Hesiod's *Works and Days* (287-291). Later the subject was frequently used both in ancient and in modern literature. Judging by the composition, Rubens followed the version of Philostratus the Elder contained in his *Life of Apollonius of Tyana* (VI, 10), where Hercules is poised between Virtue and Vice, each trying to win him over. The philosophic allegory of choosing the course of one's life, which gained wide currency in the Western European art of the Renaissance, became a favourite motif in didactic eulogies by courtiers, especially in those addressed to young princes embarking on their career. Although on the whole Rubens made a fairly wide use of the traditional "entries" and "apotheoses", he only once represented Ferdinand in the guise of a mythological hero — on the last arch of the cycle.

In 1930 Panofsky observed that Rubens had addressed the subject of *Hercules at the Crossroads* in a military manner (Martin subscribed to the same view in 1972). Ferdinand is represented as a victor who must remember that not all his enemies have been defeated, so his weapons are shown next to him. The virtue he has opted for is valour in battle. It is hard, however, to give full support to this interpretation. Ferdinand's victories opened a road to peace and prosperity for the Netherlands. This idea underlies the entire programme of the pageant. It was in this respect that Ferdinand's glories were praised also in the final arch of the cycle. The decor of the Arch of Hercules, like that of Ferdinand, contains no military attributes, except for two blazing bombs, which are not so much signs of war as symbols of the ruler's "heroic prudence" (see Martin 1972). The arch is surmounted by a palm tree, which symbolizes virtue, justice and moral triumph; the palm is winged, therefore it can only signify victory, glory, peace and prudence (G. de Tervarent, *Attributs et symboles dans l'art profane....* Geneva, 1958, pp. 10-12, 298-299). In Van Thulden's etching the banderole round the palm is inscribed as follows: *Ardua per praeceps gloria vadit iter* ("the road to supreme glory passes through dangers" — Ovid, *Tristia*, IV, III, 74). The palm is flanked by banners and there are two Victories holding the monograms of Philip and Ferdinand. The cornice is decorated with a sphinx, a symbol of Firmness, Agility and Prudence; in Van Thulden's etching, an inscription appears under the picture: *Herculi Alexikakos* (To Hercules, Victor over Evil).

The sketch was produced after 5 January 1635, the date when the Fuggers' banking house made available the extra funds for erecting a third arch, in addition to the two originally planned arches of Philip and of Ferdinand. The present sketch corresponds to Van Thulden's etching. The painted decorations for this arch were executed by Jan van Eyck and David Ryckaert. The arch was 55 ft high and 34 ft wide (15.62 x 9.65 m).

The Arch of Hercules.
The Hermitage, St. Petersburg.

Provenance: Purchased for the Hermitage from the Walpole collection, Houghton Hall, England, in 1779 (for more details see note on No. 31).

Prints: By Theodor van Thulden (1606-1669) – in Gevartius 1642, pls. 37, 38.

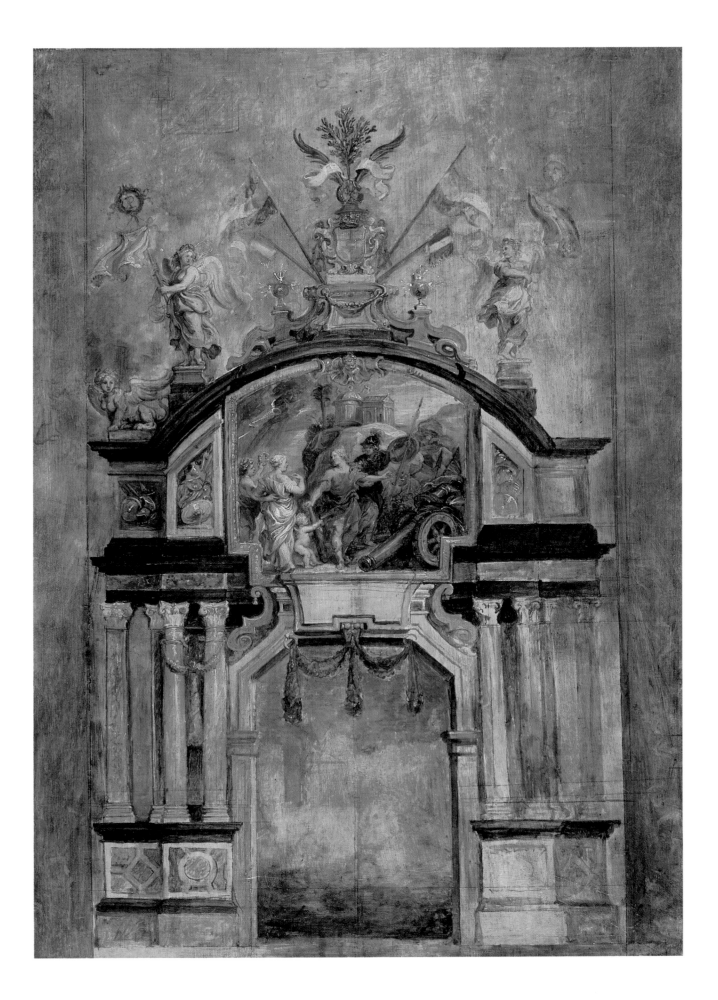

38. *BACCHUS*

Last years.
Oil on canvas. 191 x 161.3 cm.
Transferred from wood by A. Sidorov in 1891.
The Hermitage, St. Petersburg. Inv. No. 467.

The subject of bacchanalia was Rubens' favourite, and representations of Bacchus' companions, such as maenads, fauns, satyrs or Silenus, were frequently used in his work. But pictures of Bacchus himself are rare with Rubens.

As pointed out by Linnik in 1977 (see Linnik 1981), this type of Bacchus, shown as a fat reveller, had long been familiar to the art of Northern Europe. Thus, in the Netherlands' art of drawing of the sixteenth and seventeenth centuries he often personified the month of October, the time when grapes are harvested, new wine is fermented and the occasion is celebrated. This is how Bacchus was portrayed, for example, in Hendrick Goltzius' engraving of the same name. For the same reason Bacchus symbolized Autumn. It is in this spirit that the feast scene in the pavilion in the distant background of the present picture should be interpreted. Its central iconografic motif, Bacchus seated on a barrel with a mug in his hand, was not infrequent in Netherlandish art of the sixteenth and seventeenth centuries, especially in engravings (for example, the *Bacchus* fountain in the famous series of prints executed by Hans Vredeman de Vries or the emblem in Ioannes Sambucus' book [Ioannes Sambucus, *Emblemata...*, Antwerp, 1566] — see A. Henkel, A. Schöne, *Emblemata...*. Stuttgart, 1967, p. 204).

Among the possible iconographic sources of the Hermitage *Bacchus* the following were singled out by Linnik as having at least some bearing on the subject: 1) Silenus' group in Andrea Mantegna's engraving called *Bacchanalia* — Rubens' autograph drawing of it is in the Louvre, Paris; 2) Hans Baldung Grien's

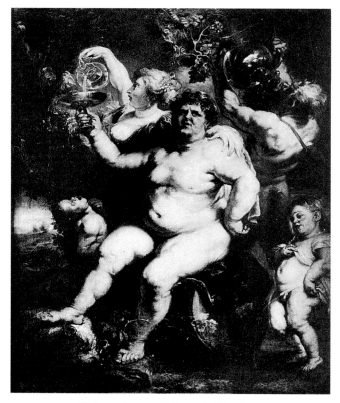

Rubens (or an old copy). *Bacchus.*
Uffizi, Florence.

engraving; 3) Titian's painting *Bacchanalia* in the Prado, Madrid, a replica of which is in the Nationalmuseum, Stockholm.

As established independently by Bailey (1977) and Linnik (1981), Bacchus' head in the Hermitage picture was modelled on the marble bust of Emperor Vitellius, six replicas of which have survived. In the opinion of Max Rooses, Rubens has sketched the Louvre bust (in the Albertina Museum in Vienna there is a drawing, which is now regarded as a copy of Rubens' original — see *Rubenszeichnungen der Albertina zum 400. Geburtstag. Ausstellung 30. März bis 12. Juni.* Vienna, 1977, No. 152). Rubens' authorship has never been doubted, especially because the picture was entered as a Rubens in the inventory of Rubens' property taken at his death and figured in the letters of Philip Rubens, the artist's nephew. In a letter by Philip Rubens to Roger de Piles, French art scholar and connoisseur (in reply to his letter of 5 March 1676), the following appears: *"Bacchus* and *Andromeda* [the so-called *Great Andromeda*, now in the Gemäldegalerie, Berlin-Dahlem] are among the last works and have not been engraved" (see *Bulletin Rubens.* 1882-1910, II, p. 167). This dating to the last years of Rubens' work is borne out by the stylistic features of the painting. Its colouring is dominated by a warm golden tonality, which permeates even the central part in white, red and blue; the clear-cut intricate contours of the moving figures are softened by the light and broad, almost sketchy handling. The figures seem to belong to the air and light infusing the space, the infinitude of which is stressed by the dynamism of the composition where the monumental group of the foreground is contrasted with the landscape in the distant background.

Provenance: In the inventory of Rubens' property taken at his death among the pictures headed as *faictes par feu Monsieur*

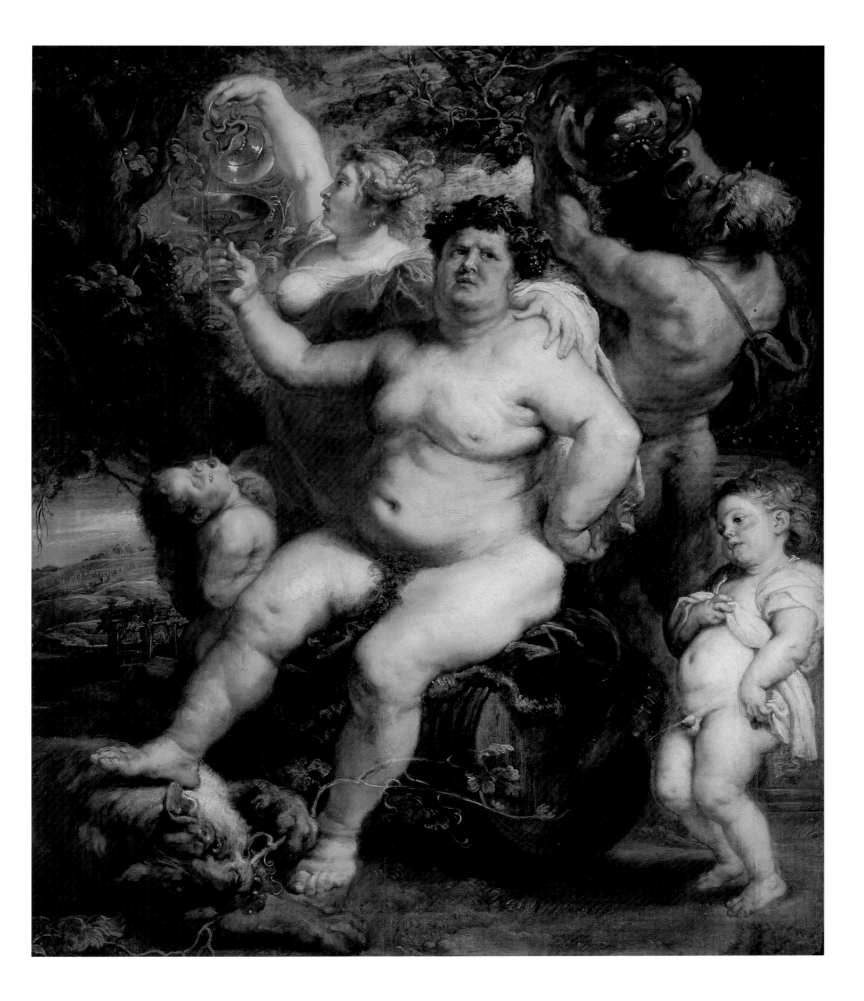

Bacchus, detail.
The Hermitage, St. Petersburg.

Rubens, item No. 91 is described as *Un Bacchus avec une tasse à la main* (Denucé 1932, p. 60). The picture was inherited by the artist's nephew, Philip Rubens, who later sold it to le Duc de Richelieu in Paris through the agency of the art dealer Mateys Musson in Antwerp and Michel Picard in Paris (see Philip Rubens' letter to Picard of 11 February 1676 — *Bulletin Rubens*, 1882-1910, II, p. 163 — also Picard's letters to Musson of 3, 6, 17, 24 and 31 January, of 3 and 7 February and of 17 April 1676 — J. Denucé, "Na Peter Pauwel Rubens...", *Bronnen voor de geschiendenis van de vlaamche Kunst*, vol. V, Antwerp, 1949, pp. 428-435, 438). From the collection of the Duc de Richelieu the picture passed into the Crozat collection in Paris, whence it was purchased for the Hermitage Museum in 1772.

Version: *Bacchus*, Uffizi, Florence; inv. No. 216 (originally in the collection of Queen Christina of Sweden, then in the collection of the Dukes of Orleans). It was considered to be an old smaller-scale copy; it is likely, however, that it was an autograph *modello* for the Hermitage picture.

Prints: By Pietro Peiroleri (b. 1741), executed in 1758 (V.-S. 1873, No. 130); inscribed: *Della Galeria del Signor Barone de Thiers in Parigi*.

Bacchus, detail.
The Hermitage, St. Petersburg.

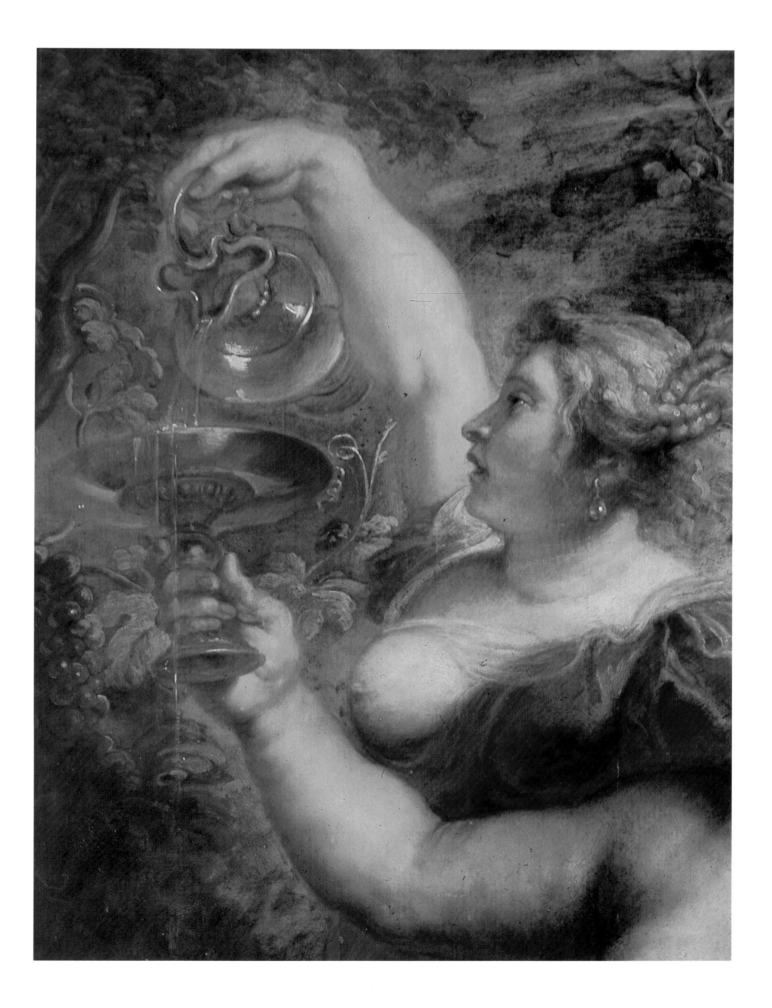

39. *PASTORAL SCENE*

1636-1640.
Oil on canvas. 114 x 91 cm.
The Hermitage, St. Petersburg. Inv. No. 493.

Glück suggested (Glück 1920, p. 95) that the subject was derived from *Aminta,* Torquato Tasso's pastoral drama (staged in 1573, published in 1581). If his supposition were true, then the scene should represent the happy end of the story contained in Elpino's monologue about the shepherd Aminta who was in love with Sylvia, a nymph (Act V, Scene I). There is no identical scene in the drama, so the supposition that the subject was borrowed from Tasso must have resulted from the fact that a version of this composition bought in 1641 for the Prince of Orange (it is believed to be the painting now in the Bayerische Staatsgemäldesammlungen, Munich) was called *Sylvia*. It is quite likely that contemporaries identified the neutral pastoral scene with the then popular subject. Similar pastoral motifs were fairly common in the last decade of Rubens' work (e.g. *Landscape with a Rainbow.* No. 30). Traditionally, although without any factual evidence, Rubensian scholars, from Hoet in 1752 (Hoet & Terwesten 1752-1770, I) to Rosenberg in 1905, believed that Rubens had portrayed Helene Fourment and himself in this piece. The same view was held by Neustroyev (1909) and Benois (1910).

The picture was bought in the eighteenth century as a work by Rubens. Rooses (1890) believed it to be not only a genuine Rubens, but one of a better quality than the Munich picture. Benois (1910) attributed it to Rubens without qualification. In *The Hermitage Catalogue* of 1958 it had the same attribution.

Rubens. *Shepherd Embracing a Shepherdess.*
Alte Pinakothek, Munich.

But Waagen (1864) and later Somov (1902) and the same Rooses (1905) described the Hermitage picture as a replica of the Munich original, without indicating when the subject was repeated. Neustroyev (1909) remarked that Rooses (1890) had no grounds to regard the execution of the Hermitage painting as superior to that of the Munich picture. Rosenberg (1905) and Oldenbourg (1921) did not include the Hermitage painting among Rubens' works. Bazin (1958) regarded it as a copy of the Munich picture. In the catalogues of the Alte Pinakothek published in 1936 and 1938 the Hermitage paintings was also referred to as a replica of the Munich version before its second touching-up (see below).

The Hermitage picture must have been produced by Rubens' studio (see the characteristics above). At the same time the typical features of Rubens' late period are so fully embodied in the Hermitage picture as to suggest the master's direct participation in its execution. It may have been produced simultaneously with the Munich picture of 1636-1640, for it seems to reflect the initial concept of the composition with its typically Rubenesque balance between the central group and the landscape, whereas in the Munich version, which underwent subsequent reworking, the landscape is of greater significance.

Provenance: Purchased for the Hermitage between 1764 and 1774. The old inventory of the Hermitage reads: "...believed to have come from the sale of King William's collection of pictures at Looe..." The present picture is probably identical with that in the Dowburg sale in Amsterdam on 7 May 1770 (see Hoet & Terwesten 1752-1770, I, p. 137).
Versions: Alte Pinakothek, Munich, ca. 1636-40. No. 328/759 oil on wood, 162 x 134. Identified as the picture listed in the posthumous inventory of Rubens' property under No. 94 among "faictes par feu Monsieur Rubens": "Un berger caressant une bergère".

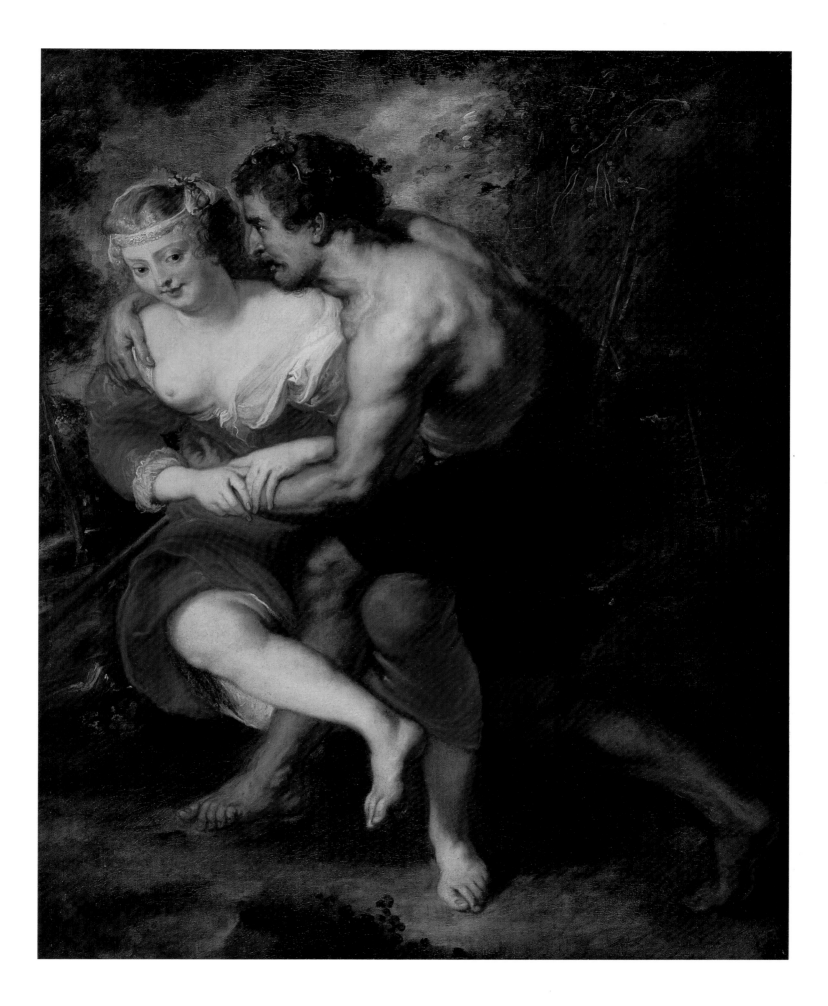

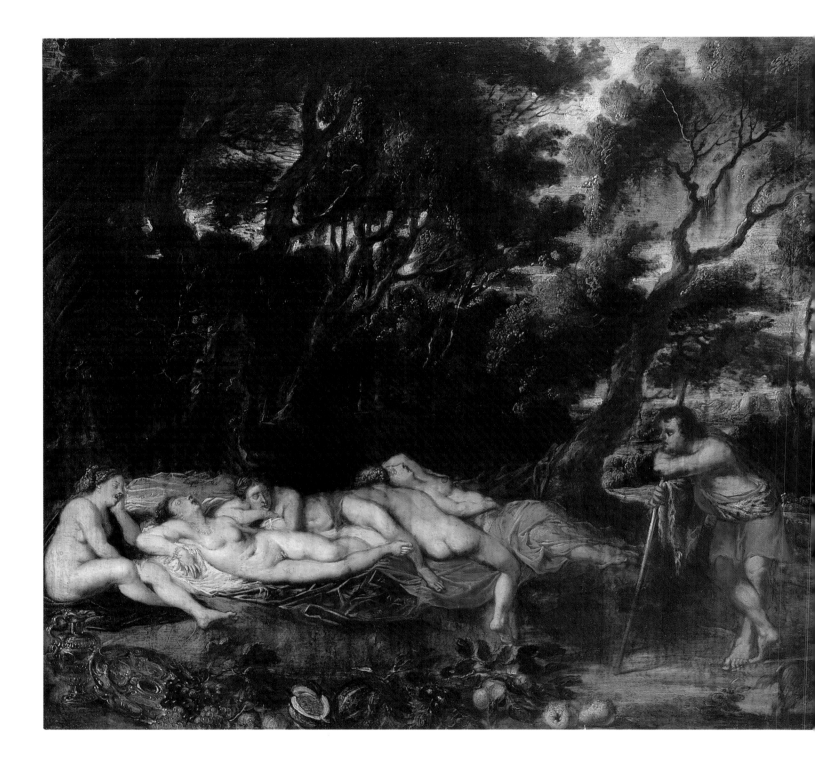

40. *LANDSCAPE WITH CIMON AND IPHIGENIA*

1630s.
Oil on wood. 49 x 73 cm.
The picture once sustained considerable damage. The figures were affected, especially the women's faces, which were restored or even perhaps repainted. The reverse side carries a nineteenth-century inscription, Rubens, and a torn label inscribed: *Cimon Iphingenis/ original of/ Sr Pieter Paul Rub...* The type of lettering and paper give grounds for assigning the label to the seventeenth century. The Hermitage, St. Petersburg. Inv. No. 8311.

The subject was borrowed from Giovanni Boccaccio's *Decameron. V. I.* In 1949 the picture was attributed by R. M. Khai to Rubens' pupil Frans Wouters (1612-1659). In 1972 N. Smolskaya substantially amended the attribution: painted by Rubens in the 1630s, it was left unfinished, until after the artist's death the figures were added by Frans Wouters, who had come from England where he then lived to take part in the valuation of the pictures left after Rubens' death (see Smolskaya 1973; 1974). The still life in the lower part of the picture, of rather inferior quality and entirely unconnected with the composition, was painted by yet another artist whose identity has not been established. The high standard evident in the execution of the landscape and its stylistic features, while differing from Wouters' pictures (like his signed work *Landscape with Satyrs and Nymphs*, National Gallery, London), are quite consonant with Rubens' paintings *Shepherd with a Herd* (ca. 1629) and *Landscape with a Shepherd and a Herd* (ca. 1638, both in the National Gallery, London).

The Rubenesque features of this canvas are manifest not only in the construction of space, but also in the treatment of the trees (a few short trees with round crowns and a thin tree with semi-transparent foliage on the right). They are equally evident in the handling of the leaves, executed in light strokes when in the shade and in lighter-coloured gibbous dots and streaks of white when in the sun, which gives the impression that the entire crown is in motion. No less characteristic of Rubens is the lighting and the general tonality of the painting (the bright rays of the setting sun which fill the air with a golden glow, the pink specks on the foliage and the red reflections on the tree trunks).

Provenance: Purchased for the Hermitage in 1937 by the State Purchasing Commission.

165

BIOGRAPHY

1577
28 June: Born at Siegen in Westphalia (Germany); Peter Paul was the sixth child of Maria Pypelinckx and Jan Rubens, an Antwerp barrister who had fled from the Duke of Alba's reign of terror.

1578
The family moves to Cologne.

1589
After Jan Rubens' death his widow returns to Antwerp with their six children.

1589-1590
With his older brother Philip, Peter Paul attends the Cathedral Latin school.

Ca. 1591
Begins to study under the Antwerp painters Tobias Verhaecht (a landscape artist), then Adam van Noort and, finally, with Otto van Veen.

1598
Becomes a Master of the Antwerp Guild of St. Luke.

1600
9 May: Leaves for Italy. For the next eight years he serves as Court Painter to the Duke of Mantua, Vincenzo Gonzaga.

1603
3 (or 5) March: Leaves Mantua and sets out for Spain. With him he takes works of art intended as presents for the Spanish King Philip II and the Duke of Lerma, the latter's premier minister. Paints *The Duke of Lerma on Horseback* (Prado, Madrid).

1604
June: Returns to Italy.

1606-1608
Lives and works in Rome where he is commissioned to paint an altarpiece for the Church of S. Maria in Vallicella (Chiesa Nuova) by the Oratorian Congregation: *The Madonna Adored by Saints* (original version is in the Musée de Peinture et Sculpture, Grenoble; the finished work is in the said Roman church).

1608
28 October: Leaves Rome after learning of the fatal illness of his mother. Arrives Antwerp about 11 December.

1609
23 September: Appointed Court Painter to the Hapsburg Regents in Flanders, Archduke Albert and the Infanta Isabella.
3 October: Marries Isabella, the daughter of Jan Brant, an Antwerp barrister.

1609-1610
Paints *Self-portrait with Isabella Brant* (Alte Pinakothek, Munich); on commission from the Antwerp city council executes the painting *The Adoration of the Magi* (Prado, Madrid) for the Council Chamber of the Town Hall.

1610
Buys a house in Antwerp and over the next few years rebuilds and decorates it according to his own design (now the Rubenshuis, Antwerp).

1610-1611
Produces the triptych *The Elevation of the Cross* (Antwerp Cathedral) for the Church of St Walpurgis. Has a great many apprentices in his workshop.

1611-1614
Produces the triptych *The Descent from the Cross* for the altar of Arquebusiers in Antwerp Cathedral (now Antwerp Cathedral).

1617
Works on a painting for a series of tapestries, *The History of the Consul Decius Mus* (Liechtensteinische Staatliche Kunstsammlung, Vaduz).

1620
29 March: Signs a contract to sketch 39 compositions for plafonds in the Jesuit Church in Antwerp (burnt down in 1718).

1622
February: Concludes an agreement with Marie de' Medici, the widow of Henry IV, to produce a large series of paintings for the gallery of the Luxembourg Palace in Paris: *The Life of Marie de' Medici* (Louvre, Paris). Publishes *I Palazzi di Genova* in Antwerp, a collection of engravings of "plans, façades and cross-sections" based on his drawings.

1622-1623
Draws 12 cartoons for the series of tapestries *The History of Constantine* commissioned by Louis XIII (cartoons not extant).

1623
The Infanta Isabella, Vice-regent of Flanders, decrees that Rubens shall receive a monthly allowance. Begins his activities as a diplomat.

1624
29 January: Raised to the nobility.

1626
20 June: Death of Isabella Brant.

1627
Travels to Holland to meet Balthazar Gerbier, an English diplomat agent.

1627-1628
On the Infanta Isabella's commission completes 15 cartoons for the series of tapestries *The Triumph of the Eucharist* (3 cartoons are in the Ringling Museum, Sarasota, Fla.).

1628
28 (or 29) August: Travels from Antwerp on a diplomatic mission. There paints *Portrait of Philip V on Horseback* (non extant).

1629
27 April: Appointed Secretary of the Spanish King's Privy Council for Flanders.
13 May: Returns from Spain to Brussels.
5 June: Arrives in London to conduct peace negotiations between Spain and England.

1629-1630
Paints the allegorical *Peace and War* (National Gallery, London) which he presents to Charles I. He is commissioned by Charles to produce 9 ceiling paintings for the Banqueting House in Whitehall, London (still extant).

1630
3 March: Knighted by Charles I. Made an honorary Master of Arts by Cambridge University.
6 April: Returns from London to Antwerp.
6 December: Marries Helene Fourment, the younger daughter of a rich dealer in tapestries, Daniel Fourment.

1631
20 August: Knighted by Philip IV of Spain.

1634-1635
Commissioned by the city council of Antwerp, he works on sketches of triumphal arches for the ceremonial reception of the new Governor, the Cardinal Infante Ferdinand, on 17 April 1635 (Hermitage, St Petersburg; Pushkin Museum, Moscow; Fogg Museum, Cambridge; Ashmolean Museum, Oxford; Koninklijk Museum voor schone Konsten, Antwerp; Musée de Bonnat, Bayonne).

1635
Buys the Chateau de Steen near Elewijt where he mainly spends the summer months. His final landscapes are painted in the locality.

1636
June: Made Court Painter to the Cardinal Infante Ferdinand. Receives a commission for 112 paintings on themes from Ovid's *Metamorphoses* for Philip IV's hunting lodge Torre de la Parada, near Madrid (most of the paintings are in the Prado, Madrid).

1637-1638
Paints *The Horrors of War* (Pitti, Florence).

1640
27 May: Writes his will.
30 May: Peter Paul Rubens dies.

BIBLIOGRAPHY

ADLER 1982
W. Adler, *Rubens. The Landscapes (Corpus Rubenianum Ludwig Burchard, 18, 1)*, Oxford, 1982.

AEDES WALPOLIANAE 1752
Aedes Walpolianae or Description of the Collection of Pictures at Houghton Hall in Norfolk, the Seat of the R. H. Sir Robert Walpole, Earl of Orford. London, 1752.

ALPATOV 1963
M. V. Alpatov, *Studies in the History of Western European Art*, Moscow, 1963 (in Russian).

ALPATOV 1969
M. V. Alpatov, *"Persée et Andromède" de Rubens*, in: *Muzeum i twórca (Mélanges S. Lorentz)*, 1969, pp. 25-30.

ALPATOV 1979
M. V. Alpatov, *«Perseus and Andromeda» by Rubens*, in: Studies in the Universal History of Art, Moscow, 1979, pp. 70-77 (in Russian).

ALPERS 1971
S. Alpers, *The Decorations of the Torre della Parada (Corpus Rubenianum Ludwig Burchard, IX)*, Brussels, 1971.

ALTE PINAKOTHEK 1938
Munich. Catalogue of the Alte Pinakothek. Official edition, Munich, 1938.

ÄLTERE PINAKOTHEK 1936
Munich. Ältere Pinakothek. Amtlicher Katalog. Munich, 1936.

ANTONOVA-MALITSKAYA 1963
I. Antonova, K. Malitskaya, *Le Musée de Moscou*. Paris, 1963.

AUST 1958
G. Aust, *Entwurf und Ausführung bei Rubens*, in: *Wallraf-Richartz-Jahrbuch*, 1958, vol. XX.

BAILEY 1977
S. Bailey, *Metamorphoses of the Grimani «Vitellius»*, in: *The J. Paul Getty Museum Journal*, 1977, vol. 5, p. 119.

BALIS 1986
A. Balis, *Rubens Hunting Scene (Corpus Rubenianum Ludwig Burchard, 18, 2)*. London and Oxford, 1986.

BAUCH 1924
K. Bauch, *Beiträge zur Rubensforschung*, in: *Jahrbuch der Preussischen Kunstsammlungen*, 1924, vol. 45, fasc. 1-2.

BAUDOUIN 1780
Description des tableaux du Cabinet de M. le Comte de Baudouin..., 1780 (manuscript. fund No 1, Archives of the Hermitage, St. Petersburg.

BAUDOUIN 1962
Rubens Diplomate. Exposition au Château Rubens-Elewijt, 1 juillet-15 septembre 1962 (catalogue par F. Baudouin). Anvers, 1962.

BAUDOUIN 1968
Fr. Baudouin, *Een Jeugdwerk van Rubens "Adam en Eva", en de relatie van Veen en Rubens*. Antwerpen (Tijdschrift der Stad Antwerpen), No 2, July, 1968.

BAUDOUIN 1972
F. Baudouin, *Rubens et son siècle*, Antwerp, 1972.

BAUMSTARK 1973
R. Baumstark, Rez. zu J. R. Martin, *The Decorations for the Pompa Introitus Ferdinandi (Corpus Rubenianum Ludwig Burchard, XVI)*, Brussels, 1972, in: *Kunstchronik*, 1973, No. 26, pp. 171-181.

BAUMSTARK 1974
R. Baumstark, *Ikonographische Studien zu Rubens Kriegs- und Friedensallegorien*, in: *Aachener Kunstblätter*, 1974, No. 45, pp. 125-234.

BAZIN 1958
Musée de l'Ermitage, Les Grands maîtres de la peinture. Texte de Germain Bazin, Paris, 1958.

BECHER 1900
E. Becher, *"Venus und Adonis". Ein neues Rubensbild. Mit einem Nachtrag*. Grünewald and Berlin, 1898-1900.

BENOIS 1901
A. L. Benois, *The Stroganov Palace and The Stroganov Gallery in St. Petersburg*, in: *Art Treasures of Russia*, 1901, vol. 1 (in Russian).

BENOIS 1910
A. L. Benois, *A Guide to the Picture Gallery of the Imperial Hermitage*, St. Petersburg, 1910 (in Russian).

BIALOSTOCKI 1964
J. Bialostocki, *The Descent from the Cross in Works by P. P. Rubens and His Studio*, in: *The Art Bulletin*, December 1964.

BODE 1909
Wilhelm Bode, *Die vlämische Schule*, in: *Gemälde alter Meister im Besitze S. M. des Deutschen Kaisers...*, hrsg. von Paul Seidel..., Berlin, 1909.

BODE 1921
W. von Bode, *Die Meister der holländischen und vlämischen Malereischulen*, 3rd ed., Leipzig, 1921 (1st ed.: *Rembrandt und seine Zeitgenossen*. Leipzig, 1906).

BULLETIN RUBENS 1882-1910
Bulletin Rubens. Annales de la commission officielle, instituée... pour la publication des documents relatifs

à la vie et aux œuvres de Rubens. Antwerp and Brussels, 1882, vol. 1; 1883, vol. II; 1888, vol. III; 1896, vol. IV; 1897, vol. V: fasc. 1, 2; 1900, fasc. 3; 1910, fasc. 4.

BURCHARD 1927
L. Burchard, "Skizzen des jungen Rubens", Sitzungsberichte der kunstgeschichtlichen Gesellschaft, Berlin, October 1926-May 1927.

BURCHARD 1927
L. Burchard, *Die neuerworbene Landschaft von Rubens im Kaiser-Friedrich-Museum*, in: *Jahrbuch der preussischen. Kunstsammlungen*, 1927.

BURCHARD 1928
L. Burchard, *Alcuni dipinti del Rubens nel suo periodo italiano*, in: *Pinacotheca*. July-August, 1928.

BURCHARD 1950
L. Burchard, *A Loan Exhibition of Works by Peter Paul Rubens.* Catalogue, October 4th-November 11th, 1950, London.

BURCHARD-D'HULST 1963
L. Burchard and R.-A. d'Hulst, *Rubens' Drawings.* vol. I-II, Brussels, 1963 *(National Centrum voor de Plastische Kunsten van de XVI-de en XVIII-de eeuw. II).*

BURCKHARDT 1898
J. Burckhardt, *Erinnerungen aus Rubens.* Basle.

CASTAN 1885
A. Castan, *«Une visite au Saint-Ildefonse» de Rubens.* Besançon, 1885.

THE HERMITAGE CATALOGUE 1911
Concise Catalogue of the Imperial Hermitage Picture Gallery. St. Petersburg, 1911 (in Russian).

THE HERMITAGE CATALOGUE 1916
Concise Catalogue of the Imperial Hermitage Picture Gallery. Petrograd, 1916 (in Russian).

THE HERMITAGE CATALOGUE 1958
The Catalogue of Western European Paintings in the Hermitage, ed. by V. F. Loewinson-Lessing, Leningrad and Moscow, 1958, vol. II (in Russian).

THE HERMITAGE CATALOGUE 1981
The Hermitage. Western European Paintings. Catalogue, vol. 2. Leningrad, 1981 (in Russian).

THE KIEV MUSEUM CATALOGUE 1961
The Kiev Museum of Western European Paintings and Sculptures. Moscow, 1961 (in Russian).

CATALOGUE OF THE KUSHELEV-BEZBORODKO GALLERY 1886
Picture Gallery of the Imperial Academy of Arts: Catalogue of the Gallery of Count N. A. Kushelev-Bezborodko. comp. by B. K. Vesselovsky, St. Petersburg, 1886, vol. III (in Russian).

THE PUSHKIN MUSEUM CATALOGUE 1957
The Pushkin Museum of Fine Arts Catalogue of the Picture Gallery. Moscow, 1957 (in Russian).

THE PUSHKIN MUSEUM CATALOGUE 1961
The Pushkin Museum of Fine Arts Catalogue of the Picture Gallery. Moscow, 1961 (in Russian).

THE PUSHKIN MUSEUM CATALOGUE 1986
The Pushkin Museum of Fine Arts Catalogue of the Picture Gallery. Moscow, 1986 (in Russian).

CDR 1887-1909
Correspondance de Rubens et documents épistolaires concernant sa vie et ses œuvres, publiés, traduits et annotés par Ch. Ruellens et M. Rooses, vols. I-VI, Antwerp, 1887-1909 *(Codex Diplomaticus Rubenianus).*

COSNAC 1884
Comte de Cosnac, *Les Richesses du Palais Mazarin.* Paris, 1884.

CROZAT 1755
Catalogue des tableaux du Cabinet de M. Crozat. baron de Thiers. Paris, 1755.

DENUCÉ 1932
J. Denucé, *Antwerp Art Galleries. Inventories of the Art Collections in Antwerp in the 16th and 17th Centuries*, La Haye, 1932 *(Historical Source for the Study of Flemish Art. II).*

DOBROKLONSKY 1940
M. V. Dobroklonsky, *Drawings by Rubens. Catalogue of the Hermitage Collection*, III, Moscow and Leningrad, 1940 (in Russian).

DOBROKLONSKY 1949
M. V. Dobroklonsky, "*The Coronation of the Virgin*" *in the Hermitage. Papers of the Department of Western European Art of the Hermitage*, 1949, vol. III (in Russian).

DOBROKLONSKY 1955
M. V. Dobroklonsky, *The Flemish School Drawings of the 17th and 18th Centuries. Catalogues of the Hermitage Collections.* Moscow, 1955, IV (in Russian).

DROST 1926
W. Drost, *Barockmalerei in den germanischen Ländern.* Potsdam, 1926 *(Handbuch der Kunstwissenschaft).*

EIGENBERGER 1924
R. Eigenberger, *Ergänzungen zum Lebenswerke von Rubens und van Dyck in der akademischen Gemäldegalerie in Wien.* Belvedere, vol. V, 1924.

EIGENBERGER 1927
R. Eigenberger, *Die Gemäldegalerie der Akademie der bildenden Künste in Wien.* Vienna-Leipzig, 1927, vols. I-II.

EVERS 1942
H. G. Evers, *Peter Paul Rubens*. Munich, 1942.

EVERS 1943
H. G. Evers, *Rubens und sein Werk. neue Forschungen*. Brussels, 1943.

FOUCART 1977
J. Foucart, *Rubens et son atelier. Paysage à l'arc-en-ciel ou Idylle pastorale*. in: *Le Siècle de Rubens dans les collections publiques françaises. Grand Palais. 17 novembre 1977-13 mars 1978*. Paris, 1977, No 152, pp. 199-201.

FREDLUNG 1974
B. Fredlung, *Arkitektur i Rubens Maleri. Form och funktion*. Konstvetenskapliga Institutionen, Göteborg, 1974.

FREEDBERG 1978
D. Freedberg, *A Source for Rubens's Modello of the Assumption and Coronation of the Virgin: a Case Study in the Response to Images*. in: *The Burlington Magazine*, July 1978, pp. 432-441.

FREEDBERG 1984
D. Freedberg, *Rubens. The Life of Christ after the Passion (Corpus Rubenianum Ludwig Burchard. VII)*. New York, 1984.

FRIEDLÄNDER 1964
W. Friedländer, *Early to Full Baroque: Cigoli and Rubens*. in: *Studien zur toskanischen Kunst. Festschrift für L.-H. Heydenreich*, Munich, 1964.

GERSON-TER KUILE 1960
H. Gerson, E. H. Ter Kuile, *Art and Architecture in Belgium. 1600 to 1800*, Harmondsworth (Middlesex), 1960 *(The Pelican History of Art. XVIII)*.

GEVARTIUS 1642
C. Gevartius [J. C. Gevaerts], *Pompa Introitus Honori Serenissimi Principis Ferdinandi Austriaci...*, Antwerp, 1642

GHERSHENZON-CHEGODAYEVA 1949
N. M. Gershenson-Chegodayeva, *Flemish Painters*. Moscow, 1949 (en russe).

GLÜCK 1905
G. Glück, *Zum Rubens-Band der Klassiker der Kunst*. 1905, in: Gustav Glück, *Gesammelte Aufsätze*. hrsg. von L. Burchard et R. Eigenberger, vol. I, *Rubens. Van Dyck und ihr Kreis*. Vienna, 1933.

GLÜCK 1907
G. Glück, *Niederländische Gemälde aus der Sammlung Alexander Tritsch in Wien*, Vienna, 1907.

GLÜCK 1918
G. Glück, *Rubens und Frans Francken der Jüngere*. 1918, in: Gustav Glück, *Gesammelte Aufsätze*. hrsg. von L. Burchard et R. Eigenberger, vol. I, *Rubens. Van Dyck und ihr Kreis*. Vienna, 1933.

GLÜCK 1920
G. Glück, *Rubens' Leibesgarten*. 1920, in: Gustav Glück, *Gesammelte Aufsätze*. hrsg. von L. Burchard et R. Eigenberger, vol. I, *Rubens. Van Dyck und ihr Kreis*. Vienna, 1933.

GLÜCK 1922
G. Glück, *Rubens' Kreuzaufrichtungs-Altar*. 1922, in: Gustav Glück, *Gesammelte Aufsätze*. hrsg. von L. Burchard et R. Eigenberger, vol. I, *Rubens. Van Dyck und ihr Kreis*. Vienna, 1933.

GLÜCK 1927
G. Glück, *Van Dyck's Apostolfolge*. 1927, in: Gustav Glück, *Gesammelte Aufsätze*. hrsg. von L. Burchard et R. Eigenberger, vol. I, *Rubens. Van Dyck und ihr Kreis*. Vienna, 1933.

GLÜCK 1933
G. Glück, *Rubens. Van Dyck und ihr Kreis*. Vienna, 1933.

GLÜCK 1945
G. Glück, *Die Landschaften von P. P. Rubens*. Vienna, 1945.

GLÜCK-HABERDITZL 1928
G. Glück und F. M. Haberditzl, *Die Handzeichnungen von Peter Paul Rubens*. Berlin, 1928.

GOELER VON RAVENSBURG 1882
Goeler von Ravensburg, *Rubens und die Antike*. Jena, 1882.

GORIS-HELD 1947
J.-A. Goris and J. S. Held, *Rubens in America*. New York, 1947.

GRIMBERGEN 1840
G. van Grimbergen, *Historische Levensbeschrijving van P. P. Rubens...*, Rotterdam, 1840.

GRIMM 1949
G. G. Grimm, *Architecture in Rubens' Pictures*, in: *Papers of the Department of Western European Art of the Hermitage*, 1949, vol. III (in Russian).

GRITSAÏ 1990
N. I. Gritsaï, *"Perseus and Andromeda: Ancient and Renaissance Ones"*. in *Problems of the Development of Foreign Painting. The USSR Academy of Arts. The I. Ye. Repin Institute of Painting. Sculpture et Architecture*, Leningrad, 1990 (in Russian).

GRITSAÏ 1993
N. I. Gritsaï, *"The Union of Earth and Water by Rubens: The Iconography"*, in: *Problems of the Development of Foreign Painting. The Russian Academy of Arts. The I. Ye. Repin Institute of Painting. Sculpture and Architecture*, St. Petersburg, 1993 (in Russian).

GRITSAÏ 1994
N. I. Gritsaï, *"The Language of Objects in the Depiction of the Feasts of the Saviour by Rubens and His

Workshop" in: *Problems of the Development of Foreign Painting. The Russian Academy of Arts. The I. Ye. Repin Institute of Painting. Sculpture et Architecture,* St. Petersburg, 1994, part I, pp. 39-41(in Russian).

GROSSMANN 1906
K. Grossmann, *Der Gemäldezyklus der Galerie der Maria von Medici von Peter Paul Rubens.* Strasbourg, 1906 *(Zur Kunstgeschichte des Auslandes. XLV).*

GROSSMANN 1951
F. Grossmann, *Holbein. Flemish Paintings. and Eberhard Jabach,* in: *The Burlington Magazine.* January 1951.

HABERDITZL 1908
F. M. Haberditzl, *Die Lehrer des Rubens. Otto van Veen.* in: *Jahrbuch der Kunsthistorischen Sammlungen....,* 1908, vol. XXVII, fasc. 5.

HABERDITZL 1912
F. M. Haberditzl, *Studien über Rubens.* in: *Jahrbuch der Kunsthistorischen Sammlungen....,* 1912, vol. XXX, fasc. 5.

HASSELT 1840
M. Van Hasselt, *Histoire de P. P. Rubens....* Brussels, 1840.

HAVERKAMP-BEGEMANN 1953
E. Haverkamp-Begemann, *Olieverschetsen van Rubens.* Museum Boymans, Rotterdam, 1953.

HAVERKAMP-BEGEMANN 1954
E. Haverkamp-Begemann, *Rubens Schetsen.* in: *Bulletin Museum Boymans,* Rotterdam, Deel V, No 1, March 1954.

HAVERKAMP-BEGEMANN 1967
E. Haverkamp-Begemann, *Purpose and Style: Oil Sketches of Rubens. Jan Brueghel. Rembrandt.* in: *Stil und Überlieferung in der Kunst des Abendlandes. Akten des 21. Internationalen Kongresses für Kunstgeschichte in Bonn 1964,* t. III *(Theorien und Probleme).* Berlin, 1967.

HELD 1959
Rubens. Selected Drawings, introduction and a critical catalogue by Julius S. Held, vols. I-II, London, 1959.

HELD 1969
J. S. Held, *Rubens and Vorsterman.* in: *The Art Quarterly.* 1969, N° 2.

HELD 1970
J. S. Held, *Rubens's Glynde Sketch and the Installation of the Whitehall Ceiling,* in: *The Burlington Magazine.* May 1970.

HELD 1974
J. S. Held, *Some Rubens' Drawings. Unknown or Neglected.* in: *Master Drawings.* 1974, No.12.

HELD 1980
J. S. Held, *The Old Sketches of Peter Paul Rubens. A Critical Catalogue.* Princeton, New Jersey, 1980, vol. I-II.

HELD 1982
J. S. Held, *Rubens and His Circle.* Princeton, New Jersey, 1982.

HERMANN 1936
H. Hermann, *Untersuchungen über die Landschaftsgemälde von Rubens.* Stuttgart, 1936.

HIND 1923
A. M. Hind. *Catalogue of Drawings by Dutch and Flemish Artists Preserved in the Department of Prints and Drawings of the British Museum.* vol. 2 *(Drawings by Rubens. van Dyck and Other Artists of the Flemish School of the 17th Century).* London, 1923.

HOET-TERWESTEN
G. Hoet, *Catalogus of naamlyst van Schilderyen. met derzelven pryzen. zedert een langen reeks jaren... verkogt.* vols. I-II, La Haye, 1752; P. Terwesten, *Catalogus og naamlyst van schilderyen... zedert den 22 aug. 1752 tot den 22 Nov. 1768... verkogt....,* vol. III, La Haye, 1770.

HULST & VANDEVEN 1989
R.-A. d'Hulst, M. Vandeven *M. Rubens. The Old Testament (Corpus Rubenianum Ludwig Burchard. III).* New York, 1989.

HYMANS 1883
H. Hymans, *Notes sur quelques œuvres d'art conservées en Flandre et dans le Nord de la France.* in: *Bulletin des commissions royales d'art et d'archéologie.* 1883.

HYMANS 1893
H. Hymans, *Lucas Vorsterman. Catalogue raisonné de son œuvre. précédé d'une notice sur la vie et les ouvrages du Maître.* Brussels, 1893.

JACOBSEN 1911
E. Jacobsen, *Gemälde und Zeichnungen in Genua. Aus Anlass des neuen Kataloges.* in: *Repertorium für Kunstwissenschaft.* 1911, vol. XXXIV.

JAFFÉ 1960
M. Jaffé, *Union of Earth and Water* Revived for the Fitzwilliam, in: *The Burlington Magazine,* October 1960.

JAFFÉ 1963
M. Jaffé, *Peter Paul Rubens and the Oratorian Fathers* in: *Proporzioni.* 1963, vol. IV.

JAFFÉ, 1966
M. Jaffé, *Landscape by Rubens and Another by Van Dyck.* in: *The Burlington Magazine,* August 1966.

JAFFÉ 1966
M. Jaffé, *Rubens*. in: *Encyclopedia of World Art*. New York, Toronto and London, 1966, vol. XVI.

JAFFÉ 1968
Jacob Jordaens (1593-1678). An Exhibition at the National Gallery of Canada, Ottawa, 29 novembre 1967-5 janvier 1969 (selection and catalogue by Michael Jaffé).

JAFFÉ 1989
M. Jaffé, *Catalogo completo Rubens*. Milan, 1989, No 78.

KIESER 1931
E. Kieser, *Tizians und Spaniens Einwirkungen auf die späteren Landschaften des Rubens*. in: *Münchener Jahrbuch der bildenden Kunst*. Munich, 1931, vol. VIII, fasc. 4.

KIESER 1933
E. Kieser, *Antikes im Werke des Rubens*. in: *Münchener Jahrbuch der bildenden Kunst*. N. F., Munich, 1933, vol. X, fasc. 1/2.

KIESER 1938-1939
E. Kieser, *Rubens' Münchener Silen und seine Vorstufen*. in: *Münchener Jahrbuch der bildenden Kunst*. N. F., Munich, 1938-1839, vol. XIII.

KIESER 1950
E. Kieser, *Rubens' Madonna im Blumenkranz*. in: *Münchener Jahrbuch der bildenden Kunst*, Munich, 1950, vol. I.

KUZNETSOV 1965
Y. I. Kuznetsov, *Rubens' Drawings from the U.S.S.R. Museums: To the 325th Anniversary of the Artist's Death. Exhibition Catalogue*, Leningrad-Moscow, 1965 (in Russian).

KUZNETSOV 1966
Y. I. Kuznetsov, Western European Still Life, Leningrad and Moscow, 1966 (in Russian).

KUZNETSOV 1967
Y. I. Kuznetsov, Western European Paintings in Soviet Museums, Leningrad, 1967 (in Russian).

KUZNETSOV 1974
Y. I. Kuznetsov, *Drawings by Rubens*, Moscow, 1974 (in Russian).

KÜNSTLE 1926
K. Künstle, *Ikonographie der Heiligen*. Freiburg im Br., 1926.

KÜNSTLE 1928
K. Künstle, *Ikonographie der Christlichen Kunst*. vol. I, Freiburg im Br., 1928.

LANKRINK'S COLLECTION 1945
P. H. Lankrink's Collection. in: *The Burlington Magazine*, February 1945.

LE BRUN 1792
Galerie des peintres flamands, hollandais et allemands... texte explicatif... par M. Le Brun..., à Paris..., 1792, vol. I, Paris.

LOEVINSON-LESSING 1926
V. F. Loevinson-Lessing, *Snyders and Flemish Still Life*. Leningrad, 1926 (in Russian).

LEXIKON 1968
Lexikon der christlichen Ikonographie, hrsg. von E. Kirschbaum, vol. I, Rome, 1968.

LINNIK 1981
I. V. Linnik, *The History of Rubens' Work on Two Pictures in the Hermitage*, in *Collected Papers of the Hermitage on Seventeenth-century Western European Art*. Leningrad, 1981 pp. 30-37 (in Russian).

LIVRET 1838
F. Labenski, *Livret de la Galerie impériale de l'Ermitage de Saint-Pétersbourg*, St. Petersburg, 1838.

LUGT 1925
F. Lugt, *Notes sur Rubens*. in: *Gazette des Beaux-Arts*. September-October 1925.

LUGT 1949
Musée du Louvre. Inventaire général des dessins des écoles du Nord... École flamande, par Frits Lugt, Paris, 1949, vol. II.

MALINOVSKY 1990
K. Malinovski, *The Notes by Jakob Stählin on the Fine Arts in Russia*. Compiled, translated from the German, introduced and commented by K. V. Malinovsky, vol. 1-2, Moscow, 1990 (in Russian).

MANTZ 1885
P. Mantz, *Rubens*. in: *Gazette des Beaux-Arts*. 1885, II.

MARIETTE 1854
Abecedario de P.-J. Mariette et autres notes inédites de cet auteur sur les arts et les artistes. Paris, 1853-1854, vol. V *(Archives de l'art français. IV)*.

MARTIN 1968
G. Martin, *Lucas van Uden's Etchings after Rubens*. in: *The Burlington Magazine*. March, 1968.

MARTIN 1970
National Gallery catalogues. The Flemish School. Circa 1600-ca. 1900. By G. Martin, London, 1970.

MARTIN 1972
J. R. Martin, *The Decorations for the Pompa Introitus Ferdinandi (Corpus Rubenianum Ludwig Burchard. XVI)*. Brussels, 1972.

MARTIN, CORPUS 1968
J. R. Martin, *The Ceiling Paintings for the Jesuit Church in Antwerp*. Brussels, 1968 *(Corpus Rubenianum Ludwig Burchard. part I)*.

METZGER 1956
O. Metzger, *Ein Frühwerk des Rubens «Ecce Homo»,* in: *Weltkunst,* 15 November 1956.

MICHEL 1771
J.-F. Michel, *Histoire de la vie de P. P. Rubens...,* Brussels, 1771.

MICHEL 1900
E. Michel, *Rubens, sa vie, son œuvre et son temps,* Paris, 1900.

MILLAR 1956
O. Millar, *The Whitehall Ceiling,* in: *The Burlington Magazine,* August 1956.

MILLAR 1960
Abraham van der Doort's Catalogue of the Collection of Charles I, introduction by Oliver Millar, Oxford, 1960 *(The Thirty-seventh Volume of the Walpole Society, 1958-1960).*

MULLER 1981-1982
J. M. Muller, *The Perseus and Andromeda on Rubens's House,* in: «Simiolus», 1981-1982, vol. 12, N° 2/3, pp. 131-146.

MULLER 1989
J. M. Muller, *Rubens: The Artist as Collecto*r, Princeton, New York, 1989.

MÜLLER-HOFSTEDE 1962
J. Müller-Hofstede, *Zur Antwerpener Frühzeit von P. P. Rubens,* in: *Münchener Jahrbuch der bildenden Kunst,* Munich, 1962, 3rd Series, vol. 13.

MÜLLER-HOFSTEDE 1966
J. Müller-Hofstede, *Zwei Hirtenidyllen des späten Rubens,* in: *Pantheon,* January-February 1966.

MÜLLER-HOFSTEDE 1968
J. Müller-Hofstede, *Zur Kopfstudie im Werke von Rubens,* «Wallraf-Richartz Jahrbuch», vol. XXX, 1968.

MÜLLER-HOFSTEDE 1969
J. Müller-Hofstede, *Neue Ölskizzen von Rubens,* in: *Städel Jahrbuch,* 1969, New Series, vol. 2.

MUULS 1966
Baron Muuls, *Les Longueval, comtes de Bucquoy, au service des Habsbourgs dans les Pays-Bas catholiques* in: *Revue Belge d'Histoire Militaire,* 1966, vol. XVI, No 5.

NEUSTROYEV 1907
A. Neustroyev, *Niederländische Gemälde in der Kaiserliche Akademie der Künste zu St. Petersburg,* in: *Zeitschrift für bildende Kunst,* 1907.

NEUSTROYEV 1909
A. A. Neustroyev, *Rubens and His Pictures in the Gallery of the Imperial Hermitage,* in: *Old Years,* January-February 1909 (in Russian).

OBERHAMMER 1967
V. Oberhammer, *Die Gemäldegalerie des Kunsthistorischen Museums in Wien,* Leipzig, 1967.

OLDENBOURG 1916
R. Oldenbourg, *Venus und Adonis, 1916,* in: *Peter Paul Rubens. Sammlung der von Rudolf Oldenbourg veröffentlichten... Abhandlungen....* hrsg. von W. von Bode, Munich and Berlin, 1922.

OLDENBOURG, 1918
R. Oldenbourg, *Die Flämische Malerei des XVII. Jahrhunderts,* Berlin, 1918 *(Handbücher des Königlichen Museen zu Berlin).*

OLDENBOURG 1918
R. Oldenbourg, *Die Nachwirkung Italiens auf Rubens und die Gründung seiner Werkstatt, 1918,* in: *Peter Paul Rubens. Sammlung der von Rudolf Oldenbourg veröffentlichten... Abhandlungen....* hrsg. von W. von Bode, Munich and Berlin, 1922.

OLDENBOURG 1919
R. Oldenbourg, *Die Plastik im Umkreis von Rubens. 1919,* in: *Peter Paul Rubens. Sammlung der von Rudolf Oldenbourg veröffentlichten... Abhandlungen....* hrsg. von W. von Bode, Munich and Berlin, 1922.

OLDENBOURG 1921
P. P. Rubens. *Des Meisters Gemälde in 538 Abbildungen,* hrsg. von Rudolf Oldenbourg..., 4. neue bearbeitete Auflage, Stuttgart-Berlin, 1921 *(Klassiker der Kunst in Gesamtausgaben,* vol. 5).

OLDENBOURG 1922
R. Oldenbourg, *Die Flämische Malerei des XVII. Jahrhunderts,* Berlin-Leipzig, 1922.

PADRÓN 1975
M. D. Padrón, *Museo del Prado. Catalogo de las pinturas. I. Escuela flamenca siglo XVII,* vols. I (text) II (plates). Madrid, 1975.

PANOFSKY 1930
E. Panofsky, *Hercules am Scheidewege und andere Antike Bildstoffe in der neueren Kunst,* Leipzig-Berlin, 1930 *(Studien der Bibliothek Warburg, XVIII).*

PERGOLA 1967
P. della Pergola, *P. P. Rubens e il tema della Susanna abogno,* in: *Bulletin des Musées Royaux des Beaux-Arts de Belgique,* 1967.

PER PALME 1956
Per Palme, *The Triumph of Peace. A Study of the Whitehall Banqueting House,* Stockholm, 1956.

PHILIPPI 1900
A. Philippi, *Die Blüte der Malerei in Belgien. Rubens und die Flamländer,* Leipzig and Berlin, 1900.

PROHASKA 1977
W. Prohaska, *Die Himmelfahrt Mariens,* in: *Peter Paul*

Rubens. 1577-1646. Ausstellung zur 400. Wiederkehr seines Geburtstages. Vienna, 1977, pp. 66-72.

PUYVELDE 1939
L. van Puyvelde, *Skizzen des Peter Paul Rubens.* Frankfurt-am-Main, 1939.

PUYVELDE 1942-1947
L. van Puyvelde, *De Aabidding door de Herders te Antwerpen.* in: *Annuaire du Musée Royal d'Anvers.* 1942-1947.

PUYVELDE 1952
L. van Puyvelde, *Rubens.* Paris and Brussels, 1952 *(Les peintres flamands du XVIIᵉ siècle).*

PUYVELDE 1965
L. van Puyvelde, *Le siècle de Rubens. Musées Royaux des Beaux-Arts de Belgique.* Brussels, 15 October-12 December 1965.

RÉAU 1912
L. Réau, *La Galerie de tableaux de l'Ermitage.* in: *Gazette des Beaux-Arts.* 1912.

RÉAU 1955-59
Louis Réau, *Iconographie de l'art chrétien.* Paris, vol. I-1955; vol. II (1)-1956; vol. II (2)-1957; vol. III-1958-1959.

RENGER 1974
K. Renger, *Rubens Dedit Dedicavitque; Rubens' Beschäftigung mit der Reproductionsgrafik,* I. Der Kupferstich. in: *Jahrbuch der Berliner Museen.* vol. XVI. Berlin, 1974, pp. 122-175.

ROBELS 1989
H. Robels, *Frans Snyders. Stilleben- und Tiermaler. 1579-1657,* Munich, 1989, p. 356, cat. No 262.

ROEDER-BAUMBACH-EVERS 1943
J. von Roeder-Baumbach, H. G. Evers, *Versieringen bij Blijde Inkomsten gebruikt in de Zuidelijke Nederlanden gedurende de 16-de en 17-de eeuw.* Antwerp.

ROGER DE PILES 1677
Roger de Piles, *Le Cabinet de Monseigneur le duc de Richelieu.* Paris, 1677.

ROGER DE PILES 1681
Roger de Piles, *Dissertation sur les ouvrages des plus fameux peintres....* Paris, 1681.

ROOSES 1886-1892
M. Rooses, *L'œuvre de P. P. Rubens. Histoire et description de ses tableaux et dessins.* Antwerp, 1886, vol. I; 1888, vol. II; 1890, vol. III; 1890, vol. IV; 1892, vol. V.

ROOSES 1905
Max Rooses, *Rubens' Leben und Werke.* Stuttgart-Berlin-Leipzig, 1905.

ROSAND 1969
D. Rosand, *Rubens's Munich "Lion Hunt". Its Sources and Significance,* in: *The Art Bulletin.* 1969, vol. II.

ROSENBERG 1893
A. Rosenberg, *Die Rubensstecher.* 1893.

ROSENBERG 1905
P. P. Rubens. Des Meisters Gemälde in 551 Abbildungen, hrsg. von Adolf Rosenberg, 2. Aufl., Stuttgart-Leipzig, 1905 *(Klassiker der Kunst in Gesamtausgaben,* vol. 5).

ROSENBERG 1926
J. Rosenberg, *Die Gemaldesammlung der Ermitage.* in: *Kunst und Künstler.* 1926.

RUBENS, LETTERS 1977
Pierre Paul Rubens, *Letters. Documents. Opinions His Contemporaries.* Introduction and footnotes by X. S. Egorova, Moscow, 1977 (in Russian).

SCHMIDT 1926
D. A. Schmidt, *Rubens and Jordaens,* Leningrad, 1926 (in Russian).

SCHMIDT 1949
D. A. Schmidt, *An Unknown Sketch by Rubens for "The Deposition from the Cross",* in *Collected Papers of the Hermitage Western European Art.* Leningrad, 1949, vol. 3 (in Russian).

SCHNITZLER 1828
G. H. Schnitzler, *Notice sur les principaux tableaux au Musée Impérial de l'Ermitage à Saint-Pétersbourg.* 1828.

SCHWARZENBERG 1977
A.-M. Schwarzenberg, *Der Ildefonso Altar.* in: *Peter Paul Rubens. Ausstellung zur 400. Wiederkehr seines Geburtstages.* Vienna, 1977, pp. 111-114.

SEILERN 1955
A. Seilern, *Flemish Paintings and Drawings at 56 Princes Gate.* London, SW 7, vol. I-II, London, 1955.

SIMSON 1936
O. G. von Simson, *Zur Genealogie der weltlichen Apotheose im Barock. besonders der Medicigalerie des P. P. Rubens.* Strassburg, 1936 *(Sammlung Heitz. Akademische Abhandlungen zur Kulturgeschichte,* 2ⁿᵈ Series, vol. 9).

SMITH 1830-1842
A Catalogue Raisonné of the Works of the Most Eminent Dutch. Flemish and French Painters... by John Smith, London, 1830, vol. II; Supplement, 1842, vol. 9.

SMOLSKAYA 1973
N. F. Smolskaya, *Un Nouveau paysage de Rubens à l'Ermitage.* in: *Bulletin du Musée National de Varsovie.* Varsovie, 1973, XIV, N° 1-4, pp. 75-85.

SMOLSKAYA 1974
N. F. Smolskaya, A Landscape by *Rubens: New Attribition. Proceedings of the Hermitage.* 1974, issue 39, pp. 4-7 (in Russian).

SMOLSKAYA 1986
N. F. Smolskaya, *New data on P. P. Rubens' Painting "The Crown of Thorns"*, in: *Reports of the State Hermitage*, issue 51, 1986 (in Russian).

SOMOV 1902
A. Somov, *The Imperial Hermitage: Catalogue of Its Picture Gallery*. comp. by A. Somov, part 2: *The Paintings of the Netherlands and Germany*. St. Petersburg, 1902 (in Russian).

SOMOV, PAINTINGS 1902
A. Somov, *The Imperial Hermitage: Catalogue of Its Picture Gallery*. comp. by A. Somov, part 2: *The Paintings of the Netherlands and Germany*. St. Petersburg, 1902, issue IX (in Russian).

SPETH-HOLTERHOFF 1957
S. Speth-Holterhoff, *Les Peintres flamands de cabinets d'amateurs au XVII^e siècle*. Brussels, 1957, p. 54.

STROGANOFF 1793
Catalogue raisonné des tableaux qui composent la collection du comte A. de Stroganoff. St. Petersburg, 1793.

STROGANOFF 1800
Catalogue raisonné des tableaux qui composent la collection du comte A. de Stroganoff. St. Petersburg, 1800.

TEYSSÈDRE 1963
B. Teyssèdre, *Une collection française de Rubens au XVII^e siècle: le Cabinet du Duc de Richelieu décrit par Roger de Piles (1676-1681)*. in: *Gazette des Beaux-Arts*, November 1963.

THEUWISSEN 1966
J. Theuwissen, *De Kar en de wagen in het werken van Rubens*. in: *Jaarboek van het koninklijke Museum voor schone Kunsten te Antwerpen*. Antwerp, 1966.

THUILLIER 1969
J. Thuillier, *«La Galerie de Médicis» de Rubens et sa genèse: un document inédit*. in: *Revue de l'art*. 1969, IV, pp. 52-62.

THUILLIER-FOUCART 1967
J. Thuillier (con un'appendice di Jacques Foucart), *Le storie di Maria de Medici di Rubens al Lussemburgo*. Milan, 1967 (*Grandi Monografie d'Arte*).

VALENTINER 1946
Loan Exhibition of Forty-three Paintings by Rubens and Twenty-five Paintings by van Dyck. Los Angeles County Museum, 1946... (Catalogue by W. R. Valentiner).

VARCHAVSKAYA 1967
M. Varchavskaya, *Certains traits particuliers de la décoration d'Anvers par Rubens pour l'Entrée triomphale de l'Infant-Cardinal Ferdinand en 1635*. in: *Bulletin des Musées Royaux des Beaux-Arts de Belgique*. 1967.

VARCHAVSKAYA 1975
M. Varchavskaya, *Rubens' Paintings in the Hermitage*, Leningrad, 1975 (in Russian).

VARCHAVSKAYA 1981
M. Ya. Varshavskaya, "Rubens and Antwerp's Romanists: On Historical Sources of Rubens' Art", in *Collected Papers of the Hermitage on Seventeenth-century Western European Art*. Leningrad, 1981 pp. 5-20 (in Russian).

VERTUE 1938
The Twenty-sixth Volume of the Walpole Society. 1937-1938. Vertue Note Books, V, Oxford, 1938.

VETTER 1974
E. M. Vetter, *Rubens und die Genese des Programms der Medicigalerie*. in: *Pantheon*. 1974, XXXII, pp. 355-373

VLIEGHE 1972
H. Vlieghe, *Saints*. Brussels, 1972, I (*Corpus Rubenianum Ludwig Burchard*. VIII).

VLIEGHE 1973
H. Vlieghe, *Saints*. Brussels, 1973, II (*Corpus Rubenianum Ludwig Burchard*. VIII).

VLIEGHE 1987
H. Vlieghe, *Rubens Portraits of Identified Sitters painted in Antwerp (Corpus Rubenianum Ludwig Burchard. partie 19. 2)*. London, 1987.

V.-S. 1873
C. G. Voorhelm-Schneevoogt, *Catalogue des estampes gravées d'après P. P. Rubens*. Haarlem, 1873.

VSEVOLOZHSKAYA-LINNIK 1975
S. Vsevolozhskaya, I. Linnik, *Caravaggio and His Followers*. Leningrad, 1975.

WAAGEN 1864
G. F. Waagen, *Die Gemäldesammlung in der Kaiserlichen Ermitage in St. Petersburg. nebst Bemerkungen über andere dortige Kunstsammlungen*. Munich, 1864.

WEINER 1923
Meisterwerke der Gemäldesammlung in der Ermitage zu Petrograd von P. P. Weiner. Munich, 1923.

WEISSBACH 1919
W. Weissbach, *Trionfi*. Berlin, 1919.

WINKLER 1923
F. Winkler, *Besprechung von Rubens. Klassiker der Kunst*. in: t. V, 4. neubearbeitete Auflage von R. Oldenbourg, 1921, *Repertorium für Kunstwissenschafft*. 1923-1924, XLIV.

WRANGEL, 1909
Les Chefs-d'œuvres de la galerie de l'Ermitage Impérial à Saint-Pétersbourg, par le baron Nicolas Wrangel. London-Munich-New York, 1909.